Key Essays

Any level of study within literature and culture requires an engagement with a wider scope of themes, issues and discourses, and these debates are often centred around key 'essays'. This book examines a wide range of these essays on topics such as posthumanism, racism, feminism, necropolitics, the Anthropocene, gender, Global North/South, neo- and de-colonialism, universals, borders and limits, interspecies relations, blackness, cosmopolitics, epistemology, and addiction.

The essays selected represent scholars from a range of disciplines, ethnicities, nationalities and genders, and offer readings relevant across the arts and humanities. Each chapter explains why the essay is of vital importance in our contemporary era, introduces and explains the key themes and theories with which it engages, demystifies any complex content and positions it within wider current debates.

Covering all of the essential debates that students and academics must engage with, alongside a close analysis and critique of contemporary seminal essays in the debate, this book will be an essential read for students of literature and culture across the arts and humanities.

Johnny Rodger is Professor of Urban Literature at the Glasgow School of Art, Scotland. He publishes both fiction and criticism. He is the author of *Hero Building: An Architecture of Scottish National Identity* (Routledge, 2015).

Key Essays

Mapping the Contemporary in Literature and Culture

Johnny Rodger

Routledge
Taylor & Francis Group

LONDON AND NEW YORK

First published 2022
by Routledge
2 Park Square, Milton Park, Abingdon, Oxon OX14 4RN

and by Routledge
52 Vanderbilt Avenue, New York, NY 10017

Routledge is an imprint of the Taylor & Francis Group, an informa business

© 2022 Johnny Rodger

British Library Cataloguing in Publication Data
A catalogue record for this book is available from the British Library

Library of Congress Cataloging-in-Publication Data
A catalog record has been requested for this book

ISBN: 978-1-032-03363-1 (hbk)
ISBN: 978-1-032-00152-4 (pbk)
ISBN: 978-1-003-18692-2 (ebk)

DOI: 10.4324/9781003186922

Typeset in Bembo
by Taylor & Francis Books

Contents

Preface

The last two or three decades have seen a massive shift in the range and scope of the humanities. The question of what it is to be human has perforce moved to centre stage, and thus forced an interrogation of the very existence of the 'Humanities' in our globalised, multi-ethnic, post-feminist, digital era of climate change.

This book provides background interdisciplinary reading which is essential across the Arts and Humanities – especially so in this intersectional age – in topics of which no one working in this field can afford not to be up to date whatever their speciality (e.g. posthumanism, racism, feminism, necropolitics, the Anthropocene, gender, neo- and de-colonialism, universals, borders and limits, interspecies relations, blackness, cosmopolitics, epistemology, and addiction).

The argument of the work is that in its very particular versatility the essay form has undergone a revival and been the most effective vehicle driving, formulating, capturing, exposing, deconstructing and analysing the contemporary shift in the terrain of the post-humanities. The intention here is that via discussion and critique of a selection of topical and highly engaging texts from prominent thinkers and writers the reader can gain fairly quick orientation to where we are in the field of art and humanities thinking. Publishing in the centenary year of Raymond Williams's birth, it acknowledges the influential work of his *Keywords* – a 'compendium of political and aesthetic terms … informed by British Marxism of the 1960s and 70s', as Emily Apter calls it. It also recognises that the authoritative and definitional approach of *Keywords* has limited critical purchase on the fragmented nature of contemporary culture. Through examination of the prose form of the contemporary essay this work seeks to map the topographical articulations of the political and aesthetic world through the post-Foucault focus not on the word but on the enunciation. Its concerns are with discursive conditions, the positioning from which utterance is made, its relations, proportions and movements with respect to a field rather than simply its grammatical or propositional sense.

The form of this work is relatively straightforward and easy to comprehend. An introduction examines the context in terms of the birth of the 'modern'

essay as a form, its uses and its significance, its position culturally, politically and morally, the most remarkable practitioners and most useful critics and critiques. The contemporary revival of the form is subsequently examined both with respect to its historically 'modern' sources and to its current day context. The main body of the text follows, with fifteen chapters each consisting in an essay which mounts a discussion by way of introduction to, and criticism of one contemporary essay (written since 2000) by a particular writer (or writers in the case of collaborators Fred Moten and Stefano Harney). These writers come from all around the globe and operate in various different disciplines; they are all prominent intellectuals and writers in that particular discipline (be it architecture in the case of Rem Koolhaas and Eyal Weizman, anthropology with Anna Tsing, philosophy with Catherine Malabou, and so on ...), and they are all well known across the humanities in general – often because of the effective interdisciplinary applicability of their work in general and as featured in the chosen essay subjected to critique here.

The book is intended not just as an introduction to these vital texts but also as a provocative and original intervention in the field itself. Thus, while making an argument for the stature and poignancy of the essay as the key form for the era, the most challenging part of the task here has been to maintain a balance between sustaining a polemical edge, embodying the fullest characterisation and summation on the one hand, and explication, questioning and critical insight on the other. Most important of all is inciting those students, academics and whoever else is intrigued to pick up this book, to go to the primary texts themselves prepared to engage, equipped for sustained study and for thoughtful interrogation.

Acknowledgements

A debt of gratitude is owed to many friends and colleagues for their help, advice, suggestions, expertise and, not least, their forbearance in the conception, writing and publishing of this book. Among many others, those most especially to be thanked are Gerard Carruthers, Lucia Cola, Jolanta Dolewska, Owen Dudley Edwards, Benjamin Greenman, Jakob Lund, Robert Mantho, Sara O'Brien, Margarita Palacios, Lionel Ruffel and Adam Sharr.

Introduction

Keytexts – the contemporary essay

When the essayist Hazlitt died penniless in 1830, his landlady is said to have hidden his body under the bed for a few days while she tried to let out his room. There is no record of what such a pragmatic soul made of any of the final scrawlings her dead client might have left behind; and the money for his last published effort was quite literally, as they say, in the post. The anecdote might be emblematic not only of the fate of Hazlitt – hidden away in the history of writing – but also of his favoured form. Yet if the essay was long considered the poor relation, intellectually, of the thesis – of method, of the rationality and logic of theory and philosophy – if it has been stuffed figuratively under Plato's bed, as it were, alongside the poets, the artists and the dramatists with all their subjective emotions – then the argument from this present work is that certain changes in global conditions have favoured an intellectual revival. It may not be a case of the essay as Lazarus (to mix our mortal myths) arising from a putative death bed exactly as was though, for these new 'conditions' are the setting for a much-changed production of the essay.

This contemporary essay has indeed been extraordinarily influential on recent thought and practice in the Arts and Humanities. Through personal, social and occupational contact in my work in the Arts and Humanities I've found that a number of engaging short prose works have been a topic of speculation, criticism and inspiration across the board: for academics, writers, visual and conceptual artists, filmmakers, musicians, dramaturgs, and political, feminist, anti-colonial, gender-activist, anti-racist and anti-fascist activists. The same recently composed essays are read in the original and in translation around the globe. Could a representation and discussion of some of those most read, debated and influential samples help make us aware of, and make legible what is going on in this literary revival of a particular form? Could we understand why so? Before presenting examples and discussing them however, an outline of the context of selection, and indeed an examination of the form of the essay, and in particular, this revitalised contemporary essay and its scope, could lay open the impulse behind this study. Whether that makes it enlightening and/or useful is, of course, another matter. There are undoubtedly

DOI: 10.4324/9781003186922-1

other models to which this work will be compared, and if there is no 'field' as such for this operation then one other work might be figured by many readers as a significant avatar.

In 1975 Raymond Williams published his text *Keywords*. In that work were gathered more than one hundred individual words – all designated clearly as 'keywords' in his own contemporary culture. These words were, in turn, each taken for a rubric under which their role, meaning and significance in language were examined by way of investigation of the formation and modification of their usage. The book was claimed to be 'a unique exploration of the actual language of cultural transformation'. The study was enormously influential on a generation and was the result of decades long work in researching, recording, archiving and analysis by the assiduous Williams. It clearly overlapped with the work of scholars in numerous disciplines (Williams was a Professor of English Literature) including lexicographers, etymologists, historians and political scientists to name but a few, and it is redolent of an austere post-war British leftism with long discussions given to such terms as 'class', 'masses' and 'bourgeois'. Given the sustained depth and concentration of study and work Williams carried out, any comparison with this present work in terms of sustained scholarship would clearly constitute an exaggerated and conceited claim. However, an immediate similarity in the two studies might be worthy of comment. The obvious formal resemblance is of the choice in both studies of significant – 'key' – examples at the discretion of the writer, to discuss and hence expose the theme (if that is the correct word) – words in one instance and short prose pieces in the other.

Any study since the 1980s which works with texts and hopes to reveal something of possible positions and functions of subjects with respect to the operations of power and knowledge is inevitably much influenced by the work of Michel Foucault in his concepts of discourse and of regimes of truth. The present study is no exception, and these Foucauldian underpinnings would certainly account for some major differences between the Williams work and this one.

Focusing on 'living language' as a site for resolution of critical and political approaches in his work to wrest the definition of culture from conservatives like Eliot and Leavis, Williams's work leans heavily on etymology, history and traditions to outline meanings which are proposed to pertain to usage of the individual terms.[1] A post-Foucault approach is more interested in the statement than the word, understanding the power of each statement not as a meaning or interpretation but in its relational qualities: how as a vector through certain regularities and continuities or discontinuities it reveals in its utterance the positions and functions of subjects with respect to knowledge and so ultimately to power. As physicist Karen Barad puts it in her essay, drawing on both Foucault and quantum mechanics, and cited here below, 'Meaning is not a property of words or groups of words'.[2] For that reason also, established and traditional forms and narratives such as Williams seeks out

through history, evolution and etymology to tie down his words are to be avoided because they limit the possible emergence – or 'irruption' as Foucault has it – of discourses as new, free and authentic events.[3] The essay itself is an exemplary form for the consideration of discourse as a contemporary event because of its open-endedness, its sense of a subject constructed through its ranging across a field, and the rejection of the attempt to represent a totality or a final objective thesis on any topic. As we can see here below, in pieces by Denise Ferreira da Silva, Rem Koolhaas and Karen Barad, the essayist often pushes their statement beyond the limits of meaning, transforming their words into things which expose sets of solid relationships in space.

Furthermore, the confidence Williams has, and the dependence he shows on the word saturated with ready-made meanings as the basic unit of the enunciation, which only has to link up with similar others, is not just paradoxically 'reductive' as he admits, but he acknowledges that 'It can of course be argued that individual words should never be isolated, for they depend for their meaning on actual contexts.'[4]

It's odd that despite numerous such doubts, admissions and caveats regarding the task, Williams persists – almost as if he would expect to hear a part of the roar of Niagara in a single isolated drop of water. Williams's scholarship is impressively thorough and the range of his intellect is admirable but for all that, the effect of reading his fine essays on any particular word is that we feel now, under the unbearable weight of information and theory, less sure about any definitive meaning than we did before reading. He seems to acknowledge this in the preface he composed for the second edition in 1983, writing of 'the work as necessarily unfinished and incomplete'. Isn't it wonderful indeed that this tweedy mid-twentieth century Cambridge don in search of meaning should provide us – apparently inadvertently – with the most powerful Derridean testimony and exposition that words cannot be defined other than through other words and hence the task of pinning down significance is endless, always and necessarily – as he admits – exceeding any attempt to limit and define, with no possible end in a final reference to an object, a thing or a concept.

Endless connotations and openness to further developments is, of course, a quality of the essay too, but the 'key' feature of the openness in the essay appears to be in articulation of and by subjects rather than in definition of objects. The 'contemporary' era has been understood by current thinkers as one in which there is a multiplicity of worlds and temporalities persisting together, and where the production of knowledge is decentred and more horizontal not only in a topographical sense but in a disciplinary sense too, where literature, for example, not only reaches out and comprehends an engagement with cute objects but also a new complexity of processes and possibilities in publication. The coming to prominence of the essay as a medium for discourse in the 'contemporary' era might indeed be understood in the light of Lionel Ruffel's description of the advent of that era as one for

which the telling question is not 'What is the contemporary?' but 'How are we contemporary?'[5]

As might be expected from the essays selected below, it is one from the field of the spatial practices and disciplines that might be taken for most exemplary in this regard – namely 'Junkspace' by Rem Koolhaas. In one type of understanding architecture can be seen as ensuring 'a certain allocation of people in space, a *canalisation* of their circulation, as well as the coding of their reciprocal relations'.[6] Koolhaas's article as discussed below does not present us with the description of a certain type of contemporary architecture nor does he attempt to discover its meaning. Instead he examines this architecture's articulations – proliferations of them – and how it organises positioning and connecting in space. What sort of relations are created there in terms of joining, of continuity, regularity, break, transition and opening? As Koolhaas puts it:

> The joint is no longer a problem, an intellectual issue: transitional moments are defined by stapling and taping, wrinkly brown bands barely maintain the illusion of an unbroken surface; verbs unknown and unthinkable in architectural history – clamp, stick, fold, dump, glue, shoot, double, fuse – have become indispensable.[7]

The contemporary essay thus celebrates endlessness – seeking always new articulations of the matter – it does not attempt to define or delimit it. Williams claimed for his book 'Keywords' that it was 'concerned with practices and institutions described as "culture" and "society"', the point is however, that as we discover again and again in different fields in these essays here below, social relations are determined by spatial effects.[8]

Nor is this, in fact, a discovery new to or from the essayist. In the sixteenth century Montaigne was already making literal examinations of articulation in discourse. When he expatiates in his essay 'An Apology for Raymond Sebond' on the silent movement of the hands, and ultimately our whole body, then, unlike Williams, it is not to demonstrate the creation of original or unique significance nor to define meaning, which in his scepticism he doubts can be provided by human language. It is to signal relations through space, to draw attention to the positional and functional dynamic in space; to show how the summoning up, the bidding forward, or deflecting of change are articulated in those relationships.

> What do we do with our hands? Do we not sue and entreat, promise and perform, call men unto us and discharge them, to bid them farewell and be gone, threaten, pray, beseech, deny, refuse, demand, admire, number, confess, repent, fear, be ashamed, doubt, instruct, command, incite, encourage, swear, witness, accuse, condemn, absolve, injure, despise, flatter, applaud, bless, humble, mock, reconcile, recommend, exalt, showgladness, rejoice, complain, wail, discomfort, despair, cry-out, forbid,

declare silence and astonishment, and what not? With so great variation and amplifying, as if they would contend with the tongue. And with our head do we not invite and call to us, discharge and send away, avow, disavow, belie, welcome, humour, worship, disdain, demand, reject, rejoice, affirm, deny, complain, cherish, yield, submit, brag, boast, threaten, extort, warrant, assure and inquire? What do we do with our eyelids? And with our shoulders? To conclude, there is no motion nor jesture that doth not speak, and speaks in a language very easy without any teaching to be understood. Nay which is more, it is a language common and public to all; whereby it followeth (seeing the variety and several use it hath from others) that this must rather be deemed the proper and peculiar speech of human nature.[9]

It is true that Montaigne engages in a rambling scepticism in this essay, detailing the vanity of rational enquiry, and he calls on humanity to rely instead on the dictates of custom (as does Hume) and faith. This might render the contemporary reader uncomfortable, yet both these latter realms are articulated by ritual (from Hume's backgammon to the Holy Mass) which defines the gestures, circumstances, behaviours and other signs which form part of the discourse. Montaigne discusses at length and is highly critical of what he sees as a presumptive tendency to believe that the significance of human language and rationality is superior to and separates them, for example, from the signing of deaf mutes and the 'inward secret motions' of animals or 'brute beasts'.

Were it not a sottish arrogance that we think ourselves to be the perfect thing of the universe?[10]

It is specifically in this attack on anthropocentrism that we can see direct links from Montaigne to a prominent feature in the contemporary essay. So, for example, to Braidotti's 'posthumanism', to Anna Tsing's 'Unruly Edges' where even fungi can articulate 'interspecies dependence', and to Barad's contestation of the excessive power given to language and her vision of agents not merely as 'observers' but as inextricably a part of a world where performativity 'allows matter its due'.[11]

The contemporary essay is a phenomenon of global provenance and reach – in this section alone we have already cited theorists and practitioners from America, Brazil, England, France, Italy, Netherlands and Portugal, and this brings us naturally to the question of the naming of this type of relatively short prose work. The title 'essay' is of course named after the French word of Michel de Montaigne (1533–92). Yet in the French language that term is no longer used to designate this type of work: the title 'essai' is reserved instead for a longer theoretical or non-fiction work, usually of full book length – something similar to what might have been called an essay in eighteenth

century English literature, as seen in Locke's *Essay Concerning Human Understanding*. The lack of proper title now for that type of longer work – the French *essai* – in English literature is problematic; the current terms are ungainly and inaccurate, 'theoretical work' is vague and clumsy, and 'nonfiction' merely tells us what it is not, but that is not something I can go into at length here. In current day French the sort of shorter prose work we call an essay is called an article. Of course, this type of work can also be called an article in English, though that often carries the connotation of some material overly dry and academic – which may too often be accurate! Given everything written above, would it be stretching hypocrisy too far after the criticism of Williams, to insist that the fact that article and articulation are cognates is of more than coincidental interest?

The essay: two kinds of modern?

The essay is a modern form. Given that this literary form, and also its very name – *essai* in the French language – was originally the contrivance of the sixteenth-century writer Michel de Montaigne, we have to understand, that by 'modern' here we mean specifically not from, nor owing too heavy a debt to ancient or classical culture.[12] There are nonetheless, also some very modern – this time in our current usage of the word as meaning up to date, of this time – aspects to the essay, which appear to have made it a choice vehicle for literary and scholarly expression in our contemporary era. It is my proposition that at the beginning of the twenty-first century we have seen an extraordinary flourishing of the essay, and by examining and critiquing an exemplary range of those short works, my aim here is to lay open the conditions and achievements of the thriving culture of the contemporary essay.

In addressing the essay as 'modern' we thus open into an apparent critical equivocation. Like Walter Benjamin's angel of history, our appreciation and critique of the essay stare at the past with eyes fixed, but they have outstretched wings as if to distance themselves immediately from that historic legacy. If we are to call this flourishing of the contemporary essay a revival, then what are the circumstances that has brought this revival about, and what are the properties and characteristics of the culture of the essay that can be said to be revived? Ultimately, of course, we may find that one response can cover for both these lines of enquiry at the one time- on circumstances favourable to revival and properties characteristic of the revival itself. We might also wonder whether the so-called revival of a form under a new set of historical circumstances, with emphasis on a different set of appropriate properties for this new context, and with an accordingly altered range of aims and targets, leaves the product still significantly similar to what was originally called an essay. Have a convincing strength of distinctive features we see in the essays written by Montaigne in the sixteenth century, Bacon in the seventeenth, Hume in the eighteenth, Carlyle in the nineteenth and Benjamin in the twentieth carried

over into the examples we give of the revived essay in the twenty-first century to merit using that same title? Or would there be greater illumination of the phenomenon and its work by coining some novel and more apt term for these contemporary writings? We might also wonder whether, given that supposedly typical sequence of avatars above as all white, male and European, we would want to continue any form with a tradition of such entitlements to its word. Undoubtedly gender, race, time and place will all have to be at the heart of the analysis of the realities and possibilities of the form of a putative contemporary 'essay'.

In this introduction to the essay then, we see the two types of 'modern' at work and always playing off one another. For unlike other prose forms – like the novel – the essay does not *represent* time and space, it embodies them and it does so in its own particular ways. As ever, Montaigne is the exemplar of this kind of play with the classical quotations which are studded throughout his essays anchoring them in the tradition of anciently established wisdom, while his own adapting and developing thoughts on contemporary life unravel in real time around them. Thus, a tension operates across both time and space in the *essais* between a conceptually complete and static ancient classical Rome and Athens, and an actually living and changing modern sixteenth-century estate in rural Aquitaine to where Montaigne has retreated to the library of his feudal chateau to formulate his ideas. That temporal dichotomy in Montaigne's work is not exactly the same as the two versions of modern I've just mentioned above at work in the contemporary essay, and which will be further explored below. Nonetheless, in a form of writing whose grounding seeks stability via reference and citation from previously completed and established work, in order to push off into new times via critiques, expositions of failures in the distinction-making of others or gaps in their thinking, together with counter-propositions and new proposals regarding the state of things now, then who could reckon the limits on the range of temporalities juxtaposed in one piece? '*Distinguo*', as Montaigne writes, 'is the most universal part of my logic.'[13]

The historically modern essay

Everything has already been said about the essay. *But what do I know?* Detractors abound across forms and through the centuries: from dramatist Ben Jonson decrying its 'few loose sentences',[14] to poet Théophile Gautier in its nineteenth century heyday bemoaning its lack of depth.[15] There have, of course, always been critics prepared to extol its virtues at length too. Yet even those latter apparently feel a need to affect a world weary, seen-it-all-before preamble to their critique. In *Essayism*, which is in effect the existentialist confession of a contemporary essayist, Brian Dillon puts it to us that at times 'the essay has seemed antique and moribund fit only for the classroom and to become an object of nostalgia for the improving or diverting literature of the past'.[16]

In his published acceptance speech for the Prix Europeen de l'Essai in 1982, Jean Starobinski states that a certain taint (*soupçon*) of superficiality is associated with the essay. Montaigne himself, says Starobinski, provides weapons to the detractors in his declaration that he ought not to be taken for a learned gentleman, for a builder of a system, or for an author of any weighty treatise. This perceived lack of depth or breadth to the form is perhaps most often discussed in connection with the very name that Montaigne chose for the form, *essai*, it being interpreted etymologically to signify an attempt or a trial, hence again not a fully thought through, sustained or completed work in itself. It is also, however, from that same interpretation of its title that critics have understood the great strength of its impulse as an open-ended, ongoing work often involving luck, play and freedom, without limited horizons, and which offers provocation to doctrine and set ideas. It might be in reference to the extent to which that positive appreciation of the essay's advantage as an open-ended form has fallen into critical cliché that Dillon makes the accusation that the essay has become an 'object of nostalgia'. If so, we may revive something of the original life-affirming spirit of that appreciation of the essay by following Starobinski's enlightening reworking of the etymology of the title. Rather than the time-worn parading of 'trial' and 'attempt', and such cognates as encapsulation of the scope of this form, Starobinski conjures up an apparently fresh set of etymologies. He finds the source of *essai* in the Latin verb *esagiare*, which means to weigh up, or to balance. Montaigne himself often uses the verb 'weigh' in reference to his operation on his material, and it is no coincidence that a pair of scales feature drawn alongside his motto '*Que scays je?*' ('What do I know?'). This reconfiguring of the representation of the work in the essay surely complements rather than replaces the inherited notions of trial and attempt, broadening our conception and reproducing the ongoing cumulative work – or even the action – in the essay (much as Montaigne himself, when adding material to the printers' proofs for his second edition in 1587 – first published in 1580 – didn't edit or adapt any of the existent material of the first edition).

Although potentially endless, for the essayist can always have more to say, by definition the essay has its limits, and in a performative sense its length is always tied up with morality. For it is the ironic tension between the contingent and the eternal, between the actual and potential, its elliptical form that is to say, that gives the essay its universal moral presence. This is also why its limit at the other quantitative extreme of style and content is the aphoristic. As Virginia Woolf, ever the precious aesthete, shows us, the essayist must absolutely 'know how to write' for, as she put it, 'we are nauseated by the sight of the trivial personalities decomposing in the eternity of print'.[17] A paradigm of the essay in miniature, the successful aphorism embodies perfect composition of the verbal, lexical and moral elements in its own tightly balanced ellipticism. Dillon refers to this attempted perfection in compositional balance as a type of 'rhetorical algebra', whereby the basic formula, performed with revelatory wit,

is x is *actually* y. The formula also reveals, however, with its 'tyranny of the verb *to be*' the inescapably sententious tendency of rhetorical form, and as Dillon puts it, the aphorist's 'addiction to assertion'.[18]

Is that addiction an affliction that has affected the essayist in general? Probably the most powerful set of assertions to be read in discussion of the essay is in an essay titled 'The Essay as Form' by Theodor Adorno. The relation of the title of this piece to its form and content relieves us of any necessity to stress its performative nature. Adorno proceeds to characterise the nature of the essay by a dense series of self-contained definitions which, although not exactly aphorisms, have something of the atomistic quality of the form, viz.

The essay, however, does not let its domain be prescribed for it.[19]

> Discontinuity is essential to the essay; its subject matter is always a conflict brought to a standstill.[20]

Its totality, the unity of a form developed immanently, is that of something not total.[21]

> ... it has to pay for its affinity with open intellectual experience with a lack of security that the norm of established thought fears like death.[22]

Citation in this manner – à la Montaigne – and here above from Adorno, can be both decorative in the sense of introducing another writer's style and approach into the otherwise univocal text, and also effective, as noted above, in establishing facts and judgements already settled elsewhere and in another time, so that the ground does not have to be covered anew. Those judgements can then be weighed up and adapted in the discourse to the contextual times and places of the new, present, essay writer. Adorno, however, eschews such method – if it be method – and adduces almost no exemplary evidence by citation or textual analysis in exposition of his theme, and in this essay relies almost entirely upon the verbal strength and originality of his assertion. The thing about critique of the essay form is that it is nearly always performed self-reflexively from within the bounds of the form itself. It is thus with its rejection of any 'higher court' to sit in judgement on it, as it were (it 'does not let its domain be prescribed') – whether that be called an 'aesthetic autonomy' or simply its refusal to conclude and conform to established doctrine – that Adorno can don his judge's wig and bring us to his assertive conclusion that 'the essay's innermost law is heresy.'[23]

There is nonetheless – and despite Adorno's ironically doctrinaire anti-positivist disregard for it – abundant literal evidence for the heretical status of the essay. That's not just to be found in the exemplary paradoxes and eccentricities of the lives of many essayists though – Montaigne retiring into private life to make public assertions, Jonathan Swift as an Anglo-Irish Tory nationalist, or Pier Paolo Pasolini as a Catholic Marxist ... For where Adorno

apparently employs the accusation of 'heresy' in a loose figurative sense asserting simply that the essay always runs counter to prevailing cultural orthodoxy and established norms, there are, in fact, archives full of recorded instances of the charge of heresy as a definitive forensic category made against essays and the writers of essays, with published judgements, sentences, punishments and so on. This categorical type of heresy belongs historically to the positive religions, and is understood as an instance of dangerous violation of teachings or religious beliefs or ideas, and as such, however, seems in an official, institutional way to be not unrelated to Adorno's presentation of the essay as non-doctrinal, that is in dealing with change and the ephemeral. One thing that is significant about this evidence is that it shows us that, right from its very birth the essay was judged to be heretical. In 1580 after the first publication of his essays in Bordeaux, Montaigne travelled to Rome and copies of the books which he carried with him were sequestered by the Vatican. This was the first of at least three interventions of consequence by authorities of ecclesiastical censorship. This first intervention seems however, to have been relatively innocuous compared to the interdictions that were to follow much later.

In 1581 the case concerning Montaigne's work was concluded by the Palazzo Sacro at the Vatican. Montaigne was charged with, among other things making too broad a use of the word 'fortune' or 'luck', which was judged a term full of 'astral determinism' and as such incompatible with human free will. The *censurae* concluded with a request for self-expurgation, by deeming it 'sufficient to ask the author to correct his own work for future editions'.[24]

A much more serious post-mortem Vatican judgement was to come, but not before evidence of a type of universal, catholic with a small 'c', Christian condemnation of the essay in the form of an interdiction on Montaigne's books in 1602 from the Calvinists in Geneva who pronounced on them as 'leading to atheism'. In 1676 the Vatican body which dealt with censorship of literary works, the *Congregation of the Index* judged again, and this time unconditionally prohibited Montaigne's works, thus placing them on the *Index Librorum Prohibitorum*. The judgement was composed by a Franciscan father Antonio Gillius and, as was the normal procedure, was signed by the various Italian cardinals who presided on that Congregation:

P. F. Antonius Gillius Ordinis minimorum retulit prima vice librum lingua Gallica, cui titulus: Les Essais de Michel Seigneur de Montaigne. Eminentissimi iusserunt, prohibendum, ubicunque, et in quocunque idiomate impressum et imprimendum.

Antonio Gillius, first report on the French language book, whose title: The Essays by Michel de Montaigne. Their eminences judged to prohibit (this book), everywhere and in whichever language it is printed or in print.[25]

Among other charges this time the judgement stated that to hold that 'To Philosophise is to learn how to Die' (title of one of Montaigne's essays) is *contra fidem Catholicam* (against the Catholic faith) and is defined as heretical by the Fifth Lateran Council in 1513. The motive and principle of the prohibition, as Ricci writes, is constituted by the question of the immortality of the soul ('l'immortalita' del anima'). The censure on Montaigne by the Vatican Congregation states that the mortality of the personal soul is a heresy shared by 'Thales of Miletus, Democritus, Empedocles, Anaxagoras, Heraclitus, Protagoras, Hippocrates, Galen, by the Cynics, the Epicureans, Lucretius and Zeno'.[26]

Montaigne is said to agree with them. We see here where studding his works with cited thoughts and reflections from other times and places got Montaigne. Yet it is striking that it is again on the question of understandings of time and duration – in this case mortality – that the essays are judged and condemned, and that these condemnations issue from particular places, Rome and Geneva at particular dates (following the upheavals of the Reformation.)

We should be careful however, that in figuring that there can be a simple process of adducing evidence to 'prove' our own points we do not fall precisely into the positivist traps that Adorno is apparently set on avoiding. What can it mean for example when we assert that Montaigne was the contriver or inventor of the essay form? For this was not some *ab ovo* pushing off from a *tabula rasa* by Montaigne. The essays as noted above are a collection of commentaries inserted in the interstices between the pre-existing discourse of classical literature, whereby he comments on topics suggested to him both by and in continuity with that classical literature and at the same time by the contemporary world and culture around him, all noted and formed in accordance with personal beliefs which he holds, as he puts it 'by external authority and command' of the church. We noted above, in his commentary on Raymond Sebond, Montaigne's call to rely on the dictates of custom and faith. Thus, the significant question is not one of originality, as Foucault puts it in discussing the nature of discourse, it does not arise with the event that is the composition of these essays, but what again does come to the fore is articulation: relationships of continuity and discontinuity, regularity and irregularity, flow and series.

Indeed, Foucault's understanding of discourse as a materialist way of structuring social relations is very useful here. Discourse, in the Foucauldian understanding, is produced by power in the distribution of knowledge and meaning which allows subjects to constitute themselves and make themselves legible in their positions and functions in the social order, and at the same time it produces practices that form the objects of which it speaks. Hence heresy itself cannot be seen – indeed, fetishised – as something unique and self-standing beyond and outwith the discourses of doctrine and orthodoxy that operate as part of the regime of truth. We see in Montaigne's case that instead of totally excluding, effacing or annihilating the essays (– neither Montaigne

nor his books are burnt at the stake!), those in charge of the propagation of the doctrine of the faith absorb the heretical works by distributing, exposing, defining and establishing a number of possible positions and orientations of the subject and the object within the discourse of that doctrine. They offer the writer some advice as to how he should approach his work, they place those works on a set list of other works creating a relationship between those works – assumed to be similar in some way – they establish what is the relationship between the subject as author and the work as literature, they create a critical discourse on the content of those works. Thus, as Foucault says, heresy is already a part of the doctrine, organised by the discursive conditions of the regime of truth in that time and place.

The official institutional evidence of the heretical nature of the essay and the essayist, does not end with its alleged innovator and the alleged birth of the form. Far from it, the efforts of the Church to censure essays and essayists continue through the centuries (until the process is abandoned in 1966) and, for example, both Bacon and Hume, prominent practitioners of the form also had their works placed on the Index. As with Montaigne, the Congregation made an initial judgement on Hume's work, then came back with a stronger condemnation some decades later. As Zanardi points out, Hume was well known, and his works 'circulated broadly' in Italy. The Vatican, in another example of how the heretical charge is in fact a discursive constitution of the positioning and functioning of subjects with respect to the regime of truth, recognised Hume as 'a model of writing and rhetoric', and in 1761 on passing their judgement condemning to prohibition a translation of his *Philosophical Essays Concerning Human Understanding* (1748) and excerpts from his 1742 publication *Essays, Moral and Political*, it was written that '*sophismatibus omnia in dubiam revocat*' '(his sophisms put all things in doubt'). In 1827 the Congregation added the rest of Hume's works to the prohibited *Index*. [27]

If one of the principal charges made by those guards of the Christian doctrine against Montaigne and his Essais regarded human will and subsequently the immortality of the personal soul (this of course in the century of Descartes's analysis and definition of the human subject and its spatial articulation in the world) then it is arguably with Hume that we first see a most explicit exposition of subjecthood and its centrality to the essay form. In the essay 'Of Essay-Writing' Hume performs a sorting through division and sub-division of the roles of the subject in the world according to the essay via construction of a series of dualisms. Some of these dualisms are more happy than others, all of them suffer from the restrictive nature of that format, and none leave the current day reader feeling comfortable. Both Montaigne and Hume spent time working in the worlds of politics of their day, as ambassadors and representatives in royal courts around Europe, and in fact, Hume's categorising of the human population according to their relationship to the essay constitutes a social and intellectual apartheid system whose nomenclature borrows heavily from the colonial order already establishing itself in his day.

Hume starts 'Of Essay-Writing' by outlining the supreme class distinction -one unchanged in letters since Plato's day – between the elegant part of mankind and those implicitly 'immersed in the animal life'.[28] There is no further reference to the latter class, they are discarded here. The elegant are then portrayed as divided between the 'learned' and the 'conversable'.[29] The essay-writer is imagined as an Ambassador from the 'Dominions of learning to those of Conversation'.[30] There then follow further distinctions made between the old and the young, between men and women, between friends of 'Reason and Beauty' and 'dull heads and cold hearts',[31] and so on. It appears to be considered a matter of course, in this universal hierarchy, that not only are the essay-writing Ambassadors all men, but so too is the entire population of the 'State' of the learned from whence they come. The question of the narrator/ essayist and gender will be taken up below but for now, we note that on women Hume writes 'the Fair Sex, who are the Sovereigns of the Empire of Conversation'.[32]

What we see here with this veritable ant colony of social distinctions, ranks, roles and positions all viewed through the relation to the production and work of the essay is clearly not at all an explosion of individual freedom and anarchy out of and away from doctrine and centralised control – as might have been feared by the Vatican's Congregation. Instead it is a shift in the type of power of the order described by Foucault as a move from a Sovereign top down power which operates via vertical hierarchy to a disciplinary model whereby social, personal and even bodily behaviours are self-regulated by the diffusion and absorption of social norms. As such the world of the essay as lovingly detailed by Hume as a type of intricate social division of labour (in the words of his great friend Adam Smith) is a part of a blueprint for the disciplining of social relations in the newly developing bourgeois world and its capitalist economic organisation which Hume goes on to detail, theorise and promote in his other essays. The essay, that is to say, arises with the advent of the bourgeois subject, for it appears as an integral part of the discourse of the long bourgeois liberation from and of the sovereign powers of the church and the monarchy.

Hume's essay also makes clear to us the essay's role in general in demonstrating how the distribution of knowledge, meaning and power through discourse creates subjects, and their possible positions and functions in society. In his philosophical writing Hume had taken empiricism to what he saw as its logical conclusion – and to its most precisely heretical position in the Christian conception, which denied the existence of a self (a personal soul) as separate from its perceptions. Might we even assert that for Hume the essay presents the concrete evidence for what he theorised in his Treatise, namely that the self is but 'a bundle or collection of different perceptions which succeed each other with inconceivable rapidity, and are in a perpetual state of flux and movement'.[33] With a slight brake applied to the 'rapidity' here (time needed to fetch fresh paper, change the pen, write the full sentence out ...) could this passage not also pass for a definition of the state to which the essay aspires?

This question of the relationship between knowledge and the constitution of the self has indeed always had a presence 'before' the essay, as an introduction to the essay, in Montaigne's very motto to his published work – *Que scays je?* (What do I know?). As Stephen Greenblatt writes in his introduction to John Florio's translations of Montaigne:

> He would not present himself as the fixed embodiment of this or that quality, for he experienced existence as a succession of inconsistent and disjointed thoughts and impulses.[34]

In the essay one performs one's self in exploitation of the discursive resources – knowledge and meaning – available. With Montaigne the relationship between knowing and being is always and of course by definition *tentative* (essai!), but it is equally and unavoidably inchoate as he is an innovator of the form, and one might even add to 'inconsistent' that it is contradictory in its probing of what we can know and from whence we can know it. Near the beginning of the essay 'On Cannibalism' Montaigne seems to make the same sort of categorical class distinction regarding the relationship of existence to knowledge as Hume makes at the outset of 'Of Essay-Writing' (and indeed similar to Virginia Woolf's distinction of the 'common reader' from 'the critic and the scholar'). Montaigne writes:

> Lo, how a man ought to take heed lest he overweeningly follow the vulgar opinions which should be measured by the rule of reason and not by the common report.[35]

Yet later in the same essay Montaigne appears to advise a very different quality of measure in taking evidence from one of his retinue:

> This servant I had was a simple and rough-hewn fellow: a condition fit to yield a true testimony. For subtle people may indeed mark more curiously and observe things more exactly, but they amplify and gloss them. And the better to persuade and make their interpretations of more validity, they cannot choose but somewhat alter the story. They never represent things truly but fashion and mask them according to the visage they saw them in. And to purchase credit to their judgement and draw you on to believe them, they commonly adorn, enlarge, yea, and hyperbolise the matter. Wherein is required either a most sincere reporter or a man so simple that he may have no invention to build upon and to give a true likelihood unto false devices and be not wedded to his won will. Such a one was my man who, besides his own report, hath many times showed me diverse mariners and merchants whom he had known in that voyage. So am I pleased with his information that I never inquire what cosmographers say of it.[36]

Arguably it is this inconsistent approach to his researches that leads to some implausible and unsustainable claims and conclusions regarding the indigenous peoples of the Americas which he comes to later in the essay, such as that the laws of nature still command them, that they have no word for falsehood or lying, and that they are a 'pure and simple' people. Again, as with Hume we see the European colonial attitude coming to the fore in the formation of these judgements. We might say of the inconsistency of the formation of that subject that for the essayist the self is not an essence, a fixed point, a rock to which perception, opinion and knowledge attach, it is always changing, adapting and developing; this self is the shift we observe in process in the essay. As Montaigne puts it in an essay titled 'Of the Inconstancy of our Actions':

> We are all framed of flaps and patches, and of so shapeless and diverse a contexture that every piece and every moment playeth his part.[37]

It is not however, just that the individual subject is 'framed of flaps and patches' and proceeds by a succession of starts and uneven progression, for equally could the conditioning possibilities for the formation of the subject in history be said to progress in such an irregular and discontinuous manner. It appears furthermore that the essay as a form mapping and recording the possibilities for subjectivity as they develop seems to come to prominence in public life particularly at moments of crisis and great upheaval in that history. Thus Montaigne writes as the Reformation splits the centralised unity of Christianity, and Hume is writing in Enlightenment Edinburgh at the dawn of modern capitalism. There are plenty of other examples. There was a definite flourishing of the essay form in the eye of the storm of the Industrial Revolution in England in the nineteenth century and it was in that thriving culture that Carlyle was to describe in his essay 'Signs of the Times' the effects of the tussle between the forces of mechanism and dynamism on human lives and minds as 'The shuttle drops from the fingers of the weaver and falls into the iron fingers that ply it faster'.[38]

In the same century Heinrich Heine offers an even more penetrating and devastating critique of the type of subjecthood that was available to most people in that time and in that place in his 'English Fragments'. Heine blames English utilitarianism and empiricism for the oppressive horror of the conditions in which he saw people live in London, and his condemnation reads as a dystopian materialist version of Hume's jolly caste system outlined above:

> the lazy lord who, like a surfeited god, rides by on his high horse, casting now and then an aristocratically indifferent glance at the mob below, as though they were swarming ants, or, at all events, a mass of baser beings, whose joys and sorrows have nothing in common with his feelings.[39]

Likewise, the greatly influential work of the essays of the Frankfurt School, including those of Adorno and Walter Benjamin, appears at the time of the

global collapse of capitalism and the rise of Nazism in the 1920s and 1930s. Particularly poignant in that work is that in the very last essay that Benjamin completed before extinguishing his own life to avoid capture by the Nazis, the 'Thesis on the Philosophy of History', he sought to expatiate on how the use of the Marxian technique of 'historical materialism' could expand the concept of the subject in history to include those who had been discarded (as in Hume's description of those immersed in the animal life) suppressed or ignored. There are endless examples we could deploy to illuminate the thesis here of the essay's special instrumentality at times of crisis: In fact it seems as though the case of the essay's prominence because of special historical circumstances could be made for almost any moment in history, for according to Achille Mbembe – as seen in his essay 'Necropolitics' (2003) discussed below – Western political power has permanently appealed to a state of exception, of emergency, war and terrorism, in order to maintain control and sovereignty. But that, reader, will be found in your future reading, already written below.

The contemporary modern essay

Is everyone an essayist in the age of social media? If the essay is indeed the performing of the self in public, where Montaigne, as he writes in his introduction, wants people to see a picture of himself in a naive, natural and ordinary way, and where he himself is the subject,[40] then do not the selfie, the tweet and the Facebook post represent a logical and very democratic development in the history of the form? Or is there something more to the essay, and especially to what we might call the contemporary essay?

In discarding the immortality of the personal soul, the essay may well have done away with the future and been condemned as heretical for living in the eternal present of a succession of personal perceptions, opinions and formulations of knowledge. Nonetheless the modern era, taking its cue from Kant, Hegel and Marx onwards, found a way to continue to believe in a glorious eternal future, despite all those cavilling individualists with their essay books! All plausible belief in that future finished, of course, around 1990 with the collapse of the socialist project in Eastern Europe, when nobody really needed Fukuyama to tell us we'd reached the end of the history of the future. Within a couple of decades or so, the global airwaves were burgeoning with the self-documented perceptions and opinions of tweeters, Facebookers and Instagrammers operating incessantly in what Groys calls 'non-teleological' time.

Montaigne is, of course, overegging the domesticity of his composer's kitchen … it's not a kitchen at all in fact, nothing quite so ordinary – it's a library lined with classical tomes in a country chateau. Adorno calls Montaigne's stance here an 'ironic modesty', and goes on to cite Lukacs saying 'The simple modesty of this word (essai) is an arrogant courtesy'[41]. In effect, and as demonstrated above, the essayists' relation to time and their exploration

of a plurality of temporalities has always been complicated more than Montaigne's naivety and modesty tropes allow him to admit, and arguably that suits the essay perfectly as a tool to explore the parameters of the contemporary era.

Like Hume's calm and spirited acceptance ('I now reckon on a speedy dissolution'[42]) of the onset of the disorder of the bowels that would kill him, the flourishing of infinite personalities on social media is a cheerful symptom of the abandonment of 'the future' not just as a dogma but as any kind of a project. That abandonment of work towards and belief in creation of future utopias – be they Christian, communist or whatever – has thus meant we occupy a proliferation of different times in our present. Where in Benedict Anderson's critique of the modernist technology of the book and the daily press, and subsequently also the radio and the TV, a synchronisation of attention and agenda was seen to forge a vast extent of people and territory into the concept of the *nation* as an 'imagined community', now, with the internet, social media, YouTube and so on, individuals log in at such times of their own choosing, consume and participate in the making of information and spectacle accessible *across the globe* in all and any time zones, such that there is now a polychronicity of attentions and agendas. As Lionel Ruffel points out, the contemporary era is not characterised by the replacement of one type of temporality by another – the internet has not completely replaced the book the radio and the TV – but by the existence of many temporalities; synchronicity, polychronicity and others alongside one another in series and in parallel.[43]

Can it really be that within this new experience of time and space, the Facebooker, the blogger and the tweeter perform en masse the role of the essayist in representing the 'flaps and patches ... of so shapeless and diverse a contexture'? Or is it even plausible to accept or reject the possibility that output of social media as a whole performs such a role? The truth is that by the term 'contemporary essay' I intend a very particular form of writing. To what extent that writing in style, form, content, provenance, and aim differs or not from the type categorised above as the 'historically modern essay' will be discussed below. There's no doubt that this contemporary essay arises out of the same set of historical circumstances as do the proliferations and polyvocalities of social media. Yet the presentation and articulation of the critique of this new contemporary situation that one finds in these essays, which can help us understand that situation and provide ways for us to operate within it – and also the very platforms, often created specifically to feature this type of writing – mark it out in its sustained analytical attention and its enlightening revelations and judgements as something different in quality from the vast majority of social media posts. That is not to say, however, that this is an elitist form, even if sometimes its deliberations strike one as dense and abstruse, and again the grounds for such an assertion will be discussed at length below.

Alongside these changes in experiencing the world in time and space – indeed inextricably a part of these shifts, has come a reassessment and re-evaluation of the human subject: what it is to be human; how we know the things

we know, and what we can and cannot do. The humanist ideal with its long history through the Greek Enlightenment, ancient Rome, and the Renaissance is arguably given its most terse and compact form by Hume in that abbreviated hierarchy of humanity viewed through the lens of the relationship to the essay, where every term in the conception of the standard human as white, rational, European and male is privileged. In this new globalised world, with the internet, digital and smart technologies, the exclusivity of that privileging with its prejudices, parochialism and colonial attitudes is unsustainable. In the Arts and Humanities – and in the sciences too – new understandings about human subjects, the production of knowledge and the ways of being in the world and the workings of power in culture and society have proliferated. I would propose here that the essay as a form has a versatility which adapts it to the rapid pace of change in the contemporary era, and that its credentials in articulating the relationship between formations of subjects and production of knowledge fits it as an analytical tool – or perhaps, rather an expositional or performative one – for any age of great social change.

The essay's role here then, is that it undoes, exposes and critiques the old models of humanity and its environment, and points the readership towards new expanded, sustainable understandings. This break-up of the old (Humean type of) privileges, which inhered in the Humanities models until recently, takes place intersectionally, that is to say across different fields and structures simultaneously and in interaction. Before we look to more thorough introductions to each individual essay I can give a brief exemplary overview of some aspects of the humanity model that it has been necessary to undo and/or rework, and give the shortest of descriptions of how some writers do that. Some of the most groundbreaking work in rethinking the subject and production of knowledge over recent decades has been carried out by feminist scholars: a long series of writers (all of whom couldn't possibly be named here, but including, for example, Luce Irigaray and Judith Butler) have exposed and undone some of the limitations, prejudices and injustices inherent in the enshrining of the male viewpoint and voice as the standard subject norm. Sara Ahmed follows in that feminist tradition with her analysis of how 'happiness' is used as a normative tool to ensure conformity to and coherence in the bourgeois social model. The work of trans activist and writer Paul B. Preciado is in many ways the embodiment of progress in work pioneered by Butler in expanding the concepts and realities of the gendered subject far beyond merely binary possibilities. Meanwhile much work has been done in reworking the notion of subject to include the non-human and understand their role in the production of knowledge: Anna Tsing is inspired by the work of Donna Haraway to look at interspecies interdependency without which the human cannot survive – and indeed Rosi Braidotti here in her piece on posthumanism even projects through at one point to a world where the human is already extinct (the transhuman). As regards the implicit Eurocentricity and whiteness of the 'traditional' model of the subject, de Sousa Santos shows how Western

thought can be inimical to the living realities and traditions of the Global South, and in his concept of 'Necropolitics' Achille Mbembe demonstrates how deadly is that model for most parts of the world, with so many lives deemed worthless. Denise Ferreira da Silva, in a piece of writing whose power vacillates provocatively between operating as an artwork and a work of philosophy, introduces 'blackness' as a mathematical parameter to the Cartesian tradition of calculation of the subject which confounds all possibility of progression of that Western model. Beyond de Sousa Santos's deconstruction of Western rationality, Barad the physicist's reconfiguring of knowledge as always situated in a Spinozistic reconvening of the relationship of the material and the conceptual reworked with the insights of quantum mechanics, and Malabou's reaching out to the deep time of geology through an alliance of philosophy and biology, we see in the works of Weizman, Koolhaas, and Moten and Harney here testimonies of the enormous psychological and sociological damage that can be done by the mechanistic progress of power in that Western tradition of thought.

So far, so academic, one might say ... Yet has the case not already been made here by me and in reference to myriad other sources that the essay is always anti-establishment, is individualistic – heretically so – and, as Montaigne wrote, cannot conform to any 'system'? Montaigne was not an academic, he retired to his own domestic residence to write and publish at his leisure; Hume's application for a professorship at Edinburgh University was blocked by the church; arch-modernist Walter Benjamin did not carry through his attempt to enter academic life and continued as an independent literary critic and essayist, and many of the footsoldiers progressing the form, like Hazlitt, Addison and Steele, were and are journalists.

Most of the writers gathered here as authors of the contemporary essay are academics. (those such as Sara Ahmed and Paul B. Preciado who are former academics would perhaps be surprised by the irony of how conform to the life of the essayist is the trope of their rejection of academic life ...) Unlike the earlier essayists, and of course, the journalists, these academics are generally writing for an academic readership too – for students and fellow professional academics. There is very little crossover – of the ambassadorial type to non-'learned' parts of society as Hume had it. Given the history of the essay as I outlined it briefly above in the first part of this introduction, and the very particular type of writing that is defined there as an essay, we might even wonder whether this output of work almost purely produced, disseminated and consumed in academia can in fact be meaningfully subsumed under the title 'essay'.

Are these essays at all? On one level, in the sense that the successful essay tests (*essais!*) and demonstrates a thing or a fact, even if it is not necessarily particularly eloquent, we might answer in the affirmative. Yet is it quite so simple? There is a long tradition in academia – and especially so in the Arts and Humanities – of setting a question on a specific topic as a course

assignment for students where the answer is required to be submitted in the form of an 'essay' of a set number of words. The essay is thus a major plank in building a valid assessment of any student's progress and achievement in the chosen field. As such the university invariably provides guidance on the composition of essays to the students. Naturally this guidance gives insight into academic thinking as to what exactly constitutes 'the essay'. What is most interesting and insightful is the position the university typically adopts in providing advice as to the use of the first-person narrator in an essay. The idea of the essay as the individual's experience and critique coming from a particular place and a particular time has, as stressed above, always had a definitional strength in consideration of the question of the essay. We might refer to that aspect of the essay as its situatedness, and that can be a particularly strong feature. In some essay-writing, the idiosyncratic stylistic features of the writer make them instantly recognisable beyond any consideration of the prominence or use of the first person – notably in the incomparable essays of Thomas Carlyle and of Heinrich Heine, for example. Nonetheless the university, while noting – in my own institution's case – that there are strong 'conceptual reasons for using I', as discussed in 'feminist, postcolonial and post-structural' discourses, still advises for students writing essays that 'avoiding a personal voice and use of I remains the safest option.' By referring to 'feminist, postcolonial and post-structural' discourse, the university is signalling an awareness of the sort of work we see in the output of contemporary essayists presented here below. The impersonal voice has been assumed to appeal to an eternally given rationality as per the positivist scientific assertion of the type $2 + 2 = 4$, but as demonstrated again and again by writers presented here, from de Sousa Santos to Ahmed, Tsing and others, this voice is based entirely on Western traditions and experience, and it is gender biased towards the male. Equally, Mbembe shows us how this impersonal rationalistic voice can be deadly to many people and communities in the world, and Ferreira da Silva, by posing a pseudo-positivistic mathematical blackness in parody of that rationality exposes the absurdity of the notion of objectivity in the impersonal voice. Somehow the university appears to believe that these realities being uncovered regarding the plausible and sustainable modes of approaching, understanding and dealing with the world and all the people in it are too complex and dangerous for certain people. In the case, again, of my own institution, they evidently believe that protection from these realities is needed and they assert of the use of the 'I' that it requires confidence and sophistication and that it is 'easier to take this position as an established scholar than an undergraduate student'.

At last, we see where the Humean style hierarchies related to production and consumption of knowledge have been hiding out – as here we find a version of them promoted by the would-be benign counsel of the university's 'student support'. Adorno reserves his most mordant scorn for this type of 'protection', seeing in it the third Cartesian rule that one begins at the simple and works up to the difficult, and comments that 'such postponement of

knowledge only prevents knowledge'. He writes further on the essay's relation to this practice: 'the essay insists from the first that the matter be considered in its whole complexity'.[44]

I have already commented above on Adorno's strong assertive style and his disavowal of any necessity to substantiate his assertions. That unharnessed reliance on personality is one of the most singular features of some of the best essay writers – as noted above of Carlyle and Heine – and though, as Virginia Woolf writes, it is 'the essayist's most proper but most dangerous and delicate tool' it has no part in the academic essay where everything must be tied down and verifiable via reference, argument or citation. Yet can that academic obligation for watertight substantiation of any assertion in an essay be reconciled with the personally situated voice as one of the glories of the form? The university evidently seems to think that there is always difficulty here, and considers that disregarding the personal voice – despite 'conceptual reasons' for its employment, as rehearsed in 'feminist, postcolonial and post-structuralist' discourses – is preferable to risking destabilisation of some types of certainty. It is not clear to what extent academic freedom might be affected by this attitude (though both Paul B. Preciado and Sara Ahmed, who both ultimately rejected academic life, may have some thoughts on this …) – and all writers included here use the first-person narrator to some extent – with the exception of Rem Koolhaas, whose 'Junkspace' appears as a non-academic very special case. Nor is it clear how the university attitude to students' writing might be influenced by, or indeed, an influence upon the writing by academic staff. In the university's defence however, might we not indeed read into their caution regarding first-person use, an acknowledgement of the complexity of the relationships between subjects and objects, between the collective and the subject, and the role of the subject in knowledge production, in accordance with the Foucauldian configuration that language speaks through the subject, and the subject and the text mutually produce one another? -as Montaigne puts it in 'To the Reader', the preface to his Essays, 'Je suis moy-mesmes la matière de mon livre' (translated by Florio as 'myself am the groundwork of my book'), in other words the subject of the book is also its object.[45] Something of that power relationship between language and subjects is discussed below in Emily Apter's concept of the untranslatable, and also in Moten and Harney's notion of the undercommons.

The above discussion aims at revealing something about what kind of writing the contemporary essay is and why it is so, but none of it goes directly to the heart of the question of why there should be a flourishing of this writing at this time. Of course, the revival could be demand-driven in the sense that cultural and political imperatives are driving new research and new work – but how is this demand translated into production, dissemination and readership of this form, and why and how does this particular form cater for those imperatives? One explanation is that certain structural factors have evolved or been put in place that have supported and nourished the growth in writing and

publication of the essay. Again, these structural factors may have been brought about as a manifestation of an already existing or developing political and cultural situation, they may have been constructed to cater for, or been enabled to empower a great need which pre-existed them.

One such factor is the speed of change in current day culture which is enabled by digital technology. Coupled with the aspects of horizontality and intersectionality which are strong features of the contemporary, this has meant that the globalised development and proliferation of ideas and intellectual culture sees a quicker turnaround than ever before. Arguably quicker and cheaper costs have enabled the expediency of the essay form to come to the fore. Because of the brevity of the form, the relative economy of resources – particularly personal – on which it draws, and the upped pace of printing and publishing in newspapers, journals, magazines and websites, the essay has come into its own as a form which has always been adept in the quick reaction to the changing situation. Jonathan Swift, Karl Marx and Mark Twain for example, were all able to respond quickly to developing political situations with their essays published in a mix of popular and learned newspapers, written alongside their more long-form prose works. Equally it might be said that two of the most expediently useful political articulations, respectively of fascism and of the bourgeoisie were published in the unmistakable styles of the novelists George Orwell, in an essay published in *The Tribune* during the Second World War,[46] and Pier Paolo Pasolini in an essay in his series 'Il Caos' for the weekly *Tempo* in post-war Italy at the dangerous times of the *anni di piombo*. [47]

A powerful force in driving the growth in essay writing in academia has been the institution of performance-based research funding systems. These are systems put in place in most countries in Europe – beginning with the UK in 1986 – to measure performance of academics in terms of their scholarship and research. To prove the validity and up-to-date originality of their research work, individual academics are expected to regularly publish books and articles with academic and scholarly publishers and refereed journals. There has been a flourishing of these journals, both online and in hard copy, and they have been able to survive – indeed to exploit the academics obligation to publish for the performance exercise, first by not paying any fee for the privilege of publishing the article (the essayist is already assumed to be in receipt of a salary from an academic position, and the reward for them is the esteem at its publication), and second by charging very high prices for their publication to be stocked in university libraries. It's not certain how extensive is the readership of these publications, although clearly some well-known and successful academics and essays are read more than others. In a lecture in Dublin, philosopher Alasdair MacIntyre, while expatiating on the need for budding academics to publish, joked that if, as he had read, the average readership for a refereed journal article was 1.5 readers, then the 1 in that figure was usually the writer's mother![48] The worry is, however, that this instrumentalisation of research, insisting that it be captured, verifiable and measurable by evaluative systems so

that it can be used for comparison and competition by institutions, leads to a pre-packaging of projects and results and a reproduction of safe conservative knowledge in recognisable form. Nonetheless, academic Irit Rogoff has been able to speak of a shift in academic research away from 'working from inherited knowledge' – that is within recognised pre-existing bodies of knowledge with recognisable methods, and adding to their accumulation – to a 'working from conditions' – where the conditions are what drives the work rather than the subject of the work, meaning that it is concerned with procedures and environments and questions about how a body of knowledge comes into being and how it can persist and what are its relations with other bodies.[49] This 'working from condition' as a rethinking of 'how' we know is a persistent feature of the essays selected for discussion below. It is true that refereed journals are far from the only type of publication publishing important and influential essays of the type discussed here though. Some of the most interesting essays cited were published by art and cultural journals like *ArtForum* and *e-flux*. Arguably, however, these journals have also benefitted greatly from this new academic publishing revival, not just in terms of the thriving culture of the intellectual and academic style, but also in those of the writers' eagerness to see their name in print or on the screen, and their willingness to accept little or no pay in return.

Notes

1 For study of Williams's use, understanding and analysis of language see especially John Higgins, *Raymond Williams: Literature, Marxism and Cultural Materialism*, Routledge, 1999; and also Fred Inglis, *Raymond Williams*, Routledge, 1998; and Jim McGuigan, *Raymond Williams: Cultural Analyst*, Intellect, University of Chicago Press, 2019.
2 Karen Barad, 'Posthumanist Performativity: Toward an Understanding of How Matter Comes to Matter', *Signs: Journal of Women in Culture and Society*, 1 (Spring 2003), pp. 801–31, at p. 818.
3 Michel Foucault, *The Archaeology of Knowledge*, Pantheon Books, 1972, p. 6 and passim.
4 Raymond Williams, *Keywords: A Vocabulary of Culture and Society*, Fontana, 1976, p. 22.
5 Lionel Ruffel, *Brouhaha: Les Mondes du Contemporain*, Verdier, 2016, passim.
6 Michel Foucault, 'Space, Power, and Knowledge (Interview by Paul Rabinow)', in Simon During (ed.), *The Cultural Studies Reader*, Routledge, 1993, pp. 161–9.
7 Rem Koolhaas, 'Junkspace', *October*, 100 (Spring 2002, pp. 175–90, at 178.
8 Williams, citation from the blurb on the back page of the 1988 edition.
9 Michel de Montaigne, *Shakespeare's Montaigne: The Florio Translation of the Essays, A Selection*, New York Review of Books, 2014, p. 144.
10 Montaigne, p. 142.
11 Barad, p. 803.
12 The juxtaposition of the modern and ancient originally refers to an intellectual debate of sixteenth-century France between those who asserted the independence of modern Renaissance European culture and those who stressed how much that culture owed to the culture of ancient Greece and Rome. The debate had

resonance across Europe and in the following century Swift wrote several satirical essays which refer to it.

13 Montaigne, p. 371.
14 In a speech by Jack Daw, a character in Ben Johnson's play *Epicone (1610)*.
15 From Jean Starobinski's speech for the Prix Europeen de l'Essai in 1982.
16 Brian Dillon, *Essayism*, Fitzcarraldo Editions, 2017, p. 32.
17 Virginia Woolf, *The Common Reader*, Harcourt Brace, 1948, p. 301.
18 Dillon, p. 78.
19 Theodor W. Adorno, *Notes to Literature*, Columbia University Press, 2014, p. 30.
20 Ibid., p. 41.
21 Ibid., p. 42.
22 Ibid., p. 38.
23 Ibid., p. 47.
24 Saverio Ricci and Caterina Fastella, 'La Censura Romana e Montaigne: con un documento relativo alla condanna del 1676', *Bruniana & Campanelliana*, 14(1) (2008), pp. 59–79, at p. 61.
25 Ibid., p. 63 (author's translation).
26 Ibid., p. 61 (author's translation).
27 Paola Zanardi, 'Italian Responses to David Hume', in P. Jones (ed.), The Reception of David Hume In Europe, Continuum, 2005, pp. 161–81, at p.168, note 27 (translation from Latin by author).
28 David Hume, *Selected Essays*, Oxford University Press, 1998, p. 1.
29 Ibid.
30 Ibid., p. 2.
31 Ibid., p. 3
32 Ibid., p. 3
33 David Hume, *A Treatise of Human Nature*, Penguin, 1985, p. 300.
34 Montaigne, p. xiv.
35 Montaigne, p. 56.
36 Montaigne, p. 59.
37 Montaigne, p. 98.
38 Thomas Carlyle, 'Signs of the Times' in *Selected Writings*, Penguin, 1971, p. 64.
39 Heinrich Heine, 'London', in *The Prose Writings of Heinrich Heine*, ed. Havelock Ellis, Walter Scott, 1887, p. 47.
40 Montaigne, p. 9.
41 Adorno, p. 35.
42 David Hume, 'My Own Life', in Geoffrey Sure-McCord (ed.), *Moral Philosophy*, Hackett, 2006, p.6.
43 Ruffel, pp. 68–9.
44 Adorno, p. 39.
45 Montaigne, p. 9.
46 George Orwell, 'What is Fascism?', *Tribune* (24 March 1944).
47 Pier Paolo Pasolini, 'Il Perche di Questa Rubrica', *Tempo*, 32(XXX, 'Il caos') (6 August 1968).
48 'On Having Survived Academic Moral Philosophy', talk given to University College Dublin, School of Philosophy, March 2009, www.youtube.com/watch?v=Hbs4MjHWh8A, accessed 19 January 2021.
49 See Irit Rogoff delivering the talk at Nottingham Contemporary in 2019 at www.youtube.com/watch?v=QGSf5N-Bm7o (accessed 19 January 2021).

Junkspace

On 'Junkspace' by Rem Koolhaas (2002)

For several months during the COVID-19 pandemic the world was locked out of Junkspace. *So, who was complaining?* Confined to domestic spaces, #stayhome gave many a forced opportunity to rethink the type of spaces that are not only functional and useful, but that feel comfortable. The residential arena may have felt restrictive and even – for some – oppressive at times, but who would have said that they truly missed their daily passage through the endlessly stale air of check-in desks, departure gates and duty frees at the airport; the epic journeys through low ceiling'd corridors and passageways of railway terminals and subway stations; and the blinding hallucinatory proliferation of brands and franchises in malls?

Yet, is the critique, the disdain for these places, and the reluctance to engage with them really anything new? Perhaps the reluctance grew in strength in the period of pandemical desuetude, and through the disengagement from these places as a necessary component in daily business. At any rate, it is not as if a disaffection with these corporate non-places was discovered for the first time. The term 'Junkspace' itself was coined almost two decades ago by architect Rem Koolhaas in an article first widely published in 2002 in the journal *October* (and since republished in various formats – notably in the form of an eponymously titled book with an accompanying essay from Hal Foster).[1] The theme of that issue of *October* was 'obsolescence', but as lockdown loosened and our feet itched to get out the door again and into the big city, perhaps that occasioned time for considering a *recrudescence*. A re-reading of Koolhaas's influential article through post-pandemic lenses may offer new, unexpected and insightful critical understanding that was not so apparent, or not of such significance, before COVID-19.

Critical works written by architects tend not to obtain a widespread public readership, but there are notable exceptions to that rule stretching across millennia, from Vitruvius's set of first- century BCE books to Le Corbusier's writings in the 1920s and beyond. If one thing does mark Koolhaas's 'Junkspace' out from those other influential texts, however, it may well be its architectural pessimism. Most architects' books have been written to explain, or even to boast of the scope of architecture – Vitruvius wrote of what vital

DOI: 10.4324/9781003186922-2

architectural contribution could be made to the administration of the rapidly expanding first Roman Empire under Augustus, and Le Corbusier made the (somewhat fascistic) case in the 1920s that architecture was the only positive alternative to the social disaster of 'revolution'.[2] In 'Junkspace', however, Koolhaas seems to be despairing of the unavoidable dystopia currently being prepared for humanity by his profession.

Beyond that purely architectural context however, a review of the environment of Koolhaas's concept of Junkspace shows us that his dystopian vision of contemporary culture is in no way unique. Similar nightmarish visions and analyses are shared by many writers and critics around the same time and across numerous different fields. These would include; Paul B. Preciado's vision in *Testo Junkie* (2008) of a pharmacopornographic regime where our bodies are regulated by manipulations and control simultaneously by both big pharmaceutical companies and the porn industry;[3] Mark Fisher's *Capitalist Realism* (2009) which sees society trapped in an endlessly oppressive capitalist system which condemns us to repetition, precarity in our lives and employments, and to no prospect of authenticity as individuals;[4] and, more recently, Shoshana Zuboff's outlining of *Surveillance Capitalism* (2019), which details how the big media giants trap and control our lives for commercial gain through manipulation of our information trawled from social media.[5] The general picture — and what all these visions and analyses have in common — is a pervasive depiction of the dystopian nature of a suffocating entrapment in the webs of faceless corporate manipulations. That is to say, a type of Foucauldian blueprint comes together through these various particular understandings and analyses, each of specific value and strength within that general picture.

Yet despite its apparent resonance, the Junkspace critique does not even seem to have a great originality in its contribution of a specific dystopian vision in the field of space, architecture, and the built environment. Some three years previous to the publication of Junkspace in *October*, French anthropological theorist Marc Augé published a book with the English language title *Non-Places*.[6] Augé's text examines a territory almost exactly co-extensive with Koolhaas's: namely the commercial and corporate structures and environments of the likes of the international airport, the vast metropolitan railway station, and the shopping mall. Where Koolhaas-come-lately appears to consign such places to the garbage bin of history as 'Junk', the analysis of Augé's equally seminal text had already denied that these are even real places at all, inasmuch as they are not relational to, or historical vis-à-vis, or concerned with the identity of, their users. If Augé sees these 'non-places' as products of 'supermodernity' whose function is to enable quick and efficient movement of people and capital (hence demonstrating the legacy of the Corbusian models for a new Paris in the 1920s) then the epigrammatic quality of Koolhaas's text, in its series of punchy, short jingles could seem like a parody of that scholarly work, almost like a pop song played over the public address system in these non-places to get all the users/clients/passers-by into the rhythm and up to the

necessary speed. The question that really presents itself to us here, though, regards the conundrum of Junkspace as a profile and an influence across numerous fields and disciplines – architecture, creative arts, design, urbanism, social sciences, etc. – a profile sustained even to the extent of being reproduced several times as a short essay published on its own in book form. How has this been achieved when it is neither original in its content – its subject having been already dealt with at length and in a more comprehensively critical and equally accessible manner – nor in its apparent judgement either on the phenomenon itself or its relevance to our era? There are yet other contexts in which we may be able to assess that question. Examination of the content or subject matter may fail to reassure us as to the enduring public interest in the piece, but both the form and the style of the text of Junkspace are immediately more striking.

As regards the form Koolhaas employs here, Junkspace can be read in relation to a very particular critical tradition which posits an architectural typology as a performative model of cultural and socio-political organisation. The most well-known and easily accessible such model of recent exposition is the Panopticon of utilitarian philosopher Jeremy Bentham as used by Michel Foucault in his book *Discipline and Punish* to demonstrate the workings of the 'disciplinary society'.[7] Foucault describes how the institutions central to that society – schools, factories, barracks, courthouses, etc. – can be understood in terms of the full surveillance operations of the Panopticon prison, whereby the single cells of the individual prisoners are arranged in circular plan around the all-seeing eye of the central control tower. In the disciplinary society the bodies of the population are controlled via this surveillance, and indeed the individuals ultimately absorb the surveillance principle, take it upon themselves, and 'normalise' their own behaviour accordingly (just as does a prisoner conscious of being under permanent surveillance in the Panopticon model). The architectural model in Junkspace is, paradoxically, at once more diffuse, more all-pervasive, and more concentrated. The whole text creates the architectural model, and when it presents Junkspace as 'always interior' – an interior which is described by reference to spatial metaphors and images which are always central to Western culture, such as 'Dantesque', 'Byzantine', 'Babel', 'Parthenon', 'Sisyphus', 'Big Brother', 'Disney', and 'Manifest Destiny' – then we understand the portrayal of a society imprisoned in its own colonial mentality. A society which wants everything on its own terms, seeks to co-opt the whole world on these terms, refuses the existence of anything outside or beyond, and denies the existence of difference. It makes no attempt to decolonise. In effect this is a Eurocentric society, unaffected in its desire to dominate and control by all the post-colonial critique of the past few decades. It is as if Edward Said's *Orientalism* and all the literature of postcolonial studies had never been written.[8]

But the model is not simply one-dimensional. Repeated use of the word 'Babel' in the text naturally invokes one of the oldest and most culturally

ubiquitous versions of this form of architectural model. The Tower of Babel myth is narrated in the book of Genesis, and hence is common culture to all the religions of the book. However, versions are also found in the lore of peoples diversely distributed across the globe, from Central America, Africa, Sumer and Nepal. In the biblical version, human beings decide to collaborate on building a tower which will reach up to heaven (hence must be figured as of infinite scale). God observes them, and to confound their hubristic project, introduces many different mutually incomprehensible languages among the different peoples of the earth. The myth is often explained in its aetiological sense as accounting for the existence of different languages. What is significant for us in the context of Junkspace, however, is that this ancient myth sets up a relationship between the possibility of the existence of, or creation of, a construction of infinite extent and the actual endless babble of language. Equally, in Junkspace, it becomes apparent that the real topic is the relationship between space and language (in its wider sense, not just verbally or literally). Even when Koolhaas appears to be discussing the endlessly ongoing new type of construction of Junkspace, he refers not to '*techniques* unknown' for physical construction of Junkspace, but to '*verbs* unknown and unthinkable in architectural history – clamp, stick, fold, dump, glue, shoot, double, fuse – (that) have become indispensable' (my italic).

This brings us in turn to the question of the style in which Junkspace is written (although is style actually separable and distinct from form and content here?). Largely composed as a series of aphorisms, it opens with one: 'Rabbit is the new beef ...' and cuts out with another: 'The cosmetic is the new cosmic ...'. Indeed, 'Junkspace' – the article – cannot be said to have a beginning and an end as such, for the whole piece is presented rather as an excerpt from a potentially endless reality to which we cut in and out at arbitrary points. The modern aphorism, as made notorious in the work of Nietzsche, is eminently powerful in this type of format: expressly non-aetiological, the pithy density of the wording specifically leaves open to the reader's interpretation the questions of meaning, significance and tendency, with no fixed, final or definitive reading. Each aphorism as a phrase, as a signifying unit, as per those two cited here above, is thus self-standing, finite, complete and delimited in its punctuated isolation. The presentation of the article as a long, potentially endless series of such self-standing units unavoidably poses the formal question – again reinforcing the tendency of the Babel type myth – of the relationship between a potentially endless series of finite units and the existence of infinity itself (i.e. between God and the numberless builders of the endless real tower).

This exploration of a nexus of relationships between the inside and outside, the finite and infinite, and the qualitative and the quantitative is not – despite the unusual appearance of Koolhaas's text – something which is new to theoretical discourse in architecture. The mid-twentieth-century architectural theorist Siegfried Giedeon, for example, seemed to have a similar notion of the relationship between technical aspects of construction and both the cultural

understanding, and the use of space as that implied by Koolhaas. Hence Giedion conceived of the major architectural problem of the current epoch as consisting in a probing of the relationship between the interior and the exterior, their interpenetration, and the communication between them. In Giedeon's broader historical vision, he saw the architectonic concerns of any epoch as programmed by technological progress, and in particular this concern with the interior/exterior problem came into play after the nineteenth-century resolution of the interior vaulting problem via the development of reinforced concrete and shell technology in general.[9] That disciplinary background in itself may help us in understanding something of the provenance of Koolhaas's work in Junkspace, but could it also lead us to a more comprehensive cultural context? Can Giedeon's critical formulation be seen as only a localised disciplinary expression of a wider existential problematic facing humanity in this period? It is arguable, that is to say, that notwithstanding Giedeon's synoptic thesis of architectural history as a series of epochs driven by particular technical problems, his highlighting of the modern concern with the interior/exterior question was much influenced by the analytical work on time and space by his contemporary, the philosopher Henri Bergson. For Bergson, the durational intensities of our inner world of consciousness can only be externalised as social expression by making them extensive, countable, subject to sequence and homogeneity. In effect this means by spatialising the heterogenous intensities of our inner world of consciousness; by treating of them as a series of simultaneous, discrete, juxtaposed objects, rather than an ongoing, uncountable, endless and interpenetrating set of processes.[10]

As quantitative additions to Junkspace are continually made in all modes, in all directions and by all means, then ultimately as an interiority it seems to tend – in Koolhaas's description of it – towards infinity. The effect of its incessant expansion is no longer simply quantitative, no longer countable and rational, but is an interpenetration of endless multiplicity: a mood (with its 'verbs unknown and unthinkable in theory') rather than a measure. It is then a multiplicity like the states of consciousness in the mind, which are not the same as the ordered multiplicity of the units of number, and it seems to belong not to a rational or measurable space, discrete and countable, but to an irrepressible qualitative order which we feel from Koolhaas's text to be at once exhilarating and terrifying; like the intensities of Bergson's consciousness, or indeed the boundlessness of Freud's Unconscious.

Alternatively, we could put it like this: the mode of Junkspace, as noted above, is the verb; it is always a 'doing', and thus has the continuity and indivisibility of an act, as opposed to the divisibility, discreteness and countability of an object. And the fact that those aphorisms of which the text is composed are so short and punchy only emphasises what is – in the final analysis – the most telling quality of this piece of writing; namely its performativity. One of the most noticeable aspects to the reader of this text is that if one's attention is diverted, or if you have to put the text down for some reason, when you pick

it up again it is extraordinarily difficult to re-find your place. This is partly because in the unending series of aphorisms – each with their own form and truth – there is no organising narrative or argument running through the whole piece. Each sentence more or less stands complete on its own with its own system of meaning, yet piled up as Junkspace with all the other sentences. Hence we have a text which is an example itself of the very phenomenon it seeks to define. With the text as with Junkspace itself, Koolhaas 'replaces hierarchy with accumulation', and again like Junkspace itself, the text is 'additive, layered, lightweight', and is not articulated by an overall understanding and an organising principle of the whole. The text, like Junkspace is potentially endless, and tends – in its accumulation of idiosyncratic, self-standing additions – towards the infinite, with its proliferation of aphoristic truths bringing the world gradually inside itself. The text performs Junkspace itself. Thus this text is important not for what it says, but for what it does (though with J. L. Austin, godfather of the performative, maybe we cannot say that ultimately these are different things).[11] So actually, while the world was confined to the domestic arena as the pandemic raged, we could easily pick up an online copy of the article and be reassured that Junkspace kept on performing infinity.

Notes

1 Rem Koolhaas, 'Junkspace', *October*, 100 (Spring 2002), pp. 175–190.
2 Le Corbusier, *Towards a New Architecture*, Architectural Press, 1946, p. 13.
3 Paul Preciado, *Testo Junkie: Sex, Drugs and Biopolitics in the Pharmacopornographic Era*, The Feminist Press, 2013.
4 Mark Fisher, *Capitalist Realism: Is There No Alternative?*, Zero Books, 2009.
5 Shoshana Zuboff, *The Age of Surveillance Capitalism*, Profile Books, 2019.
6 Marc Auge, *Non-Places: Introduction to an Anthropology of Supermodernity*, Verso, 2009.
7 Michel Foucault, *Discipline and Punish: The Birth of the Prison*, Penguin, 1991.
8 Edward Said, *Orientalism*, Penguin, 2003.
9 Siegfried Gideion, *Space, Time and Architecture*, Harvard University Press, 2008.
10 Henri Bergson, *Time and Free Will*, George Allen and Unwin, 1950.
11 John Langshaw Austin, *How to Do Things with Words*, Martino Fine Books, 2018.

Blackness matters

On '1 (life) ÷ 0 (blackness) = ∞ − ∞ or ∞ / ∞' by Denise Ferreira da Silva (2017)

At first glance, and for the briefest of seconds, the title of this essay seems a category error. The piece[1] was published in the monthly online art publication *e-flux*, yet strangely appears to be headed by a mathematical equation. Its stark ciphers for relations and calculations are shorn of the more humane conjunctions and padding of the verbal statement and seem strikingly incongruous with the expected tone of the forum. When those seconds pass, however, we've picked up smartly on three substantive verbal terms, which also populate that title, respectively 'life', 'blackness' and 'matter' and a social narrative is conjured up before us. Before moving on with our reading of the main body of the text, we return to the maths with additional linguistic resources. What does it mean? We translate − or rather, transliterate: Life (as 'one') divided by blackness (as 'zero') equals infinity divided by infinity, or infinity minus infinity. We can understand why the one, the wholeness, might represent life; we can also understand why, given present human conditions and the political constitution of the world (and see Achille Mbembe's *Necropolitics* here), someone should aver for their calculations that blackness is as nothing, or rather, zero. But what is the significance in the fact that the resolution of this division is given on the right-hand side of the equation as infinity minus infinity or infinity divided by infinity. A basic mathematical logic seems to tell us that infinity minus infinity and infinity divided by infinity cannot be the same thing. Surely the first comes to zero and the second to one. But then again, that would only be true, if infinity were in fact a number which it is not, that is, it does not have a definitive value, so as it is, in fact, a concept of endlessness then these mathematical operations involving it, the minus and the division can only signify processes ... endless ones at that? Hence blackness will never be summed to life ... is this the conclusion we should reach? That the process of trying to understand how and what way, and by what quantity blackness will be approximated to life will never end? The mathematical mix of numbers with concepts ('blackness') − or is it with matter? (and does it matter?) − doesn't operate by the 'normal' rules here. We're startled out of our complacency. Out of our complicity. The eruption of a strange order, a heresy of the illegitimate introduction of mere matter into the ideal realm of number

DOI: 10.4324/9781003186922-3

is compounded immediately after that title with a series of dictionary defini-
tions by way of epigraph. It is only on consultation of the reference notes that
it is made clear that this is a dictionary entry of the meaning of 'matter'. But
again, the same question arises as with the title and epigraph – namely, is the
reference a part of the text, is it inside or out? At any rate we're given a jolt
once more by the unexpected and incongruous format. We're then further put
out of joint by the sudden leap and transformation in the series of numbered
definitions 1 ... 2 ... 3 ... 4 ... 22a ... b ... c ... Once into the body of the
text we will understand why that leap from everyday definitions to specialist
philosophical meaning is made, but for now it's unsettling – and why are 17
definitions overlooked? Do they not matter? What does it mean when something
doesn't matter?

We've only got as far as the title and the epigraph and already everything
seems awry here: we're spinning off uncontrollably and incoherently across
apparently incompatible orders: from mixing maths and prose to evidently
random and incomplete arithmetical progression, the alphabet, lexicography
and etymology. It's not simply the question – as was posed by Derrida – of the
undecidability of the title and the epigraph.[2] What is their relationship to the
body of the text, Derrida asked, are they a part of it or not, inside it or out,
and how do they engage with it? Nor is it simply a question of the perfor-
mance of illegitimate hybrid calculations – for it is demonstrated above that
something of that can already be worked out ... and translated. In the preface
to his *Order of Things* Foucault brings to our attention a passage in Borges
where the latter constructs a fantastic and incongruously variform taxonomy of
animals (supposedly from a Chinese dictionary), organised in alphabetical
series.[3] The animals are categorised:

> a/ belonging to the Emperor b/ embalmed c/ tame d/ sucking pigs e/ sirens
> f/ fabulous g/ stray dogs h/ included in the present classification i/ frenzied j/
> innumerable k/ drawn with a fine camel hair brush l/ et cetera m/ having
> just broken the water pitcher n/ that from a long way off look like flies.

The effect of this series, of course, is comic, the effect of Ferreira da Silva's title
and series is not. Yet they share something of the same format: elements placed
in unrecognisably formulated series and unexpectedly propinquitous relation-
ships. Foucault's commentary on Borges work here would seem nonetheless to
have some validity in application to Ferreira da Silva too. It is 'not the pro-
pinquity of these things that is impossible' Foucault writes, 'but the site on
which propinquity would be possible'. And again 'though language can spread
these before us, it can only do so in an unthinkable space'.[4] Hence placing
'life', 'blackness' and 'matter' alongside and in engagement with the Western
mathematical tradition of calculating relationships in space, and in series also
with the Western ordering of meaning and language and philosophy and sci-
ence, renders the site of that propinquity unthinkable. We see here set out in

stark algebra, and before we even enter Ferreira da Silva's essay proper, that when it comes into relation with its other, the whole grounding of the Western tradition is shown up for absurd and unthinkable. That's just for starters.

On reading the rest of the text we discover that the title and epigraph together are in some type of synoptic relationship to the main body. They encapsulate at once the twin aspects of the Western tradition, an attitude of critique towards that tradition and an engagement with it. All this will be elaborated upon at greater length in the text, and if the regular and abbreviated proximity of incongruous elements of the title and epigraph does away, as per Foucault, with the possibility of a sustainable ground for that tradition, then that leaves all the more open space for a free-floating elaboration. In the text Ferreira da Silva's language of intervention is dense and poetic – poetic in the sense that it pushes the lexical to new limits, insists on new, unwonted and awkward contexts for words and concepts and brings us to question whether a 'figurative' use of vocabulary is constituted by a refusal to accept given standards. Paradoxes and impasses abound: the qualitative category of 'blackness' is employed in a mathematical equation as though it were a quantitative category, yet at the same time its quantitative content is set at zero.

Somehow this crude adaptation of resources, the call on the body, the *matter* as an inaccurate, unrefined and incomplete – not to say mute – semiotics which yet reaches for the infinite, reveals an underlying reality of mathematics as a poetics of gesture. What she calls the 'itinerary' of the article is this: there are at least three fronts – inside, outside, and against – on which da Silva engages simultaneously with that Western tradition here. Needless to say, these three fronts are not discrete, they rather overflow into and out of one another through the piece, and neither are they mutually coherent. From outside its universalist pretensions da Silva dismisses out of hand that tradition as encapsulated in her title and epigraph, in which the 'mind has access to truth' because 'its workings are adequately captured by mathematics and reasoning.' At the same time, she also engages on the inside of that tradition, and shows her patient and careful understanding of it and how well versed she is in its intricate and difficult historical workings. Meanwhile, she introduces new matter into and against that tradition, in other words, not to rejuvenate or carry it on, nor even just to refuse it, but to compromise it and to break it. This inconsistency of approach may appear simply uncongenial to mathematical method and an outrage of the terms of what, drawing evidently on Marx, da Silva calls her 'Equation of Value'. She does however, declare, almost in the same breath, that this is a 'thought experiment'. Besides, the violence of inconsistency might be one thing that she is trying to expose in that tradition: one that maintains blackness as a matter with no form which therefore has no calculable value to pose against and unbalance a certain notion of the 'universal' that has hitherto been consistent in Western thought.

Da Silva points to the 'determinacy' in ethical formations, which has created preordained winners or superiors in the 'game' of the Western moral universe.

She dismisses the ethical indifference with which 500 years of colonial and racial violence is not only deemed acceptable but makes sense. Stepping away from a historical description or an active political programme to counter that violence, and 'from the usual analytical path', she illustrates via the artwork of Nkanga and her juxtaposition of 'places of shine/spaces of obscurity', how it is not only ongoing and ubiquitous around the globe, but operates in a figure/ground positioning of colonial oppression and denial of blackness.

Da Silva gives a brief and succinct summary of the history of the formalisation of the 'ethical syntax' which entails ongoing racial violence, exposing its development from Descartes, who grounds reasoning in the ideal certainties of mathematics and its guarantee in the Christian god, through to Kant and Hegel and the establishment of the subject as an ethical entity, whose sensible universality is determined through the a priori forms of a purely European time and space. Da Silva cites Hegel's declaration that the black person is a mere thing, an object of no value even 'in their own lands'. It is then, and contemporaneously with her dismissal of this tradition and with her scholarly engagement, understanding and exposition of it, that da Silva puts the formless – and thus ignored and violated – matter of blackness back into the ethical equation – her 'Equation of Value'. On the one hand, of course, this is absurd on a formal level because mathematics as an ideal science can only deal with pure forms as numbers and abstracts (e.g. $3x$), and not with actual matter (viz. Euclid's axioms). Yet she insists, and runs us through a series of calculations whose impossibly desperate logic cannot hope to attain even to the tortured resolution of a surd. Oddly though, it is here that we see something of Descartes's cultural certainty while proceeding in doubt, in da Silva's operation. This wilful insistence achieves a certain momentum, an unthinkable and irrepressible force as though it belonged to a work of art, or to the order of the symbolic. It is, however, the weight of real and actual suffering – as blackness – that crushes the skeletal ciphers of the ideal. An illogical, impossible manoeuvre, which is performed, nonetheless, before our eyes.

Da Silva is well aware, of course, that on a philosophical level this clash has arisen continuously through Western history. The mathematical surety of our knowledge has already been undone by Heraclitus's declaration that you cannot step in the same river twice and by Nietzsche's denial of the very existence of the order of number.[5] Hume too, released knowledge from the multiple rational bracings and continuities of mathematics – but then he was also a customary racist.[6] Yet with this revealed potential of blackness to unsettle ethics, we see with da Silva, for the first time, what Nietzsche claimed could not come into being until we found a new grammar – namely, 'another horizon of existence'.

Elsewhere da Silva refers to her operation here as 'hacking'. She defines hacking as 'a decomposition that explores, unsettles and perverts forms or formulae; it is an active misunderstanding, misreading, misappropriation; but also a response to a call'.[7] The hacker, that is to say, does not operate to determine

outcomes but to disrupt them. If the mathematical formalisation of knowledge was developed in Western thought, as da Silva asserts, to examine and understand the 'cause of changes', 'alterations' and 'motions in space', from Descartes through to its highest classical refinement in the calculus of Newton and Leibniz, and thence to the modernism of quantum mechanics of Einstein and Bohr, then hacking is a taking of position in that spatial dynamic, and with respect to existing operations of power and deployments of knowledge. The hacker, as subject, is an outsider who moves inside the system in order to work against it.

In accordance with these considerations on da Silva's techniques – or methodology, if it can be considered as such – an analysis of the positioning and functioning of material within this essay might provide strategic insight. Our attention is drawn continually to the role played by the referencing and foregrounding of Nkanga's artwork – and not just because in the published version the colourful images of the artwork have been exploited by the graphic designer to maximise eye-catching effect, although, for sure, that *does* play a role in this art review. At any rate, the material might appear to some readers to be of a somewhat anomalous texture, given the otherwise strict and careful mobilisation (as per the hackers tentative, alert and wary progress through a vigilant and touchy territory …) of scholarly and political resources. The cynic might even suggest that reference to – and dare they say it, illustration by – an artwork is the price she had to pay for publication of this abstruse philosophical and uncompromising political text in a super-trendy online art publication. In the first and most obvious place, that would be to ignore the position that *e-flux* has established for itself as a regular publisher of extensive cross-disciplinary theoretical and critical prose by contemporary artists and thinkers at the cutting edge of new analyses. The editorial thinking behind this publishing venture appears to be not only that an art form can host a broad cross-section of critical thinking, but that contemporary art should specifically comprehend such work; and in fact, both Weizmann's and Groys's essays discussed in this volume were also published in *e-flux*. Besides, da Silva herself does more than hint at her use of Nkanga's work here almost as a type of alibi. She writes 'for the most part what I do here is try to emulate Nkanga's artistic intervention into Western culture with an analytical formal artefact'. So it is not a matter of decorating abstruse erudition with some artistic colour. Da Silva shows us how in Western thought it is only with formal insertion into the ethical regime that a subject can exist, that it can matter. Blackness is banished from such existence as it is formless. In emulation, as she puts it, of Nkanga, da Silva 'activates blackness's creative capacity' by posing it as an artefact, a thing against the formal mathematical procedures and interrelations of calculation. As noted at the top of this article, this illegitimate, heretical manoeuvre destroys the ground, and makes any basis for relationship other than propinquity unthinkable, just as Foucault notes with amusement happens with Borges's fantastical and meaningless series. Like Freud's analysis of the joke and how it works,

words are put in a relationship where they are treated as things, the consequent release of mental energy which was previously employed in maintaining their charge of lexical meaning is vented physically – in laughter.[8] Equally, da Silva describes her pushing of terminology to the limit in pseudo mathematics beyond discursive meaning as 'an experiment in nonsense'. But nobody is laughing at the endless process of making blackness matter.

Notes

1 Denise Ferreira da Silva, '1 (life) ÷ 0 (blackness) = $\infty - \infty$ or ∞ / ∞: On Matter Beyond the Equation of Value', *e-flux*, 79 (2017), www.e-flux.com/journal/79/94686/1-life-0-blackness-or-on-matter-beyond-the-equation-of-value.
2 Jacques Derrida, 'Before the Law', in *Acts of Literature*, ed. Derek Attridge, Routledge, 1992, pp. 181–220.
3 Michel Foucault, *The Order of Things*, Routledge, 2002, pp. xvi–xvii.
4 Ibid., p. 18.
5 Friedrich Nietzsche, 'Aphorism 19', *Human All Too Human*, Cambridge University Press, 1996, p. 22.
6 David Hume, 'Of National Character' in *Essays and Treatises on Several Subjects*, 2 vols, A. Millar, London 1768, Vol. 1, p223–43, at 235.
7 Denise Ferreira da Silva, 'Hacking the Subject: Black Feminism, Refusal, and the Limits of Critique', www.youtube.com/watch?v=T3B5Gh2JSQg (accessed 21 March 2021).
8 Sigmund Freud, *Jokes and their Relation to the Unconscious*, Penguin, 1973.

The superpositioning of cuteness
On 'The Cuteness of the Avant Garde' by Sianne Ngai (2005)

Who would have thought that the operation and engagement with 'the cute' could repair the modernist dilemma of alienation of the avant-garde from society at large? Certainly not one of the foremost critics of the modern era, Clement Greenberg, who in his influential article on 'kitsch', originally published in 1939, described the phenomenon variously as 'mechanical', a 'vicarious experience' of 'faked sensations' which 'operates by formula' and is the 'epitome of all that is spurious'. Greenberg saw kitsch as an effect of the industrial revolution. The uprooted peasantry, removed from the environment of their native folk culture in the rapid urbanisation of the time, literate in the city and hungry for diversion from oppressive industrial employments, consumed commercial 'simulacra of genuine culture'.[1] Equally, if that is the *classic* modernist view of mass culture, then it is in the same context that we might read the critique of the 'genuine' modern or avant-garde artist as ineffectual in reaching and being appreciated by those kitsch loving masses with their own avant-garde art works. Both Buerger and Williams, for example, distinguish between the modern and the avant-garde and see the latter as a cultural dead end with its concern with obscurities, alienation and narrative discontinuities.[2]

Sianne Ngai's essay[3] is, however, about 'the cute', which is not exactly the same as kitsch. Her understanding of the positioning of the 'taste concept' of cuteness is that it 'cannot be fully enfolded into kitsch'. At the same time, she implies nonetheless, that all cute things are kitsch with the statement 'cute objects can of course be kitschy, but not all kitschy objects are cute'.[4] This leaves us with the tantalising feeling that Ngai's style itself is rather cute. That also seems an appropriately exploratory performance by the critic in this moral environment, and could bring us cutely into play with her own definitions, as it were.

Like Greenberg with kitsch, Ngai comes back again and again to gnaw at the question of the defining characteristics of 'cuteness'. It is as if she never manages to fully quite capture it in one, and indeed she attempts to outline the very source of the elusive quality, noting of cute objects that 'the less formally articulated … the cuter it becomes'.[5] Unlike Greenberg, however, her assessments are made from an ever-changing dynamic of positioning in relation to the question, which endless shifting partly constitutes her own cute

DOI: 10.4324/9781003186922-4

performance. At a basic level she sets out the non-evaluative formal aspects of cuteness – smallness, compactness, softness, simplicity, pliancy, and so forth; she then moves to a Greenbergian moralistic plane where the roundness and softness of the cute is 'feminine' and 'infantile';[6] then on the pathetic level she lists specific affects which it 'call(s) forth' – 'helplessness, pitifulness and even despondency';[7] and ultimately, of its more provocative agency she writes of the cute that it 'invites physical touching'.[8]

The initial example of cuteness, of a cute object (to which much of the above is applied) that Ngai offers us – and shows us photographs – is a frog shaped bath sponge with simple and unrefined representation of a face (two black circles for eyes and two smaller black dots for nostrils). Ngai helpfully demonstrates the 'cute' texture of the object by showing a hand 'squish' it in one of the photos. That 'spurious' engagement alone would have been sure to have earned Greenbergian disdain. Yet this cuteness is seriously the means by which Ngai intends to work 'a reconciliation of modernism and mass culture'. To make good, that is to say, the type of ineffectuality in avant-garde artists criticised by Buerger and Williams. It is already obvious from Ngai's complex positioning with regard to the cute that this is not just an attempt to get beyond the difficult abstractionism and intellectualism of the modernist avant-garde by escaping into the consumption, sentimentality and nostalgia as of the 'anything goes' nihilism of the postmodern. Her critique is much more nuanced, original and complex than that. Besides, what would be the point in attempting to effect a latter-day reconciliation in the crisis of theory and practice in an age – the modern, or for that matter, the postmodern – which is already over, done with and superseded by our current era with its own concerns? Is this just the 'I told you so' wisdom of a cultural historian's retrospection, or worse still, the tardy and pointless meddling of a dilettante know all? In fact, we can avoid the notion of supersession of movements, trends and eras in art and culture altogether by perceiving Ngai's understanding of and work within relationships in aesthetic history as one of superposition. This concept of superposition is one which has various applications and meanings across different disciplines. There is the fairly straightforward geological notion that with sedimentation of rock formation through time, that the lowest strata are those earliest deposited. A more complex but not unrelated form of superposition exists in quantum physics, whereby small particles as individual units can exist in different states (say for light energy as both a wave and a particle) and in different places at the same time until a measurement intervention is made. The popular narrative exposition of the phenomenon is in the fable of Schrödinger's cat: when the aforesaid animal is locked in a box with a radioactive source, and we cannot know at any one time whether it is dead or still alive. So, until such times as we look into the box, the cat exists in a state which is a superposition of both those states, is both dead and alive.

Maintaining that some entity is both alive and dead at the same time and that it is in one place and simultaneously in another one might also be figured

as a pretty cute standpoint. Superposition has been understood as a phenomenon characteristic of a new relation to time and space which is referred to as the 'contemporary', and Ngai's take on the cute can be viewed through that lens. This concept of superposition, of occupying simultaneously different states and places and temporalities, is useful in helping us to understand what Ngai is doing here. She engages with the criticism of modern avant-garde art (as per Buerger and Williams) as an ongoing debate by weighing in lightly and cheerfully on the side of the difficult and abstruse assertions of Theodor Adorno (who died in 1969 before finishing the book where he made the relevant assertions, namely *Aesthetic Theory*).[9] Ngai then apparently makes this contribution by performing that post-modern trick of 'anything goes', a manoeuvre that settles for the obscure, the unknown, non-transparent and irrational to expose the hubris of modernist and enlightenment rational absolutism. This manoeuvre would also have been sure to kindle the chagrin and ire of such modernists as the Greenberg of the kitsch article. Yet, ironically, in Ngai's work, this apparent postmodern manoeuvre in the choice of topic 'the cute', is invested with all the intellectual and theoretical ballast of an analysis worthy of approach and interaction with Adorno's uncompromising work. All these art movements, debates, eras, practices, critiques and understandings are alive in one moment in Ngai's essay. Nothing is lost. This multiplicity of times in one moment, where no epoque is closed and done with, is indeed a measure of how contemporary is Ngai's operation. 'The superposition of apparently contradictory temporalities rather than the succession of distinct and homogenous ones is another name for the contemporary', wrote Lionel Ruffel in his seminal text *Brouhaha*.[10] 'Our era is "contemporary"', he goes on to write, in as much as 'we live simultaneously in several times'.[11]

Moving beyond the setting out of the field, its population, and her own positioning, Ngai then starts to act on her own declared concern, which regards specifically the relationship between cuteness and avant-garde poetics. The work she does on this takes place in what might be described as two case studies (though it's not clear if the case study is not too dated and static a procedure for employing a more traditional interpretative practice than what here is in effect the plotting of the dynamic ahistorical trajectory of a dialectic). The two cases are, somewhat worryingly, exploited to rather stereotypical ends: the visual arts case is illustrative and the literary one which follows is more discursive.

Having exposed the often vulnerable, disempowered or weak appearance of cuteness or the objects designated as cute (like the teddy bears manufactured with a game leg) Ngai goes on to probe the tendency of those objects to incite more sadistic feelings of mastery and control as well as those nurturing, maternal instincts. Accordingly, it was a cultural environment of the weak, the defeated and the crushed, she speculates, that made post-Second World War Japan such a fertile ground for exploration and production of the cute with an explosion in manufacture and creation of cute graphics (like Hello Kitty and

the wide-eyed Manga kids as wounded and distressed), toys, and other objects. This thriving – if that is the word for a vulnerable, damaged culture – did not go unnoticed or unexamined by visual artists, who, as Ngai showed us, explored the realities and the significance of the 'cute' in Japan. Many of these artists tested the shared territory and the boundaries between the artwork and commercial merchandise in the way Andy Warhol did in the West. Ngai follows artist Takashi Murakami's development of a painted cute character, 'DOB', in his work, which, through the years, seems to absorb the sadistic attitude given to the cute, and to give it *back* as an agent through menacing deformations of the face, jagged teeth and so forth. Not only does this reveal how the 'veiled or latent aggression' of the subject can be converted into aggression *towards* the subject, via the cute object's capacity for retaliation here, but it shows how it is possible for the cute to be both aggressive and helpless at the same time. Suddenly, it appears that we have entered into equivocal, enigmatic and volatile territory. As the possible sets of relationships in and with the cute changes (or is it develops or evolves, or simply mutates?), Ngai describes how Murakami develops his practice further to the point where it is a verbal/literary graphic practice, and he claims that it had always been performed with the aim of critical engagement with American letter-artists like Jenny Holzer and Barbara Kruger.

This literary turn is convenient for Ngai is a literary academic and as such we can see how she uses this development in her critical narrative to focus attention now on the cute as a verbal/linguistic phenomenon rather than as a material commodity. We can nonetheless appreciate the virtuosity with which Ngai has led us from a point at the beginning of the essay where she declares that 'nothing could seem more adverse to the traditional understanding of literary modernism or the avant-garde than the 'culinary' idea of cuteness[12] via a long preparatory dialectical detour through cute as a material commodity and then as a commodity represented in visual art, to the point where she can finally introduce us to the particular reality that literature in the specific form of lyric poetry has been 'forced to negotiate its relation to cuteness in a way that other literary genres and forms have not'.[13] There are, of course, structural reasons why the cute should be a particularly thorny question for lyric poetry. Despised and feared by Platonists, by Stalinists, by self-appointed moral guardians of the youth (like Quintilian), and collectives of all sorts, the lyric is the subjective poetry of the lone individual singing their thoughts and feelings into the world. Modelled and named after the young Orpheus with his lyre, the lyricist is mesmerised by the delight of their own ecstatic incantations as they descend alone into a personal existential hell to find their love. They face the world and all the dangers and threats of the world, that is to say, naked, with nothing but the power of their own charm. No one would deny that the three lyric poets chosen for exemplary exposition by Ngai – Gertrude Stein, Francis Ponge and Bob Perelman – are paragons of charm, and the question of power, or imbalance of power, or powerlessness, is central to relationships in the

works she examines here.[14] What objects could be more innocent and harmless to the poet than some buttons, an orange, a potato, and a simple drawing of a toy dinosaur? In fact, Ngai's category of the experiencing of cuteness as 'an aesthetic encounter with an exaggerated difference in power that does something to ordinary or communicative speech'[15] could surely be applied equally to the work of the lyric poet as described above. Given what was written there regarding those who despise the lyric there may be some irony in the great resemblance of the imbalances, shifts and plays of power in this evolving dynamic of the cute as Ngai presents it, and the Master–Slave dialectic of Hegel's *Phenomenology*. Hegel's construct represents an encounter between two subjects of unequal social power – the master and the slave – where there is a struggle for recognition, and self-consciousness can only be achieved by each via an equal recognition from the other and recognition of oneself in the other. In the Ponge poem the insignificant harmless object, the orange, is powerless to resist violence which is imposed by the poet in their representation and their oblique personification and also by the consumer who will devour it, but the 'expression' of the orange, figurative and actual, both injures it and forces it to produce its defence or retaliation in the form of the aesthetic quality of its inner essence – a paradigm, of course, for the lyric poet, powerless and ineffectual as they sing mournfully, agonisingly in an uncaring world. Ultimately in this dialectic between the real and the figurative, and not necessarily in that order, the poet and the cute object, we might very well ask, who, or what is the subject here? In Hegel's dialectic true freedom would only be possible when there were reciprocal recognition and commensurate power and that would bring an end to the antithesis of subject and object in a higher unity. In Bob Perelman's lyric the subject appears to be suffering aggression from the object, the toy dinosaur, and appears not to be in control of the narrative content, finally seeing their appeal to the object left unanswered. In the operation with the cute, that is to say, there is no resolution, no move to a higher plane of unity, there is a persistent playing out of powerlessness between different positions, and that is why Ngai can write that 'the cute object … might even serve as the best example of the *modernist* artwork that Adorno clearly privileges as a synecdoche for art in general in *Aesthetic Theory*'.[16]

If it seemed at the outset of this article, unlikely that the cute object (probably in the form of a plastic model of a knight in shining armour …) could come to the retroactive moral rescue of avant-garde art then actually we now see that Ngai's case is even more acute than that. For ultimately this essay is focussed on bringing cute objects – a kitsch army one might say – specifically to the aid of one of the most hard-edged and uncompromisingly modernist theorists and supporters of the avant-garde, namely Theodor Adorno. Attention has already been drawn here in the Introduction to the assertive and sententious abstract style of Adorno's aphoristic writing in *The Essay as Form*. Ngai goes further and suggests that Adorno's style itself is cute, writing that the

aphorism is 'western philosophy's most folksy, and dare I say it, cutest sub-genre'.[17] As Adorno indeed put it, art is ' social through and through by virtue of its very anti-sociality'.[18] And in Ngai's metaphorical take, the cute can give unparalleled insight into, and dramatise the value of that ineffectual and powerless social state in resisting commodification and exchange. The cute, as a thing, shows us how lightheartedness, and the knack of judging 'exclusively by abstaining from judgement' endow it with the ability to survive (and be expressed) in difficult places.[19] So, as Ngai says 'theorising powerlessness ... in a society that worships power is, in fact a special or distinctive power of all artworks in their thing-character'.[20]

Notes

1 Clement Greenberg, 'Avant Garde and Kitsch', *The Partisan Review*, 1939, pp. 34–49, at p. 10.
2 Peter Buerger, *Theory of the Avant-Garde*, University of Minnesota Press, 1984; Raymond Williams, *The Politics of Modernism*, Verso, 1989.
3 Sianne Ngai, 'The Cuteness of the Avant Garde', *Critical Enquiry*, 31(4) (Summer 2005), pp. 811–47.
4 Ibid., p. 813.
5 Ibid., p. 815.
6 Ibid., p. 814.
7 Ibid., p. 816.
8 Ibid., p. 815.
9 Theodor Adorno, *Aesthetic Theory*, Bloomsbury Academic, 2013.
10 Lionel Ruffel, *Brouhaha: Les Mondes du Contemporain*, Verdier, 2016, p. 196 (author's translation).
11 Ibid., p. 71.
12 Ngai, p. 813.
13 Ibid., p. 815.
14 Gertrude Stein, *Tender Buttons: Objects, Food, Rooms*, Los Angeles, 1991 [1914]; Francis Ponge, *The Voice of Things*, trans. Beth Archer, New York, 1972, pp. 147–8; Bob Perelman and Francie Shaw, *Playing Bodies*, New York, 2004.
15 Ngai, p. 828.
16 Ibid., p. 841.
17 Ibid., p. 842.
18 Cited by Ngai, ibid., p. 842.
19 Ibid., p. 847.
20 Ibid., p. 844.

Chapter 4

How matter matters
On 'Posthumanist Performativity' by Karen Barad (2003)

In his 1939 essay 'The Invention of Space' the classicist scholar F. M. Cornford described how on learning geometry, in his pre-Einsteinian boyhood, Euclidean space was simply accepted as a common sense. It was not always so, though. He recounts how when the Greek mathematics, which Euclid synthesised and codified into a coherent whole, was relatively new, the Greek mind recoiled in horror. The resistance of pre-Euclidean common sense to the new boundless vacancy and the infinite stretch of the straight line through space, he writes, was tenacious. Equally, he speculated, shall the modern European Euclidean common sense resist the new spatial conceptions of Relativity – and it may take centuries before we accept it as a new normal.

> There was a pre-Euclidean common sense, whose conception of the world in space had to be transformed into the Euclidean conception, just as our Euclidean common sense has now to be transformed into the post-Euclidean scheme of relativity.[1]

Cornford shows us how the atomistic theories of Leucippus and Democritus entailed the necessity for conception of an infinite stretch of blank empty space, for the movement, positioning and interaction of the isolated individual atoms/objects which were proposed as the fundamental entities of existence. At any rate, in the ideal of Plato, in the axiomatic denial of material content of Euclid, and then in the fear and distrust of the world by Descartes, Western thought carried forth a tradition of privileging the ideal, the spiritual and/or the intellectual over the material world as a means of knowing, understanding and being.

Stirrings of that new post-Relativity everyday consciousness or commonsense of space and time were, however, already noticeable to some commentators contemporary to Cornford. Both Walter Benjamin and Erwin Panofsky were already noticing change and writing in the 1930s of its appearance in the new media technologies – and in particular in cinema. Both critics seemed to believe that the relatively new, and in 1920s–1930s Germany especially innovative, medium of film was providing new possibilities in conceiving of time

DOI: 10.4324/9781003186922-5

and space and their interrelationships. Panofsky writes of the unique and specific possibilities of film as 'the dynamisation of space and the spatialisation of time',[2] and Benjamin points to the technical realities of how and what was being achieved,

> with the close up, space expands; with slow motion movement is extended … and unconsciously penetrated space is substituted for a space consciously explored by man … The camera introduces us to unconscious optics as does psychoanalysis to unconscious impulses.[3]

To our own age such optimistic critique and the stake put in media technology has seemed a bit of a false dawn. As Ravi Sundaram put it:

> We now know that Benjamin's 'gamble' with technology was buried by Auschwitz; post-war populations were tamed by mass television and Fordist capitalism. Guy Debord's classic *the Society of the Spectacle* laid bare the edifice of the post war boom. In 1985 Jean Baudrillard published his landmark essay 'The Masses: The Implosion of the Social in the Media.' Caught in the vortex of permanent (informational) participation, the public was no longer constituted by contingent political speech but absorbed by transparency.[4]

It seems appropriate somehow that the most recent substantial progress towards adapting our everyday understandings and dealings with the world to the consequences of Relativity and other discoveries/developments be made by a physicist. Karen Barad's article 'Posthumanist Performativity'[5] with its pun on 'matter' appears to be written for – or, at least largely appreciated by, an Arts and Humanities readership. Her prose style smacks of the abstruse opacities of continental philosophy. Like Heidegger, for example, she both invents new terms, and takes simple everyday terms and puts them to abstracted, specific uses (e.g. her use of 'phenomenon') with special meanings and specific range which apply only for the purposes of her own demonstrations, expositions, proofs and theories, thus creating a type of intellectual jargon which tests the patience, endurance and abilities of the reader. The difficulties are compounded by her use of complex scientific ideas and drawing specifically on the work of Danish nuclear physicist Niels Bohr (1885–1962). Like Barad, Bohr did not like to make too strong a 'two cultures' distinction between physics and philosophy. Indeed, Bohr's vision of the compatibility and necessary complementarity of physics and philosophy is very much of the same tone as his reluctance – as described by Barad – to accept any of the dualisms (nature/culture, subject/object, knower/known, world/word) that have riven the history of Western thought and life. In particular, his experimental and theoretical work in physics led him to critique and reject the Cartesian model of the world as an object 'out there'. Hence in that model there is a nature/culture

split and the world can be known and engaged with by human subjects only through representation, in other words in language – mathematical and specifically geometrical representation in the Cartesian case. New empirical findings discovered in experimentation in the atomic domain demonstrated to physicists in the early twentieth century that there can be no disinterested, disengaged neutral, platonic knowing of objects in the world. As soon as an observer engages with the world, that is to say, then that world changes and is changed by them, by their very engagement. Barad expresses the situation as, 'We do not know because we stand outside the world, we know because "we" are *of* the world. Part of the world in its differential becoming.'[6]

The exemplary situation in quantum mechanics is that under experimental conditions sometimes basic entities act as though they exist in the form of particles, and sometimes in the form of waves. Not only that, but by attempting to observe or measure these entities their form, and thus behaviour (i.e. as particles or waves) changes. This is the understanding that is analogised in the paradigm of Schrödinger's Cat which is referred to here in the chapter on Sianne Ngai. As with the question of particle or wave, the state of the cat can be either dead or alive, or neither, or both, until it is decided one way or the other by our engagement with the box in opening it up. It is therefore because a true epistemology – that is a true understanding of what we can know and how we know it, cannot be obtained through representation (or, in other words, reflection) as no truly independent and neutral observation can be made on the world, that *diffraction* comes to the fore as an alternative mode for understanding our relations with and knowledge of the world. The standard definitions of diffraction as a specifically scientific phenomenon are usually retailed in a representation of a series of micro entities – electrons for example – fired at and through a small gap in some material in order to measure how their behaviour as waves or particles changes or adapts when they come into contact with changed conditions via this gap in the material. Barad adopts this phenomenon of diffraction as an analytical tool – drawing on influence from Donna Haraway – with an expanded and re-elaborated range of application to comprehend, in Haraway's words, 'a mapping where the effects of difference appear'.[7] Thus diffraction is specifically an analysis of the being of entities via their effects on one another.

If all the above attempts to cover the theoretical and intellectual background to Barad's work, nonetheless at the beginning of the essay she immediately sets out her agenda which is to reinstate matter and to 'give it its due' in our relations with the work. The theme has come to her, she declares, through its development in Feminism and in Science Studies, and also in queer theory.

What compels the belief that we have a direct access to cultural representations and their content that we lack towards the things represented. How did language come to be more trustworthy than matter?[8]

Thus she laments the prominence of the so-called 'linguistic turn' where everything, all material, is deemed accessible only as represented in language or some other cultural representation, viz. Derrida's supposed 'there is nothing outside the text'[9] or Baudrillard's 'The Gulf War did not take place'.[10]

Central in following Barad's work here are the understanding of the special significance she gives to the concept of 'phenomena', and to the operation of 'Discursive Practices' within these phenomena. As noted above, Barad uses abstruse, often awkward and certainly unusual locutions alongside a deal of jargon and even the use of everyday words with special and particularised references relevant and defined within her own system. This can make heavy weather for even the seasoned reader of theory and philosophy. One is reminded of the difficulties of reading Heidegger, and if the aim of dis-establishing language, as it were, and putting words and concepts to new work is to allow the possibility for the emergence of original, vital, authentic and clearly defined thought, then a deal of success has been achieved. At the same time, however, the particularised set of meanings assigned to terms within this closed and self-referential system, while creating a working model for Barad's purposes, makes the task in hand here – to unravel these meanings and rela-tionships within the system and to provide clarity by expressing them in other words – almost impossible to carry out satisfactorily. Like Bohr, Barad pro-poses that the primary ontological units in our dealings are not 'things' but phenomena. These phenomena are viewed differently, however, from the classic sense we know from Kant's philosophy. These phenomena are con-stitutive of reality. This is a reality which is not composed of things-in-themselves or things-behind-phenomena (both as unreachable noumena in Kant's philo-sophy) but of things-in-phenomena. Which is to say that phenomena are constituted by sets of relations in the world through whose intra-active dynamic – or as Barad puts it, through the topological reconfigurations/ entanglements/relationalities/(re-)articulations – things or relata emerge and become intelligible. It is these relations and intra-actions which are ontologi-cally primary and the agency resolving matter and other intelligible properties and meanings does not take place in time and space but is the making of spacetime itself.

Another central role on Barad's exposition is played by *discursive practices*. This notion has largely been inherited from Foucault and it is important to note that it does not refer to spoken or written language practices – that would be a 'mistake of representational thinking'[11] writes Barad – but to agential intra-actions that take place within phenomena as envisaged above. Just as language is not privileged here, equally humans only play a specific agential role in these intra-actions alongside other components. Barad proposes 'a posthuman refiguring of the nature of materiality and discursivity and the relationship between them, and a posthuman account of performativity'.[12] Discursive practices are involved in the articulation of positions, of the possi-bility of production of subjects and objects, the emergence and circulation of

knowledge and configurations of boundaries, properties and meanings. Thus discursive practices are an ongoing dynamic performance which defines what meaningful statements are possible and makes way for them to be enacted (for example through thinking, calculating, measuring, filtering and so on) through agential intra-action of components in the phenomenon. Just as the phenomena here differ in definition and operation from those of Kant's philosophy, so the discursive practices differ from Kant's a-priori conditions by being immanent and socio-historical rather than transcendent conditions of experience. Barad also draws on the similarity between Niels Bohr's conception of an 'apparatus' as a set of local conditions that enable and constrain knowledge practices, and Foucault's conception of discursive practices.

It is only finally, having set out at length, patiently, and with a deal of complexity, this model of epistemology and ontological realities that Barad can return to her original quest, to show us how matter matters, how matter is a feminist issue, and how matter in this understanding is not a property but a becoming, a doing, a congealing of agency. For the separation of knowing and being – seen in one of its most extreme but 'central' forms in the Cartesian mathematical model of the world extended out there – assumes, as Barad writes, 'an inherent difference between human and non-human, subject and object, mind and body, matter and discourse'.[13]

If that initial aim of Barad's, to show that the power of language has been too substantial and that matter matters, seems, literally, a down-to-earth intention then the result could nonetheless hardly be said to be the new commonsense of the post-Relativity understanding of time and space as envisaged by Cornford. Is that even such a bad thing though? Certainly Barad seems to understand a certain type of value and to use the notion of commonsense in the pejorative, as when she dismisses representationalism as, 'Representationalism is so deeply entrenched within Western culture that it has taken on a commonsense appeal.'[14]

The power of such a criticism here by Barad seems to depend on connotations of the 'traditional', of the prejudiced, and perhaps the complacent, and even the superfluous, which might attach to the use of commonsense. Of course that pejorative judgement need not necessarily be the only one applicable. If we look again to the critique of Benjamin and Panofsky on cinema, we see the description of an effect of cinema as a new art which could fit the bill as a developing spatial commonsense in a positive way, inasmuch as new awarenesses, perceptions, engagements and understandings of space and time and their interplay were being enabled and becoming commonplace among the general population. Can Barad's seriously worked through, but difficult and abstruse intellectual exercise really make a dent in representationalism as a widespread – or commonsense – mode of apprehending reality? To be fair, that is not really her aim if she is publishing in the journal *Signs: Journal of Women in Culture and Society*, and it is unlikely that a film of the work will appear in cinemas any time soon ... Then again, any piece of sound scholarly

critical work can stand on its own disinterested merit, and there is no obligation, perhaps not even any intention, to have a range of impact extending as broadly as the culture of popular entertainment and everyday life. Besides, as Ravi Sundaram tells us, wasn't the new commonsense of space and time as propagated by cinema soon co-opted as a corporate agenda by the media to mesmerise the masses with spectacle? We can be reasonably confident that the 'irruption' of the original and authentic statement of Barad's conception of how approaches to knowing cannot be separated from those of being in any full and proper understanding and engagement with the world will ensure that it influences much further work in the Arts and Humanities, and is not about to be parodied and prostituted by pioneers of the new spatial and temporal frontiers of the entertainment industry.

Notes

1 F. M. Cornford, 'The Invention of Space', in M. Čapek (ed.), *The Concepts of Space and Time*, Springer, 1976, pp. 3–16, at p. 5.
2 Erwin Panofsky, *Three Essays on Style*, MIT Press, 1995, p. 96.
3 Walter Benjamin, 'Art in the Age of Mechanical Reproduction', in *Illuminations*, trans. Harry Zorn, Schocken Books, 2007, p. 236.
4 Ravi Sundaram, 'Aesthetics, Technological Politics and the Video Age', undated, www.thedrouth.org/aesthetics-technological-politics-and-the-video-age-by-ravi-su ndaram, accessed 24 October 2020.
5 Karen Barad, 'Posthumanist Performativity: Toward an Understanding of How Matter Comes to Matter', *Signs: Journal of Women in Culture and Society*, 1 (Spring 2003), pp. 801–31.
6 Ibid., p. 829.
7 Ibid., p. 803, note 3.
8 Ibid., p. 801.
9 This is an oft-seen mistranslation of 'there is no outside-text' in Jacques Derrida, *Of Grammatology*, trans. Gayatri Chakravorty Spivak, Johns Hopkins University Press, 1976 (French edition published 1967), p. 159.
10 Jean Baudrillard, *The Gulf War Did Not Take Place*, trans. Paul Patton, Indiana University Press, 1995.
11 Barad, p. 819.
12 Ibid., p. 818.
13 Ibid., p. 829.
14 Ibid., p. 806.

Posthumanism

On 'Posthuman Humanism' by
Rosi Braidotti (2013)

Rosi Braidotti has been described – and described herself – as a New Materialist. The standpoint could be defined as of one who is philosophically a monist (Braidotti uses the adjective 'monistic' at several points through her text here[1]) and rejects the long-ingrained Western habit of dualist thought of the types material versus mind, subject versus object, nature versus culture, and so on. In fact, it is probably a position she shares with most, if not all, of the contemporary essay writers discussed here, with Karen Barad and Denise Ferreira da Silva perhaps the most notable for their intellectual presentation of the case for material and against dualism. Of course, the rejection of transcendentalism and dualism is not a new thing in western thought, and has featured strongly and historically in the work of Heraclitus, Spinoza, Hume, Nietzsche and Bergson to mention just a few. From more recent work, the New Materialists could also have taken influence and inspiration from Deleuze, who claimed that this monist tradition is a minor one, and that these thinkers cited above had been neglected to a certain extent by the 'mainstream'. Given Braidotti's aims here though, it is not clear how useful or relevant it is anyway, to refer her to a tradition which, even if not absolutely orthodox, is nonetheless all European, all white, all male. Those aims of this essay, set out by Braidotti at the beginning, namely to assess the constructions of the human, of the idea of the Human at work in the Humanities, may appear simple inasmuch as they are surely part of a straightforwardly conscientious procedure expected of any professional in their field. Yet actually, a moment's consideration can bring home to us how, in her field, the rethinking of the concept of the human entails a massive epochal and constitutional paradigm shift. Indeed, this essay alone appears to address several questions simultaneously and all of great import and of varying depth and range into and across the field. The essay turns out to be part history of the field of Humanities; part diagnosis of the perceived failings and harmful aspects inherited; part analysis of how the various components fit together and work; part critique of these workings and of its relations to its others; part suggested therapy to bring about change in existing components; part prescription of new directions which ought to be taken; and part rallying cry to keep the humanist faith despite all the rest. Braidotti criticises the Humanities

DOI: 10.4324/9781003186922-6

for its 'entrenched bad habits' and calls for change, writing that there is a lack of 'epistemological self-reflexivity' which is an obstacle to any change.[2] Simply by engaging in this quest, in submitting the field to those various types of reflexive interrogation as here above, it appears that she herself has performed a major push towards the epistemological turn she calls for.

For the idea of the 'human' – the image of 'Man' in the Humanities – has historically been that of the Eurocentric white male (that is, where Europe is seen as purely a rational and civilising power in the world). This is, of course, precisely the rational, male, upper class, colonial European as figured as a worthy essay writer by Hume (cited in the introduction). Central to this 'motor' and cultural logic of Humanism is the dualistic system which always privileges one side (e.g. mind over matter, culture over nature etc.) and sees difference from the 'norm' as 'pejoration'.[3] In a paragraph which could be describing Hume's essay writer, Braidotti writes:

> By organising differences on a hierarchical scale of decreasing worth, this humanist subject defined himself as much by what he excluded from as by what he included in his self-representation. Subjectivity is equated with consciousness, universal rationality and self-regulating ethical behaviour, all of them equating masculinity and European civilisation, whereas Otherness is defined as negative and specular counterpart: irrationality, immorality, femininity and non-westernness.[4]

Braidotti's essay thus engages in a pragmatic setting out of the space where a rethinking of the human subject for the Humanities in our own multi-ethnic, post-feminist, digital age can take place. This call for an epistemological turn to examine the ways that the Humanities construct 'the human' is, of course, not unrelated to Karen Barad's work on how 'we', as *of* this world, can know, or otherwise have access to apprehend, engage with matter, and how it matters. Barad is examining those deep underlying structures of reality by phenomenological method in a purely philosophical sense, understanding from the disciplinary precepts of both moral and what used to be called 'natural' philosophy (physics) that the being of a thing cannot be separated from our ways of knowing it. (hence Barad's term *onto-epistemo-logical*). Braidotti's work has a slightly more utilitarian concrete political reach inasmuch as it looks to find an appropriate socio-historical contemporary reality of knowing and understanding the human which is just and equitable in all its applications across the Humanities. Thus Braidotti's essay, unlike Barad's, does not give us a detailed step by step unravelling of the phenomenology of the human, but looks at what have been the consequences of certain understandings, and why and to what effect thinkers, movements and politics have mobilised 'schemes of thought and figurations'.[5]

Instrumental in loosening the grip of the paradigm of the rational Eurocentric white male standard definition of the human have been various

historical developments which Braidotti gathers under the rubric of anti-Humanists. Prominent among these were the post-structuralist thinkers and philosophers who were especially active in the lead up and aftermath to the events of 1968, which social upheaval brought about great changes in French academic culture and French life in general. In association with this movement, she mentions Michel Foucault and Jacques Derrida, and much work was done in exposing the arrogant and unavoidably oppressive – not to say fascist – tendency of the totalising nature of Western Enlightenment rationality in the light of the atrocities perpetrated by the west in the form of Hiroshima and Auschwitz.

Braidotti also points to the work of feminists – specifically French intellectual Luce Irigaray – whose critiques not only stem from women's othering by that standard male white model but to the patriarchal posturing entailed which is 'objectionable not only on epistemological grounds, but also on those of ethics and politics'.[6]

Anti-colonialists and post-colonial thinkers are also grouped together as part of the anti-humanist movement. Fanon, Spivak and Said are named in rejecting the contradictions of the aims of the Western humanist model, and the inhumanity of the reality of the west's 'drive to mastery'[7] in the Global South (for definition see de Sousa Santos) via the claim to a universal and scientific rationality.

Finally, from within the disciplines, but breaking out from the straightjacket of those 'traditional' models of the human Braidotti describes how over 'the last thirty years' (she was writing in 2013) new interdisciplinary research areas identifying as 'studies' – 'gender, feminism, ethnicity, cultural, post-colonial, media and human rights' studies, critiqued the Eurocentric and male-centred model.[8] This critical atmosphere is symptomatic of the post-humanist predicament writes Braidotti, where Foucault's death of 'Man' exposes the theretofore flaw of structural anthropomorphism and the models of the Humanities, and the methodological nationalism – where education, disciplines, funding, research fields, objects and boundaries set at national levels is also viewed as problematic.

If this anti-Humanist front as described by Braidotti shows how change in the Humanities models of the time arose via attack or critique from within, as it were, then she goes on to show how the very environment, and the external objects on which the Humanities work in effect also contributed to the forces for change. Braidotti refers to this phenomenon as postanthropomorphism, and where anti-Humanism is usually driven, as per above, by traditional humanist methodologies and mobilisations, postanthropomorphism often has a greater science and technology influence on it – earth sciences, biogenetics, media, cybernetics and robotics. Braidotti describes how advanced capitalism, unlike the undifferentiated, unisex, rational Europe-only model of the 'traditional' humanities, 'actually produces differences for the sake of commodification'.[9] It is in fact a producer and multiplier of differences which are 'packaged and

marketed under the labels of "new dynamic and negotiable" identities' and endless proliferation and choice for consumption.[10] Thus, as Braidotti, writes, from 'fusion cooking' to 'world music'. The obvious avatar of this latest type of totalising control is Foucault's concept of biopower. It is characterised by the state's control of subjects through a range of techniques with the ability and power to direct and regulate their actual bodies in space and can be visualised in the architectural model of Bentham's Panopticon prison of which more is said above in the chapter on Rem Koolhaas's 'Junkspace'. We can also draw attention here to Paul B. Preciado's analysis of the pharmacoporno-graphic regime whereby our bodies are manipulated simultaneously by big Pharma and the porn industry. That is to say that via the normalisation of the use of Viagra and the contraceptive pill, porn, sex toys and other techniques then appetites are synthetically created which allow for enabling, empowering and directing (sexual) energies in the subject. As Braidotti says of the corporate operation, it 'triggers a proliferation and a vampiric consumption of qualitative options' and the 'opportunistic political economy of biogenetic capitalism turns Life/zoe, that is to say, human and non-human intelligent matter – into a commodity for trade and profit'.[11]

Braidotti notes here that at the same time, while selling to, controlling and directing clients, big corporations are also gathering data – 'what constitutes capital value in our social system is the accumulation of information itself, its immanent vital qualities and self-organising capacities'.[12] The 'success of Facebook', as Braidotti puts it, is at the most banal level of this type of gath-ering information, and more can be read about the way big media giants use our info for manipulation and commercial gain through a reading of Shoshanna Zuboff's *Surveillance Capitalism* (2019),[13] and databanks of biogenetic, neural, and mediatic information can indeed be figured as 'the true capital today'.[14]

As capitalism for its own use reduces bodies to an informational substrate, so it is indifferent in its global operation to those differences and dualisms perpe-trated in the 'traditional' Humanist models, and indeed differences are levelled out and equivalencies found between life forms. This has broken down the particular dualism of bio/zoe, where human life (bio) was privileged over any other forms of life. There are theoretically then, no longer special rights and properties attached to the life of one species, and this is also seen in the type of interspecies studies pioneered by Donna Haraway, and seen here below in the work by Anna Tsing. Yet, of course, the breaking down of borders goes fur-ther, for Haraway was also a pioneer in studying relations between humans and the machine in her book *Cyborg Manifesto* of 1985. For feminist thinkers that book showed the way to a problematisation of traditional gender and feminist stereotypes through examination of the human interface with non-biological hardware. Our everyday interactions with the robotic, the digital, and with artificial intelligence leads us not only to question as Braidotti points out, our new relationship with matter, and 'what happens to subjectivity in this com-plex field of forces and data flows'[15] but also leads to a recrudescence of the

'two cultures' paradigm of the alienation and mistrust between the sciences and the humanities, as the latter strays into what appears as the territory of the former.

One aspect of the global economy that is particularly anthropocentric, according to Braidotti, is that in its unsustainable excesses which threaten the planet, it establishes a panhuman bond of vulnerability. This bond is strengthened through popular culture − in film and sci-fi through the use of the problematisation of ecological relationships and the practices of biogeneticism and robotics and digital culture. Ultimately then Braidotti shows us a scholarly culture where, as seen in her exposition of the posthuman and the post-anthropocentric, renewal of scope and engagements of the discipline have been imposed both from within and from the wider world beyond. This, she says, has led to a heterogeneous abundance of methodologies, approaches and discourses. Despite the apparent displacement and outrunning of the Humanities by the daily realities of advanced global capitalism however, she remains positive (as, incidentally, were both Fanon and Said for an extra-European renewal of the Humanities), and sees the use of new resources for the disciplines, citing exploitation of new media and technology and scholarship in innovative fields like animal studies and eco-criticism. This multiplicity and non-unified direction of the Humanities can no longer be organised around philosophy as the heart and master theory which judges truths and neither can the human be the unique subject of the posthuman Humanities, far less with 'Man' as that exclusive, universalist European rationalist with his dead certainties. As Braidotti puts it:

> Posthuman subjectivity reshapes the identity of humanistic practices by stressing heteronomy and multi-faceted relationality instead of autonomy and self-referential disciplinary purity.[16]

The irony is that with the 'epistemological turn'[17] which Braidotti thinks is necessary, she is asking precisely for that self-referentiality of and by the discipline, in order that it can overcome its introversion and isolation and, as mentioned above, clarify how things can be known and what are the conditions of knowing them rather than simply defining what is to be known. The subject of knowledge is thus already a configuring, a relational entity, a complex and dynamic assemblage of functions and positions, technologies and narratives. In other words, an understanding of knowledges made possible and actual by discursive practices.

Notes

1 Rosi Braidotti, 'Posthuman Humanities', *European Educational Research Journal*, 12(1) (2013).
2 Ibid., p. 11.

3 Ibid., p. 2.
4 Ibid.
5 Ibid., p. 15.
6 Ibid., p. 3.
7 Ibid., p. 4.
8 Ibid., p. 2.
9 Ibid., p. 6.
10 Ibid.
11 Ibid.
12 Ibid., p. 7.
13 Shoshana Zuboff, *The Age of Surveillance Capitalism*, Profile Books, 2019.
14 Braidotti, p. 7.
15 Ibid., p. 6.
16 Ibid., p. 9.
17 Ibid., p. 10.

Chapter 6

Companion species
On 'Unruly Edges' by Anna Tsing (2012)

Anna Tsing makes bold claims about the scope of her short essay here: there are 'big stories to tell'.[1] Yet she puts the claims with characteristic, if paradoxical modesty. Over the span of the work she could almost be said to develop a satire via botanical parody of the male/female, ideal/particular, mind/matter type dualisms that have riven Western culture with her posing of the power of the mushroom against the ear of wheat. Yet is there method in her mirth? We should perhaps not be surprised by Tsing's penchant in a scholarly essay to bring things down to earth and evoke the common touch, given that she adjoins her dedication to Donna Haraway to the very title of the piece. For Haraway's playful vernacular way with language, her ceaseless breaking of interdisciplinary boundaries (and especially the science-humanities rift), her unacademic mode of posing of her own bodily experiences and sensations as exemplary and as validation of standpoints, have trailblazed a feminist path to truths which were beyond the scope of the rational Humanist Man (the type discussed in the Braidotti chapter). To say that Tsing is under Haraway's influence and that she finds Haraway's style congenial may be simply to say one thing twice. Haraway was not only groundbreaking in her analysis of the human-machine and human-material relations (again, as described in the Braidotti chapter) but is a pioneer in what she terms (and Tsing cites) 'companion species'. In numerous publications Haraway has detailed how various other species of animals have shared social and personal engagements and history with humanity. It would be irresponsible (when species meet) she notes, to deny our tangled and intricate pasts, and examples of animals whose entanglements with us she deals with at length include pigeons and their involvement and use in imperial wars and in working class leisure; and dogs (including her own pet Cayenne) and their involvement and use in our discursive practices around geopolitics, nationalism, sex, gender and race. (think of the pure breed German Shepherd, Irish Terrier, English Bulldog, Scottie Dog and 'Lassie' etc.).[2]

Haraway is also aware of, and discusses recent philosophical forays into the concept of animality and the way of the animal, for example Derrida's short essay 'The Animal that therefore I am' and Deleuze and Guattari's concept of 'Becoming Animal'.[3] The remarkable thing is that Haraway can give rein to a

DOI: 10.4324/9781003186922-7

full theoretical discussion on Derrida's critique of the Cartesian rejection of the animal as a machine with no soul and his analysis with respect to Bentham's question 'does it suffer?', and also Deleuze and Guattari's symbiotic notion of 'becoming animal' as an access to different species' ways of knowing, while simultaneously – that is, in the same book – she gives full evidence of her folksy non-academic style, including a vivid description of her dog Cayenne's kisses, when 'her tongue has swabbed the tissues of my tonsils.'[4]

Much of this work on animals is covered in the field of one of those new posthumanist interdisciplinary 'studies' which Braidotti writes of as having arisen in the last twenty years or so; namely, Animal Studies. Donna Haraway not only pushes the standard universal and rational voice of academic enquiry into a totally personalised and even visceral one, dealing with her own insides (tonsils), but she also edges the consideration of the 'companion species' beyond that of the pet (her dog Cayenne) and far into the realms of another dimension than 'the animal'. In dealing with the depth, the history and the long-term effect of the phenomenon, she calls for an examination of human genomes and pathogens – which would reveal, she declares, a record of our companionship with other species. Again here, she is breaking down the 'two cultures' barriers. For at the qualitative level of a definition of what companionship might be, she manages to evoke Derrida while drawing for support on the theoretical structures of Karen Barad. (Can anyone read the word 'undecidable' in a literary context without thinking of Jacques Derrida?)

Companion species is a permanently undecidable category ...[5]

By 'species' here, Haraway explains, is meant an entity – singular or plural – that is not predetermined as 'artefact, landscape, machine, organisation or human being', but comes to its agency, its companioning 'intra-action', as Barad puts it, within a phenomenon, it works out, it performs, within a possible and ongoing set of intra-relations, positions and functions with other entities, what are the contingent dynamics of its operation.

If, as a biologist, Haraway calls for an examination of the 'phenomena' of companionship at the scale of molecular or genomic evolutionary history, then as an anthropologist, Tsing does her disciplinary equivalent by treating us to a social evolutionary history of the theme. In her typical deadpan manner – almost as folksy as Haraway – the history she gives us is one of overpopulation and the oppression of women (have these two ever been separable in Western history?) as a 'love affair between people and grains'.[6] That is to say that if fungi, and the mushrooms of her title are a foragers crop, and foraging does 'not require territorial exclusivity', allows us to learn about ecological relations, and to 'nurture landscapes',[7] then this essay is mainly *not* about such a nurturing companionship but one which has been, in Tsing's telling of it, a long term experience of reduction, assimilation and enclosure. This history is one of civilisation, and so the example of the mushroom is offered to us only as an enticing growth on the margins with an intriguing promise of alterity. Tsing puts it succinctly, 'Fungi are the enemy of monocultural farms and farmers.'[8]

For her story is actually that which is most usually abbreviated in the history class (and thus losing all the detail and original everyday human experience given in some part by Tsing) into the passage from the Palaeolithic to the Neolithic age. In other words, the shift in social pattern of human beings from hunting and gathering as a way of life (and of gathering fungi among other things …) to the settled life of cultivation and raising domestic animals. Thus, the development of agriculture. For Tsing, that, in turn, entails another word, this time cited from Engels as 'the world historical defeat of the female sex'.[9]

That's quite a lot of history to be getting on with in such a short article. How does that work out chez Tsing? It is the story of human companionship with grains, but unlike the Haraway story of companionship with dogs and pigeons, (and Tsing's with mushrooms) that companionship has a largely deleterious effect on humanity, and ultimately on planet earth. The stages of the story seem to follow roughly thus: in the first place she notes that in the Middle East from whence this civilisation first emerged, research shows that it is easily possible to make a good living from foraging from the large stands of grain which grow wild. The clichéd history tells us that there was greater 'convenience' and 'efficiency' to settled cultivation of these grains, but in fact scientific studies have shown it was more labour intensive and that the unique advantage of intensive cereal culture was that it can support elites.[10] Thus, as the late architectural historian, Bruno Zevi, put it, with settlement the former wandering tribes 'were subjected to a tribal chief, and the chessboard made its appearance.'[11] We see powerplay, patriarchy, hierarchies and elites emerge in these settled communities and, as Tsing points out, agriculture and the state arise together. It's worth noting the work of architectural criticism here because the spatial question and positioning (e.g. where we find and pick mushrooms and where we grow and harvest grains) is outlined briefly by Tsing. She also hints strongly – that is, prepares the ground – for the inside/outside and enclosure questions, which are inseparable from the consideration of the formation of elites and are discussed by both architectural writers here – Weizman and Koolhaas. At the very moment of settlement and foundation of the settled community (where the elite will settle and from where they will take charge), the sacred ceremony, notes Rykwert in *The Idea of a Town*, of ploughing the border/edge/limit around the settlement is carried out.[12] This ritualistic ploughed border between the inside and the outside marks where town walls will then be built to separate the privileged town dwellers from those outside. The symbolism of the use of the new technology – the plough as the instrument of agriculture – to make the limits of the civic and the seclusion of the elite is clear. It is no coincidence that the Chinese symbol for 'town' or 'city' is the same as that for 'wall'. Indeed we could journey from one end to the other over the greater extent of the earth's surface making the same sort of cultural discovery, for in the Slav 'grad', in Greek 'polis', in English 'town' and in Scottish Gaelic 'baile', the words for town or city are all cognate with the word for 'wall' or 'barrier' or 'fence' or some notion of enclosure in those languages, and hence

exclusion – the creation of exclusion, of an inside and an outside is seen as constitutional in the establishment of the town or significant settlement.

Tsing acknowledges that story, and in Barad-form, she tells the narrative of the phenomenon of grain cultivation from the 'inside' with formation of subjects in a grain-cultivating culture and a range of positions, interactions and effects, boundaries, properties and meanings arise. It is indeed, because, as Tsing writes 'Human nature is an interspecies relationship',[13] and not a neutral, disengaged presence apart from the rest of nature/the world, that their story can only truly be told and understood through 'diffraction' as related by Barad as a knowledge of the being of different entities via their effects on one another. Thus, the carbohydrate-heavy diet introduced by the culture of grain cultivation allowed women to have more children, indeed 'as many as possible' in order to support and work for the power of the elites and their representative in each household as the paterfamilias. The household as such becomes the unit of organisation of this culture, strengthened and made cohesive by 'love' whereby the woman/mother/housewife helps fix hygienic and love boundaries at the edge of the house. At this point, we as readers might want to cross-reference Tsing's opening sentence 'Domination, domestication and love are deeply entangled'[14] with Sara Ahmed's article discussed here on 'happiness', and it is also here where Tsing writes:

> For all its matriarchical possibilities it seems fair to call this interspecies love affair [with grain], echoing Friedrich Engels, 'the world historical defeat of the female sex'.[15]

It is then this self-contained unit of the family, which sets the limits of its cohesive principle of 'love' within hygienic, spatial and ethno-racial boundaries which is exported round the world as the model and, 'engine'[16] as Tsing calls it, for administering colonialism in the form of the plantation. As Achille Mbembe has said of the plantation as a colonial form which is closed and monadic, always privileging the interior, 'It is the constitutional denial that we humans co-evolve with the biosphere.'[17]

Tsing then turns her focus in particular on society in the USA as the vortex and power centre of this grain-culture colonialism. US publics, she asserts, learn to conceive of their domestic hygiene of loving family units as 'the good' as opposed to individualistic loners and destruction bearing terrorists who hate rather than love. It is, in turn, she says, this self-perception of 'goodness' that allows and equips them in their own eyes to 'make moral decisions for the whole world'.[18] Tsing's wry, deadpan commentary on that everyday moral reality opens up an apocalyptic panorama from the family living room.

> In protected homes across the empire, humans have been curled up in their armchairs with their pets and their species-simulated snacks to watch the destruction of the rest of the world on TV.[19]

Through her ironically light touch, the domestic becomes such a loaded concept that the very mention of the words 'living room' in relation to Tsing, makes the words themselves ring almost as sinister as their cognate German cousin 'Lebensraum'. For the culture of grain cultivation has, in Tsing's analysis, created a society which wields power and colonises, encloses and controls space to which it is the self-appointed moral gatekeeper,

Under this tutelage, our species's being is realigned to stop Others at home's door.[20]

In the meanwhile, as much on the edges of her essay, as in the world at large, fungi as 'biological and social diversity', as Tsing tells us, 'huddle defensively in neglected margins'. They flourish in 'agrarian seams', on the edges, between field and forest.[21] We are reminded here, in fact, of Ngai's analysis of the cute. There already exists, of course, a cultural profile of the mushroom and toadstool as cute objects – we might think of their representation in children's literature, as the natural furniture, as seats, shelter from the weather etc. – in the world of the fairies, for example. What could be more cute than the solitary mushroom on the edge of the field of uniform wheat cultivation, standing delicate and alone against the might of the agrarian USA? Tsing manifestly utilises that cute profile, discusses fungi as small, pliant, vulnerable, disempowered objects/beings which invite physical touching – but as with Ngai's description of the cute performance as a complex negotiation of power balance, the hard-edged, nasty, retaliatory side of fungi is also revealed to us. They are not only benign, for fungi have survived in radioactive Chernobyl, they can accumulate heavy metals, flourish deep in contaminated mines, and like the revengeful, aggressive objects Ngai describes, they can be lethal and poisonous to humanity. Fungi could indeed be seen as the lone terrorists working to the destruction of the goodness of the wheat field. So, while Tsing offers up the biodiverse, and the species companionship of the fungi as a possibility counter to the closed monoculture of grain dependency, she reminds us that this 'is no place to search for utopia'.[22] We are, in fact, granted by Tsing a special insight into that dialectic of the cute as described by Ngai. For we see it here in the figure of the mushroom as, in effect, the system of moral hygiene, where we are invited to intervene in the world's becomings, to range, discern, judge and engage as subjects with the play of power and possibilities, rather than just curl up in our armchairs at home with our pets, our snacks and our TV, while the 'other' is locked outside.

Notes

1 Anna Tsing, 'Unruly Edges: Mushrooms as Companion Species', *Environmental Humanities*, 1 (2012), pp. 141–54, at p. 141 (from the abstract).

2 Donna J. Haraway, *When Species Meet*, University of Minnesota Press, 2008; Donna J. Haraway, *Staying with the Trouble: Making Kin in the Chthulucene*, Duke University Press, 2016.

3 Jacques Derrida and David Wills, 'The Animal that Therefore I Am', *Critical Inquiry*, 28(2) (Winter 2002), pp. 369–418; Gilles Deleuze and Felix Guattari, *Capitalisme et Schizophrenie, L'Anti-Oedipe*, Éditions de Minuit, 1972.
4 Haraway, *When Species Meet*, p. 16.
5 Ibid., p.165
6 Tsing, p. 146.
7 Ibid., p. 142.
8 Ibid., p. 147.
9 Cited by Tsing, p. 146.
10 Tsing, p. 145.
11 Bruno Zevi, *The Modern Language of Architecture*, Australian National University Press, 1978, p. 20.
12 Joseph Rykwert, *The Idea of a Town*, MIT Press, 1988, passim.
13 Tsing, p. 141 (abstract).
14 Ibid., p. 141
15 Ibid., p. 146.
16 Ibid., p. 148.
17 Achille Mbembe, 'Out of the Dark Night (Theory from the Margins)', www.youtube.com/watch?v=sWHYQ6CqP20 (accessed 7 May 2021).
18 Tsing, p. 151.
19 Ibid., p. 152.
20 Ibid., p. 151.
21 Ibid.
22 Ibid., p. 152.

Feminism and happiness
On 'Killing Joy' by Sara Ahmed (2010)

There might be a debate over the question for whom this essay was written, and by whom, in the sense of, what position does the writer take? It doesn't present – despite the title – as a history, and at some points the language definitely sounds the tone of an incitement or rallying call – 'We can learn … We must learn …'[1] Yet who is the 'we' that is being rallied? There are several contextual points we can note in considering the question but it's not clear how they stack up. Sara Ahmed reveals herself, her writer's standpoint, as a lesbian feminist woman of colour, and the essay is produced in *Signs*, an academic journal published by the University of Chicago, which styles itself by way of subheading as a *Journal of Women in Culture and Society*. Ahmed was an academic at the time of writing the article but became disillusioned and since then has left academia to become a freelance writer. It could be argued then, that some aspects of her position as a writer, of her construction of a persona, and of a collective 'we' for whom she writes are similar to another essayist examined here, Paul B. Preciado. Both Preciado and Ahmed are freelance intellectuals who had a long, profound and complicated experience with academia, and they could also both be said to be engaged in their work in the long queer struggle against heteronormativity.

Preciado makes some striking assertions about feminist history in the 'Amnesiac Feminism' chapter of their book *An Apartment on Uranus*. Like all other forms of subaltern struggles and minority resistance movements, writes Preciado,

> Feminism suffers from a chronic lack of knowledge about its own genealogy. It doesn't know its vocabulary, forgets its sounds, erases its voices, loses its texts, and doesn't have the key to its own archives.[2]

That is because 'history is written from the viewpoint of the conquerors'. Preciado invokes Walter Benjamin here, and calls on 'the conquered', or we might say, the losers in history, to rewrite history from their own point of view. That, Preciado continues, would be the only way 'to interrupt the time of oppression'.[3]

DOI: 10.4324/9781003186922-8

Ahmed shares much with Preciado's manifesto here, in terms of rewriting experience on behalf of those excluded, ignored or put down, but unlike Preciado she does not necessarily set herself up against a set figure of an antagonist with whom there can be no reconciliation. This might be where the amorphous, indefinite feel to her invocation of the collective 'we' comes in. Ahmed writes four times in this essay of being 'at the table' thus signalling participation in, or at least presence at a debate, even if often uncomfortable and under enough oppression there to be silenced as a killjoy feminist. Preciado, on the other hand, apparently has more of a separatist tendency, is often more inclined to be dismissive rather than engage with an antagonist – especially, for example, in the scenes described in the book *Testo Junkie*, albeit a semi-fictional tract. That tentative, unfinished business nature of Ahmed's narrative and the sense that she wants to bring 'us' (viz. 'we must learn') along with her, is also germane to consideration of whether her work here constitutes a history – either of that feminist type that Preciado believes is lacking, or indeed of any other type. Despite the subtitle ('history of happiness' – but was that specific wording an editor's intervention?), we realise that, in fact, Ahmed's work here is not only not a '*history*' of happiness but is precisely not about happiness either. It is instead, a critique of that possibility, and a proffering of an all too real feminist alternative of 'unhappiness'. Rather than a part of a 'history' indeed, it seems more appropriate to see this essay as an archaeological work, in the Foucauldian sense of drawing on elements and components whose position, functioning and relation to one another are emergent and certainly do not have an obvious chronological order. As the Italian poet Montale once wrote, history cannot be written until all the chronicles have been completed.[4] This view would be consistent with Ahmed's description of an active engagement, in terms of both shaping and drawing on archives which she calls 'unhappy archives', and which are assembled around the struggle against happiness. This archaeological work also involves her with the very Benjaminian constituency of losers and rejects to which Preciado refers.

> I thus offer a different reading of happiness, not simply by offering different readings of its intellectual history but by considering those who are banished from it or who enter this history only as troublemakers, wretches, strangers, dissenters, killers of joy.[5]

The concept of the 'wretch' seems particularly key in characterising Ahmed's approach here. She is careful to define a wretch again as 'a stranger, an exile, a banished person' yet she also writes that 'Feminists might be *strangers* at the table of happiness'[6] (my italics). Thus a tension is maintained here by not quitting or refusing to engage with the others' agenda because you are deemed a stranger to it, but by sitting on at the table, or as Donna Haraway might put it, by 'staying with the trouble'. Ahmed asks if we could rewrite the history of happiness with the agency of the wretch? For the wretch is *cast* as a wretch, it

is not something inherent in their essence. We can clarify the thrust of this point by looking to Judith Butler's assertion that 'vulnerability is not an attribute of the passive individual but a feature of social relations'.[7] So Ahmed's position is one of dissent rather than of exile. That is to say that while the social relations endured by the wretch, as she implies, are to be made unwelcome, marginalised, put down, and perhaps also resented, she nonetheless refuses to remove herself – or the wretch's rewriting – from the happy table where it happens that history is written.

It is significant that the metaphorical table in question is further particularised and indeed actualised as a dining table – for this is a domestic scene. The dynamic of happiness is used as a normative tool to ensure certain aims and positions are given priority in that domestic scene. Ahmed shows us how shades of strength in the formations of sharing an object of happiness, and having a fellow feeling for someone who has that object, can be identified as modes of distribution of power in 'the moral economy of happiness' in that domestic scene.[8]

Ahmed draws on both her personal experience and literary research to examine how it is that happiness operates to structure hierarchy in the family. She describes the awkward feeling as a daughter at the dining table in her own 'conventional family'. This, is in her case, not just because of disappointment over the banality of the reality of happiness – where, like a bride might feel on her wedding day, 'We cannot always close the gap between how we feel and how we think we should feel. To feel the gap might be to feel a sense of disappointment.'[9]

Ahmed as a feminist cannot and will not concur and comply with the familial consensus on happiness, in the face of the persistence of unhappy realities like sexism. The resulting restricted range of possible communions leave her 'at odds with the performance of good feeling' where 'happiness is sustained by erasing the signs of not getting along'.[10] In this atmosphere of 'rigid domestic ideology'[11] the feminist killjoy is perceived as being unhappy herself because she broaches unwelcome subjects and this brings dissensus and unhappiness – or as Ahmed calls this trope 'the myth that feminists kill joy because they are joyless'.[12]

By seeking out and researching literature on happiness and the place of women in the family, Ahmed is evidently breaching the very duties she finds outlined there. She reads Rousseau's *Emile* published in 1762 as an instructive discourse on how to educate a young man. Recommendations are also made there for the appropriate behaviour of a wife and a daughter. The recommendations include not giving way to curiosity and not indulging the imagination, which amounts to avoiding reading books in order to nourish happiness in the family. Ahmed sees these recommended points on female behaviour as serving to avoid a resulting nurturing of wider political consciousness 'not only of gender as a restriction of possibility but also of how the restriction was not necessary'.[13] She finds an aptly querulous expression of the

consciousness of that sexist restriction and its relation to unhappiness in the more recent text of the activist and writer Audre Lorde:

> Was I really fighting the spread of radiation, racism, woman-slaughter, chemical invasion of our food, pollution of our environment, and the psychic destruction of our young, merely to avoid dealing with my first and greatest responsibility to be happy?[14]

This focus in Ahmed's work on the 'trouble' in the domestic arena finds an intriguing parallel in the work of Anna Tsing as discussed above. While for Ahmed the domestic is constituted as an unbearably blinkered, self-perpetuating and exclusive environment, in Tsing it is the heart of a toxic invasion of all other cultures, human and otherwise spatial and biological. Yet while Tsing chooses to leave that source of trouble for a life on the feral margins creating an inclusive and healthy interspecies alternative which critiques the mono-cultural domestic from a proliferating outside, Ahmed stays on the inside and takes her critique to the table. In many ways, however, these positions are complementary, and unfold new discursive possibilities to the inside/outside problematic. There is an analogous role played by happiness for Ahmed and by love for Tsing in their understandings of that problematic. In their respective models, happiness and love are a type of shibboleth which guarantees entry to the interior. This phenomenon is also expanded by metonymy in both cases from the domestic as the household to the domestic as the nation. Where for Ahmed citizenship is ultimately a technique for ensuring a hierarchical assign-ment of happiness – ensuring, that is, a seat at the table – so for Tsing, love – a standard of US domestic intimacy, she notes – is the sign, the family sign, that marks the boundary of the home, where the Other who does not love (the terrorist, for example) will not be allowed to enter.

There is, of course, a long tradition in Western thought and domestic praxis of setting up an interior/exterior dualism where the interior is always privi-leged. We see this even in the retailing of the apparently scientific parable of Schrödinger's cat; for it is when it is closed in the interior that the cat, in our conception of it, enjoys its richer set of possibilities, unspoiled by a grim opening to the outside. A brief discussion is to be found above in the chapter on Anna Tsing of how this dualism plays out in patterns of human settlement both in the domestic and civic realms. Its most refined, or certainly its most ideological expression – the cat in the relativity box notwithstanding – is to be found in the seventeenth-century philosophy of René Descartes. Often con-ceived of and described as one of the foundations of modern European philo-sophy, its metaphysical standpoint of a separation between mind and body seems to parallel and provide intellectual grounding for the sort of exclusivity both Tsing and Ahmed see in the domestic realm. For Descartes the only true, authentic and sustainable existence is in thought, in the mind, the indivisible interior of the subject, because even if that thought is wrong or misled, it still

signals the existence of the subject who has thought it. In the meanwhile, the outside, or the extended beyond can only be experienced by the senses, which cannot be trusted as they might be tricked by some evil demon. The only reliable access we can then have to knowledge of the extended exterior is via the calculations and ideal conceptions of mathematics – *ideal*, as that science has, as per Euclid's axioms, no real content. As an essentially dead, depoliticized zone with no real content it can then be manipulated and exploited without effect on our real being. It is in the light of this foundational thought that we can conceive of the work of Tsing and Ahmed not just as 'revolutionary forms of political consciousness'[15] but as revelatory forms too. For that work exposes the inevitably dangerous – even apocalyptic – consequences of a certain habitual humanist mode of understanding the world and our role in it with regard not just to fellow humans or other species, but indeed to all the space that our operations make for us and them. The irony is not lost on the posthumanist however, when they read how Descartes carefully and sensitively describes his physical situation, the room he inhabits, his own body and the clothes he wears, how he heats himself by the fire. It seems the question of position, at the table, beside the fire, and how to pose one's very body from the domestic interior into the discourse on methods of knowing and being is just as vital to Descartes as it is to Ahmed. Yet all Descartes's preparation for these meditations ultimately leads to denial of the real existence of any of it, while Ahmed stays with it all rejecting the normative happiness, and so could be said, like the chorus in the *Oresteia*, to be suffering into truth.

Notes

1 Sara Ahmed, 'Killing Joy: Feminism and the History of Happiness', Signs: Journal of Women in Culture and Society, 35(3) (2010)., pp. 571–94, at p. 573.
2 Paul B. Preciado, *An Apartment on Uranus*, Fitzcarraldo Editions, 2019.
3 Ibid.
4 '*non puo' sorgere storia se prima la cronaca non le prepari i suoi documenti*'; Eugenio Montale, 'Cronache di una disfatta', in *Auto da fé: Cronache in due tempi*, Il Saggiatore, 1966, p. 30.
5 Ahmed, p. 573.
6 Ibid., p. 582.
7 Judith Butler, *The Force of Non-Violence*, Verso, 2020, p. 201.
8 Ahmed, p. 585.
9 Ibid., p. 581.
10 Ibid., p. 582.
11 Ibid. (quoting Gayle Greene).
12 Ibid., p. 583.
13 Ibid., p. 589.
14 Ibid., p. 590 (from Lorde, *The Cancer Journals*, 1980).
15 Ibid., p. 592.

The pharmacopornographic pandemic
On 'Learning from the Virus' by Paul Preciado (2020)

When he heard that the first marketed vaccine in late 2020 for COVID-19 was produced by big-pharma giant Pfizer, who also produced the Viagra brand of sildenafil in 1988, the coincidence would hardly have produced a bat of the eyelid in surprise from trans activist and philosopher Paul B. Preciado. Already, in the middle of that *annus horribilis* of disease, Preciado had been making the case that the global pandemic had created conditions for the consolidation, and the speeding up of the application of what he had already for a decade or longer been nominating as the pharmacopornographic regime. Variations of the case featured in several essays by Preciado in 2020, published in *El Pais* and *Art Forum* and elsewhere, and arguably the most powerfully concise form is to be found in 'Learning from the Virus'.[1]

Explications of the pharmacopornographic regime often take off from a consideration of its ground in and development of Foucault's concept of bio-politics as the series of strategies whereby human life processes are managed and controlled by authorities of power and knowledge. In Foucault's disciplinary society (-as discussed in the Koolhaas's 'Junkspace' chapter in reference to the Panopticon model) institutions control and organise and direct the behaviour of human bodies via disciplinary mechanisms like the drill, the rota, the timetable and so on. Thus, in the school all pupils' desks face the teacher and the class are trained in rote learning; in Barracks soldiers are drilled in formations and in marching manoeuvres, moving their bodies together in time and space; and in prisons, inmates' behaviour is regulated by locked cells and surveillance. The repetition of these behaviours leads subjects to adopt them and 'normalise' them, so that they internalise the mechanism and discipline themselves, as can be seen in Foucault's discussion of the Panopticon prison model in *Discipline and Punish*. Preciado describes how since around the 1970s we have been 'in the throes' of a metamorphosis from those forms of disciplinary and architectural control that were particularly characteristic of the industrial age, to 'forms of micro-prosthetic and media-cybernetic control.' In nominating a new developing strain of biopolitics as 'pharmacopornographic' Preciado is referring to the encouragement of proliferation of sexual desire, and the enabling of the enjoyment of pleasure and attainment of sexual

DOI: 10.4324/9781003186922-9

goals and satisfaction via widespread transmission of pornography in media and the availability and dissemination of pharmaceutical products – in effect, sexual micro-prosthetics – like Viagra and the contraceptive pill. As Preciado puts it:

> In the domain of sexuality, the pharmacological modification of consciousness and behaviour, the mass consumption of antidepressants and anxiolytics, and the globalisation of the contraceptive pill, as well as antiretroviral therapies, preventative AIDS therapies and Viagra are some of the indicators of biotechnical management, which in turn synergises with new modes of semio-technical management that have arisen with the surveillance state and the global expansion of the networks into every facet of life. I use the term *pornographic* because the management techniques function no longer through the repression and prohibition of sexuality but through the incitement of consumption and the constant production of a regulated and quantifiable pleasure.[2]

The fundamental difference then, in the pharmacopornographic regime from the disciplinary, as regards the biopolitical management of the subject, is that the body no longer inhabits disciplinary spaces where power acts upon it, but it ingests or otherwise absorbs (in the case of the pornographic film), and thus is inhabited by disciplinary space. With the COVID-19 enforced lockdown in countries across the globe, the trope of the 'interior' as the place where control was micro-managed and played out will take on a special role and significance here, but even in Preciado's earlier works the significant subjective narrative scenes are nearly always juxtaposed as taking place in domestic interiors in contrast to the chapters of public and socio-political theorising in unspecified space. Nevertheless, his conscious and critical assertions on the concept of the interior, when abstracted from the subjective narrative 'action', remain ambiguous. He can state for example, that 'our apartments are the new cells of biovigilance' while asserting of the actual subject that 'there is nothing to discover in sex or in sexual identity: there is no inside.' These statements are, of course, not necessarily contradictory, referring respectively to the trajectory of an operation and to the space in which that takes place. The concept of 'inside' is complicated further when Preciado asserts of the pharmacopornographic management of life in *Testo Junkie* – and in chiasmatic reference to Rem Koolhaas – that it is 'an architecture that transforms inner space into exteriority and the city into interiority and junkspace'.

If anything, we can understand that in the production of subjects via stimulation of desire, and supply of pleasure, the potentially inexhaustible stores of that pleasure outpace any need or even possibility for economic organisation or management, where economic is understood in that classic sense necessary for the disciplinary order of the industrial era, as the deployment of *scarce* resources towards ends. As McKenzie Wark points out, there is no possibility

of ownership of desire, no scarcity, and as 'sharing multiplies desire' it is end-less and bountiful.[3] Hence the complexity of configurations of space for its management must be topographical rather than economic.

That complexity of spatial configurations and relations and the figure of masturbatory solitude which is conjured for us by Preciado stands in an odd and provocative contrast to Ahmed's at-the-table interior inhabited by an evident plurality of domestic antagonists, and makes us wonder what, if any, is the relationship between pleasure and happiness. Is it that happiness turns its smiling face to the crowd and pleasure its groan to the wall? Preciado's book *Testo Junkie* was originally published in his native Spanish, and other works like his essays have been written or originally published in French (*Apartment in Uranus*). With the inexact lexical mapping of translation in mind then, we might get more purchase on that relation between happiness and pleasure if we think of the latter in terms of the French concept of 'jouissance' which has no direct equivalent in English, and in its Lacanian use it reaches beyond simple enjoyment and delight to include its seeming opposites in angst, pain and suf-fering – which seems significantly more aligned with the full experience of sexual desire and pleasure.

With its global spread, and the consequent introduction of measures like self-isolation and quarantine, the COVID-19 pandemic immediately revealed to the world at large some realities of biopolitics at work in managing rela-tionships between space, the community and the individual body. Preciado tells us how, just as Foucault lays open the truth that all politics are a politics of the body – of creating physically existing subjects – so the dead spots and inhumane prejudices of any political system are always exposed pathologi-cally – in other words, all communities get the plagues they deserve. This direct connection between the *social* body and disease is codified etymologi-cally in the cognate relationship between *community* and *immunity*. Preciado points to work by philosopher Roberto Esposito highlighting the fact that the root -*munus* means 'duty' or tax and is related to the 'privileges' enjoyed by organised society.[4] Hence com-munity consists in those who enjoy the duties and privileges proper to social inclusion, and the hierarchisation of that com-munity is constituted by the im-mune, who are those who enjoy the privileges without having to pay the duties. Equally the non-English native word 'de-munised' would apply to those who are excluded from the privileges (e.g. those lower classes who are excluded from protective rights, and, for example, have to work in supermarkets during lockdown). The fact that the word 'immune' originally carries civic rather than medical meaning is significant. Preciado cites Emily Martin stating 'The body's immunity is not a biological fact independent of cultural and political variables'. At no time was this made clearer than when the western governments were able to jump to the front of the queue in ordering stocks of the newly released Pfizer vaccine, and administering programmes establishing priority categories of their populations who would receive it. Indeed, the public vaunting of their power to do this

(particularly by the then, spectacularly insecure, Brexiting UK) was dubbed 'vaccine nationalism'.

As noted above, Preciado implies that the COVID-19 pandemic accelerated a social mutation that was already underway. Just as the form of any pandemic is shaped by the social and political formations which give it room to flourish – every society gets the pandemic it deserves – equally the measures which are adapted to confront and manage the epidemic are always a staging of the 'community', in that they reveal who is valued – the immunised – and who is excluded – de-munised. Preciado backs up his case here with evidence from history. The syphilis pandemic from the sixteenth century brought on obsession with the sanctity of monogamous bourgeois conjugal rights and injunctions against cross class and race mixing, and marriage to immunise the sovereign class against infectious inferiors. Equally the AIDS crisis of the 1980s saw widespread introduction of a series of immunising surveillance techniques and hygienic regulation codes covering sexual practices (such as the wearing of condoms) and the exclusion from the healthy community of dangerous others, including homosexuals, prostitutes, drug users and populations of the Global South.

Pandemics thus expand to the whole population regulations and control measures which up to the moment of their eruption are applied only to those excluded from the community. Over the last decade or so, the west has been closing its borders to the rest of the world. Some aspects of this development – like Trump's showboating propaganda strategy for promoting the impossible construction of a complete and effective frontier wall between USA and Mexico – have undoubtedly been scare tactics to radicalise the population and bring them in behind the exclusionary agenda (the sort of thing seen from so many classic and dangerous rabble-rousing dictators like Hitler). In his writing on frontier Walls and on Borders, philosopher Étienne Balibar sees the pro-liferation of such walls around the world like some sort of pacifier for the would-be securitised populations and asserts that ironically they 'testify for an irreversible decline of actual sovereignty'.[5] These walls do not in fact stop migrations, they only make them more difficult and thus cost more lives. Nonetheless, the building of an actual wall in Israel/Palestine and the effective creation of military guarded death traps in the Mediterranean and the English Chanel to prevent ingress of desperate extra-communitarians (who risk their own and often their children's lives in wild attempts to cross the high seas to gain even the despised and oppressed status of asylum seekers or refugees in the lands of plenty) seek to keep the West immunised to the precarious human existence in the Global South.

For Preciado the COVID-19 pandemic effected a sudden leap in the logical progression of the virtualisation of the exclusionary practices of this society as outlined above. The regulations and control measures did indeed 'expand to the whole population', as the lockdown shifted those barriers and unassailable borders back to the front door and indeed on into the interior where every connected individual is sealed-off in #stayhome isolation. This reminds us, in a

way, of course, of Anna Tsing's pre-covid description of the domestic USA scene as where humans 'have curled up in their armchairs with their pets and their species-simulated snacks to watch the destruction of the rest of the world ...'. In a slightly less apocalyptic if still very worrying take, Balibar reads this merging of the interior with the limit as a point where the difference between juridical and the political – or to put it in other words, citizenship and subjection – become indiscernible.[6]

In Preciado's terms this new #stayhome immunitary community is immunised from the others outside because they do not have skin. That is to say that they do not touch goods with bare hands, they do not pay with cash but shop remotely by card, they have no face as it is hidden behind a mask, and cybernetic prostheses – Facebook, Instagram, Zoom – mediate their social engagements. The excluded from this skinless, faceless, untouchably immune society include those who are deemed unable to adapt to a digital age: the old, the sick, the lower classes, the immigrants. In fact, Preciado sees those involved in wage labour as in a type of confinement to physical space, where they and only they, touch and are touched by dangerous actual things.

When Preciado states that long before COVID-19 a process of social mutation – to the pharmacopornographic regime – was already under way, his researches go back farther and to more unlikely places, than one might imagine. The difference between quarantine for COVID-19 and for other previous plagues is that with COVID-19 it is not just a case of confinement of the body to the domestic interior, but that interior also becomes the centre of 'production and consumption and political control.' In his doctoral work Preciado found an early model for this operation in the management of a porn empire by Hugh Hefner from Playboy Mansions. For nearly forty years, Hefner more or less ran his porn empire (which itself was only possible because of the contraceptive pill) from his bedroom – his 'pharmacopornographic cell' as Preciado calls it – addicted to amphetamines and communicating and organising his vast business via early video connections, telecommunication devices and networks.

The real significance and importance of the Hefner/Playboy example though, is that it stands as an illustration – along the lines of the Foucauldian model – of how power networks develop and come into control usually not by the devious supra-management and methodical planning of some supremely evil one (like Descartes's 'evil demon of utmost power and cunning') but by the coming together of a series of historical possibilities, necessities and chances through time as a 'blueprint'. Preciado already felt the need to stress at the beginning of this piece that although the hypothesis is that epidemics are social constructions rather than biological phenomena, this take is in no way related to the currency of the type of conspiracy theories which claim the virus to have been manufactured specifically as a tool for some planned authoritarian power grab. The Hefner case, with its at once mildly risible and distinctly sinister operation via a clunky concatenation of wannabe futuristic – but to our

current-day eyes obsolete, inefficient and just odd – devices, demonstrates precisely – as a harbinger for the virtual age – how the blueprint of power operations comes together from a series of less than obvious (and often unlikely) heterogeneous forms and contents. And it is, for most of us, only retrospectively that there can be seen to be an inevitability – far a less a plan by a central authority – about these developments. That's not to say that power is not involved in making decisions and in choosing the paths of these developments, but generally power operates along the possible channels that open up for it (thus the personal computer coming together as a technology gradually through developments from its avatars in radio, stereo sound systems, television, video cassettes etc) to gain its ends – for better or worse – and not at a meta-level of evil control always for the worst of political ends.

It is nonetheless, alongside this most illustrative study of how the blueprint of the workings of power comes together that we come to surprise and wonder at Preciado's sudden and unexpected closing conclusion. As a reaction to this new virtual confinement to the interior, isolated from the world Preciado calls on us to 'turn off our cellphones' and 'disconnect from the internet'. From a critic, artist, philosopher and activist who had always apparently gloried in the anarchical taking of the tools of the pharmacopornographic regime into their own hands – his self-administering of testosterone in *Testo Junkie* – and in the detourning of the porno world to his own particular ends, this seems on the face of it, an incongruously Luddite incitement. No doubt the Luddites got a bad name and their own closing down of the machines – as analysed at length in writings by E. P. Thompson and Eric Hobsbawm[7] – was in fact, part of a complicated range of mobilisations and tactics for engaging with power on their own terms comparable with the phenomenon of hacking in our day, and could likewise, in a sympathetic light, be described – as Preciado describes his advocacy for switching off – as revolutionary. Beyond that 'switch off' however, Preciado doesn't proffer here any other advice or outline for counter-mobilisation.

Notes

1 Paul Preciado, 'Learning from the Virus', *ArtForum* (May/June 2020), www.art forum.com/print/202005/paul-b-preciado-82823.
2 Ibid.
3 McKenzie Wark, *General Intellects: Twenty-one Thinkers for the Twenty-first Century*, Verso, 2017, p. 232.
4 Roberto Esposito, *Living Thought: The Origins and Actuality of Italian Philosophy*, Stanford University Press, 2012, p. 256.
5 Étienne Balibar, 'Reinventing the Stranger: Walls all over the World, and How to Tear Them Down', *symplokē*, 25(1/2) (2017), pp. 25–41.
6 Ibid.; Étienne Balibar, 'At the Borders of Citizenship: A Democracy in Translation?' *European Journal of Social Theory*, 13(3), pp. 315–322.
7 See E. P. Thompson, *The Making of the English Working Class*, Penguin, 2002; Eric Hobsbawm, 'The Machine Breakers', https://libcom.org/history/machine-breaker s-eric-hobsbawm (accessed 4 January 2021).

Epistemologies of the Global South

On 'Public Sphere and Epistemologies of the South' by Boaventura de Sousa Santos (2012)

The clarity and level-headedness of Boaventura de Sousa Santos's prose and vision – even in translation – makes for a pleasurable experience of enlightenment, but given his topic, it must bear a ballast of paradox. De Sousa Santos, professor of sociology from Coimbra in Portugal has the Global South for his field, and the thrust of his research is to make clear how and why Western knowledges and approaches to political, economic and social developments have neither the right, the awareness, nor the know-how to claim effectiveness in that field (which makes up most of the contemporary world in physical extent and population).[1] You might expect, that is to say, that proceeding in such a task resembles nothing more than digging your own grave.

De Sousa Santos has been much influenced by Marxian thought, meaning that he has read Marx as vital social theory rather than as a revolutionary guide. That influence is interesting at a fundamental level not least because his attitude and operation in his field of the Global South seem to form a chiastic inversion to that of Marx. On 10 June 1853 Marx famously wrote approvingly of the historical role of the British Raj in the *New York Daily Tribune*, commenting that despite England's 'vilest interests' and 'her manner of enforcing them', she was with her Empire 'the unconscious tool ... of social revolution' in India. In the current day for de Sousa Santos, it is despite their best intentions that the interventions of Western ideas and methodologies imported from Global North have harmful effects on political and social ecologies of the South. Of course, Marx's specific ideas about the effects of British Imperialism on India emerge as more nuanced in his later more mature publications, but nonetheless they did not go uncriticised by many of his followers, by political and cultural commentators and analysts, and by academics. Perhaps most notable amongst the criticisms of Marx's Eurocentrism in this regard was the specific charge of 'Orientalism' levelled at him by Edward Said. Yet if 'Orientalism' in Said's construction of that enormously influential postcolonial concept means something like observing, judging or acting upon the non-Western world with a mentality imported from the West, and which views the non-West as a distorted version of itself and its own imagination then we might wonder if de Sousa Santos is really saying anything that is new? Is his

DOI: 10.4324/9781003186922-10

critique of the appropriateness of Western models for the Global South not merely a re-invention of the *Orientalism* of Said, first published in 1978?

The characteristic which distinguishes de Sousa Santos's work from Said's, in fact, seems to lie in the relation of thought to action, or, theory to practice which is one of the main themes of this essay, and which is not unrelated to the question of precision and clarity in de Sousa Santos's work in general. He is a writer and an academic, it's true, but his engaged political practice includes being a founder of the World Social Forum, which works collaboratively in and with the struggle for global social justice with the specific belief that there is no social justice without cognitive justice. In other words, there are many different kinds of knowledges which are valid and co-exist in different places and situations and one type of knowledge can only dominate and exclude others to the detriment of social justice (i.e. Eurocentric colonial knowledge and practice). For de Sousa Santos, decolonisation, the necessary – if negatively focused – process of liberation from colonial and colonised mentality (which has entailed both ontological degradation of many peoples and 'epistemicide' – a killing off of the knowledges of the vanquished and colonised peoples – 'the losers') still leaves the problem of what must positively replace 'colonialism', what new understandings and knowledges? In this proactive philosophical and pragmatic position we can specifically see the influence on de Sousa Santos of Marx's dictum: 'The philosophers have only interpreted the world, in various ways, the point, however, is to change it.' (De Sousa Santos actually cited this final line of Marx's eleventh thesis on Feuerbach in a talk he gave to Nelson Mandela University in South Africa on 4 June 2020.[2])

It is in the step towards opening up the possibility of action or actions in specific places, of recovering, reconstituting or reconfiguring particular knowledges, that de Sousa Santos's commitment to precision can be appreciated. In this article he is addressing a readership from or with an interest particularly in Africa, and he is dealing specifically with the social theory of the 'Public Sphere', originally developed by Habermas, and applied widely in the Global North. Beyond the particularities of this essay however, de Sousa Santos carefully establishes a definitional clarity in every concept he uses, such that the otherwise most vague and obscure terminology is immediately rendered operative– for example, the Global South ('not just a geographical concept'[3]), the Abyssal Line[4] and Epistemologies of the South.[5] Our attention is drawn to this relationship of critical theory to action however, only when de Sousa Santos raises the question of the inadequacy of conventional theory for addressing contemporary problems of development, democracy and so on, entailing the necessity to supplement and qualify the ample set of nouns with adjectives – e.g. *radical, participative* or *deliberative* democracy. This might in some way seem analogous to Braidotti's description of how a broad range of studies (gender, ethnic, etc.) have appeared in academia to supplement and adapt the disciplines in the Humanities to new realities. De Sousa Santos doubts, however, if these qualifiers of original Eurocentric conceptions can

solve the problem of adapting Eurocentric conceptions, like 'public sphere', in working for social emancipation in the Global South. Furthermore, the most progressive struggles have often been organised by grassroots and non-metropolitan groups, writes de Sousa Santos, whose relationship to theory and political organisation has not been regular, traditional or orthodox by Eurocentric standards. The spontaneous, innovative variety of emancipatory practices adopted on the ground and on their own terms in the Global South (e.g. by the Zapatistas, ATAC, and landless movements in Brazil), have, in turn, called on post-rationalisations and heterogenous concepts and analyses that serve the needs of the moment and subvert the order of critical theory and progressive struggles first worked out at length and established as orthodoxy in the Global North (de Sousa Santos specifies, in Germany, England, France, Russia and Italy). This has led to mistrust and scorn from the traditional and Eurocentric left who perceived such pragmatics as 'opportunist rationalisations or rhetorical exercises'.[6] (De Sousa Santos claims that such an attitude was prevalent at first in relation to the work of WSF) Meanwhile, just as the grassroots activism of the Global South (e.g. of the WSF) is invisible to Western theory, then those activists have come to mistrust and do without any dependence on, or feeling of obligation to renovate or otherwise engage to dialectically adapt that critical tradition. The resulting problematic between theory and practice is summed up neatly by de Sousa Santos in a way which, somewhat ironically, calls to mind Kant's dictum on the relation between intuitions and thought.[7] De Sousa Santos calls it a 'phantasmal relation', and writes 'from the point of view of theory, theoretical bricolage never qualifies as theory; from the point of view of practice, a posteriori theorisation is mere parasitism'.[8]

Although this essay has as its ostensible critical object the 'Public Sphere' theory of Habermas in its applicability to the Global South, de Sousa Santos is careful to introduce his critique tagged here with the caveat that it is not his 'purpose to engage here in detailed analysis of the concept'. The critique rather holds up the 'Public Sphere' as an exemplary case regarding the validity of the putative universality of Western theoretical approaches when they come into confrontation with the Global South. At least part of its rhetorical strength as such an exemplary case for publication in an essay in an academic journal rests in the fact that de Sousa Santos can reveal here that the author, 'world renowned German philosopher' Jurgen Habermas himself admitted that his work effectively excluded four fifths of the world's population from its scope and is 'limited and Eurocentric'.[9] As de Sousa Santos puts it, the 'universalist' theory gets to decide for itself what it includes and what it excludes, who is in and who is out.

Having thus constructed the case for both the invalidity of and inapplicability of general Western theory for the Global South as a type of auto-da-fé, and having shown how the production of an abyssal line by Western modernity renders the Global South invisible, de Sousa Santos does not advocate however for the 'dumping' of the rich Western tradition into 'the dustbin'. Instead, he

recommends 'keeping distance' with respect to the tradition, which he then goes on to define as placing oneself 'simultaneously inside and outside what one critiques.' For once de Sousa Santos's definitional bent does not provide us with immediate clarity here – indeed, there is a decided spatial incompatibility, is there not, between the metaphors of keeping distance and at the same time being both inside and out? If we stick with the *local* difficulty however, we might wonder if the inside of the Western tradition to which he refers is the bourgeois interior where 'love' and 'happiness' are hoarded against the outsider as per chez Tsing and Ahmed respectively? Or is it Foucault's totalising panoptical interior of modernist knowledge, from which, as de Sousa Santos feels obliged to add in a note, 'there is no emancipatory way out',[10] and thus we are trapped in a metaphorical 'Junkspace' à la Koolhaas? De Sousa Santos soon clarifies that it is the house or 'dominant' versions of Western thought that he wishes to avoid (or keep at a distance). By naming Nicolas of Cusa and Pascal as the type of 'forgotten' thinkers that he has in mind as typifying something 'closer to subaltern, silenced, marginalised versions of modernity and rationality' he outlines something that sounds very similar again to Deleuze and Guattari's 'minor' tradition. As already noted and used as an example here, one of the most prominent thinkers (and essayists) of that marginalised modernity was Hume. His philosophical works were largely ignored while he lived, but later condemned for the heresies of rejecting the occidental orthodoxies of essential selfhood and of causality, seeing both as mere effects of habit. The case of Hume illustrates in one body of work how some 'transgressive' epistemologies of the Global North might continue to be employed with validity and effectiveness, while at the same time other aspects of that work (viz. Hume's Eurocentrism, his views on race, gender and class) are unworthy.

In the latter part of the essay it becomes clear how definitional precision is actually a tool de Sousa Santos uses to manage an exposition of the relationship between theory and practice. This relationship has become phantasmal and undermined by a mutual 'hermeneutics of suspicion' between social movements of the South and traditional and modern theories of the North. De Sousa Santos believes that unthinking the theoretical apparatus that underpins the 'monumental Eurocentric justification of the unequal relations between the Global North and South'[11] is only a credible undertaking if theory engages in 'rearguard' action to support the practice of social and grassroots movements on the ground and a grappling with actual conditions in the Global South.

To this end de Sousa Santos believes that the 'task ahead' consists in understanding the grounds for emergence of new possibilities and new relations between theory and practice. Thus it is essential that there is a clarity of understanding what he calls 'Epistemologies of the South', namely, the processes by which knowledge is produced and held to be valid by and through the practices of marginalised and colonised peoples, and how these knowledges are viewed in relations with other sets of knowledges. De Sousa Santos broaches this task by establishing that the position as regards these knowledges and the hegemony of

the West is as Hamlet put it to his friend, that 'There are more things in Heaven and earth, Horatio, than are dreamt of in your philosophy.' From there de Sousa Santos describes at length four steps towards a recognition of alternative ways to knowledge, theories and concepts of Epistemologies of the South. The steps are, firstly, 'A Sociology of Absences', which is research aimed at showing that objects which don't exist are produced by those which do, and reversing that process. These objects don't exist because they are deemed outwith the scientific, high culture linear time standards of the West as being 'ignorant, backward, inferior, local or particular, and unproductive or sterile'.[12] Secondly, a 'Sociology of Emergences' is an opening to a type of speculative time allowing for the unexpected, the surprising and the unpredictable, which are uncongenial to Western rationalistic logics of the long stretch of empty Euclidean space and Kantian time. Thirdly, comes the 'Ecology of Knowledges'. This idea is related to the principle that 'Social Justice is grounded in Cognitive Justice' – de Sousa Santos recognises that in the given conditions of the real world under global capitalism a more balanced distribution and access to knowledges is not possible. But more credibility can be given to non-hegemonic sets of knowledge, and standard scientific knowledge can be challenged, confronted and put into debate with other knowledges. This results in a counter-hegemonic use of these knowledges: thus an ecology of knowledges emerges. The final step de Sousa Santos nominates as 'Intercultural Translation'. This work is founded on the idea that all cultures are incomplete in themselves and dialogue and confrontation with one another can allow for mutual intelligibility and progress. The process of 'diatopical hermeneutics' refers to an interpretation of two or more cultures or practices together such that points of similarity and those for debate can be identified. So, on the cultural hand, de Sousa Santos has proposed an exercise in examining, comparing and transplanting concepts of human dignity found in the Western concept of human rights, the Islamic concept of *ummai* and the Hindu concept of *dharma*. Equally in the field of practice, he calls for a comparison of the strategies of labour movements and feminist movements across the globe to find out what approaches they share and how and what they can learn from one another –which would not imply a relativist or universalist attitude is desired but that each could become more nuanced and articulated in its methods.

It is thus with this 'definitional clarity' as regards the problematic and with the certain and clear delineation of propositions to work in and with many different voices that de Sousa Santos makes a precisely positive contribution to the otherwise nominally purely negative concept of decolonisation.

Notes

1 Boaventura de Sousa Santos, 'Public Sphere and Epistemologies of the South', *Africa Development*, XXXVII(1) (2012), pp. 43–67.
2 Boaventura de Sousa Santos, 'Decolonising the University and Beyond', www.youtube.com/watch?v=enqNHDYdBwE (accessed 18 December 2020).

3 Boaventura, 'Public Sphere and Epistemologies of the South', p. 51.
4 Ibid., p. 46.
5 Ibid., pp. 51–61.
6 Ibid., p. 49.
7 'Thoughts without content are empty, intuitions without concepts are blind'; Immanuel Kant, *Critique of Pure Reason*, Cambridge University Press, 1998, pp. 193–4.
8 Boaventura, 'Public Sphere and Epistemologies of the South', p. 49.
9 Ibid., p. 46.
10 Ibid., p. 63, note 10.
11 Ibid., p. 62.
12 Ibid., p. 52.

Counter-forensics

On 'Open Verification',
Eyal Weizman (2019)

The philosophical field of epistemology, which plays such a prominent role in so many of the essays examined here, is brought into sharp relief as a practice in the work of Weizman.[1] If de Sousa Santos problematises the relationship between theory and action in the face of global social injustice, then arguably we can conceive of a spectrum or a sliding scale of possible modes of addressing the problem. Thus, Mbembe examines the historical and political aetiology of injustice in his theoretical concept of 'necropolitics'; Moten seeks a broader social commitment than the 'professional' in the humane plenitude of fugitivity; de Sousa Santos prepares the theory to be ready for action with 'Epistemologies of the South'; and with Weizman epistemology is an active political and social engagement for justice.

While with Karen Barad, we see a complex theoretical exposition of her epistemological position that approaches to knowing cannot be separated from those of being in any understanding, Weizman's practice and activism through his group 'Forensic Architecture' demonstrates quite simply that the way we know something is what it is. In an attempt to know what is the truth or truths about events where injustice may have occurred, Weizman's models (video, prose, sketches, 3D) let us see it, hear it, and sometimes touch it too. But the environment in which he works unavoidably leads us to ask who decides what and how we know. That is, from what position we approach, and who can control that positioning? Considerations of the epistemology in the essays considered here are generally invoked and articulated in a positive sense, with promotion and approval of a recent coming to awareness of its vital role in our ability to create a more just world.[2] Yet Weizman also turns our attention to a world where epistemologies are a form of employment of knowledge to nefarious, unjust and iniquitous ends. This is the 'post-truth' age where not only does the 'evolving information and media environment enable(s) authoritarian states to manipulate and distort facts about their crimes' but these states also attack and undermine those institutions (very often those that belong to their own 'liberal' constitution) that traditionally support, uncover and promote truths and justice, namely 'universities, science laboratories, mainstream media and the judiciary'.

'Dark Epistemology' is the name Weizman gives to a set of operations as a form of denial or negation, which 'compounds the traditional roles of

DOI: 10.4324/9781003186922-11

propaganda and censorship'. In using Dark Epistemology, these states do not seek to persuade or promote people to a certain political agenda, but rather to obfuscate, confuse and foster a sense of mistrust in media which has the result, as Weizman puts it, 'rather to blur perception so that nobody knows what is real anymore'. A series of techniques referred to by the military as 'psychological operations' (psy ops) – which include broadcasting misleading information via bombardment of social media (see the case of Cambridge Analytica), accusations of fake news, ad-hominem attacks and focus on any minor inconsistent details in criticism – are all employed in order to render the whole case untrustworthy, any criticism of a state's corrupt dealings discredited and reduced to an apparently incoherent, partisan and unsustainable set of irrelevant viewpoints.

Weizman notes that some associations have been made, and parallels drawn between these operations to undermine any possibility of getting at 'the truth', and the work of post-structuralist thinkers in showing truths as a production of power relations. Indeed, it's true that Baudrillard's famous denial that the Gulf War ever took place, and Derrida's alleged assertion that there is nothing beyond the text, now sound on the face of it like nothing so much as the type of brash responses which Donald Trump fired from the hip at 'fake news' journalists in his presidential news conferences/briefings. If post-structuralism is thus blamed by some for creating the sort of critical ambience whereby no 'truths' are to be trusted and thus one in which the 'Dark Epistemology' of state corruption could thrive, then still Weizman does not believe that such a critical juncture – be it valid or not – calls for a wholesale return to positivist reliance on truths upheld by 'established guardians of power/knowledge' (and dismissed here so notably by Braidotti (among others) as the rationalistic productions of 'European Man').

To avoid such kneejerk reaction, Weizman has been meticulous in refining the specifications of what might be called his Epistemological Method of Practice. Weizman believes that post-structuralism's suspension and critical deconstruction of power's operations in producing truths are indeed a vital tool in examining the corrupt and criminal operations of states. Like de Sousa Santos with decolonisation, he also believes it is not enough to dismantle those harmful structures, but real, valid and healthy structures should be put in their place. So unlike de Sousa Santos, who then provides the grounds for that positivist action (via his outlining of 'Epistemologies of the South') Weizman and Forensic Architecture not only provide the grounds but proceed to carry out the positive action too. The name Weizman and Forensic Architecture give to their methodology is, as per the title of this essay 'Open Verification'. It consists in the gathering of 'open source' materials to construct their own case about the circumstances or sequences of any particular event which took place and about which they believe the state, the police or whatever authority appears to have been in charge, may or may not have been entirely honest, straightforward or open in their public representations of it. The case put together by Forensic Architecture via text or video or 3D models will then be

presented on a forum – be it in a gallery, to a court of justice, online, to gathering of activists, etc – where there might be a route to justice. The 'open source' of the materials refers to the fact that the materials – documents, testimony, videos, data – are gathered from publicly available sources, be it uploaded to the internet by activists or casual viewers, or gained via freedom of information requests. As these sources are multiple, variform, of many different types of provenance and often not from any official or authoritative body, they may be full of raw information which has to be processed, but they represent a harnessing of empiricism not towards simple positivistic ends, but as a counter-hegemonic practice. The name of the methodology itself makes clear that this activity is not aimed at identifying and isolating truth (or even 'veritas') as a noun or as a singular essence, but as a verbal noun 'verification', thus a practice which 'is contingent, collective and poly-perspectival'. The rigorously lucid construction of this methodology extends not only to the validation of components at every level in the depth of the investigation ('verification' refers to an event as a whole, whereas 'authentication', we are told, is used to establish the authenticity and provenance of the individual documents and pieces of evidence – a video of audio file, for example – which are brought together to make the case) but also to a type of spatial awareness of the very performance of authentication. That is to say that the authentication is conceived of as in two dimensions – a vertical one, being the question of how pure is the evidence presented, whether it has been doctored or tampered with; and a horizontal one, which refers to its authentication via its consistency and corroboration with other files and pieces of evidence gathered in constructing the particular case.

Given the particularity of this description – and, indeed, clarification – of their work, the question might now arise in the reader's mind, as to how the campaigns and projects of the group – Forensic Architecture – can actually be gathered together under the the that title. In what way can this work be considered as architecture? Weizman, is himself, by profession an architect, but he only explains the use of the qualifier 'forensic' in terms of its adjectival relation to 'forum' as originally that public arena where most famously in Roman history courts were held and justice enacted. So forensic, etymologically speaking, means evidence, the legal case made public. As for this work being an architecture, that's a categorisation that both the group and Weizman have spoken and written about elsewhere.[3] At first it is not obvious how reconstruction of crime scenes with heavy reliance on video evidence to show that, for example, a Bedouin villager was wrongly accused of killing an Israeli policeman as a terrorist act; that members of the Greek fascist Golden Dawn group had murdered an activist and police ignored the evidence; and that a bomb dropped from an Israeli plane had killed two Palestinian children; are promising grounds for a claim to involve architectural theory, method or technology in the conceiving, organising, exposition or presentation of that material. Yet, in fact, there are several levels at which we can conceive of this work as

architectural. On first encounter there is a most immediate and superficial resemblance or approximation to the tools, techniques and concerns at play. Representations are made of objects in space; measurements are taken in both space and time; calculations are performed regarding dimensions and circulation which amount to a programme for action in that space. In terms of the attempt, through constructing models, to bring into view all that happens within, and everything that impinges upon a certain space at a certain time, we are reminded of the philosopher Suzanne Langer's unusually liberal, but useful definition of architecture as a 'total environment made visible'.[4] Equally we might look at a more traditional definition of how the tools of architecture work in and on space for a measure of Forensic Architecture's conformity or otherwise to the mores of the discipline. In 1519 Raphael theorised in a letter to Pope Leo X that the plan, section and elevation are the three fundamental types of architectural design drawing. They are not mimetic or representational drawings, they are not drawn from the point of view of someone experiencing that space, but as design drawings they are diegetic, that is to say they seek to be objective or all-knowing, seen from an idealised viewpoint which eschews all subjective or perspectival viewpoints through accurate measurement. In this way they are reliable for an instructional purpose and create a relationship between 'looking' and making. The three different drawings comprehend all three spatial and material dimensions on the inside and outside of the prospective building and thus create a model of the total environment. When Weizman writes that 'the more perspectives' and 'the more videos within the model the more complete our view of the event is' he is declaring that the tendency of their models is towards 'making the total environment visible' and this totalising tendency is constructed via the addition of multiple viewpoints, multiple witnessing which construct the body of space as do Raphael's three fundamental types of drawings. Unlike Raphael's models however Weizman's cannot claim to be diagetic, or completely objective, because it is built of many individual subjective viewpoints, with their own perspectives on the space and the events therein. The witnesses or the viewpoints are, often, though not always, actually involved in the event or action themselves.

It is these constitutional aspects of Forensic Architecture's approach that their opponents seek to exploit as weaknesses. The open processes that Forensic Architecture employ – 'multiple, subjective, located and situated perspectives' – are attacked and rejected by the authorities for their subjective testimonies, and for the very multiplicity of their case, which has to be constructed at length in time and space against an already completed case by those authorities. The Forensic Architecture case often consists in a complex narrative or performative series of positions and not a standard simple rebuttal of the antagonists' case. In a crude invocation of the 'two cultures' dichotomy, the personnel of Forensic Architecture have on occasion also been dismissed as unreliable as they are artists or creatives and because their work, as such, having appeared in galleries and museums is not submissable under the rigorous standards of legal evidence.

The question of the positionality of the epistemological practice of Forensic Architecture is thus a spatially complex one that is not easily viewed within the inside/outside spatial dualism. For Weizman and Forensic Architecture this idea that their case, their models, their exposé, is not constructed as official insiders, that often it is not performed or submitted in a state court of justice; that it is conceived and constructed outwith and beyond the State prosecutors' office – and indeed often without their ken – that it is compiled without the stamp of approval, co-operation or privileged access to the knowledge and evidence held by police, or the army or other official investigators, is to them often, and ironically, an advantage. Their operation, like that of Sara Ahmed, rejects complicity with the official story of 'happiness' in the interior and performs the role of public killjoy for the state establishment.

Yet is it not a logical absurdity to expect that one can operate from the outside on the interior when the heretofore most credible spatial model of that 'regime of truth', Foucault's Panopticon, depicts the discipline of the interior as unavoidably internalised and absorbed by all subjects, and that interior, as per Koolhaas, of infinite extension and still under ad hoc expansion such that there is 'no emancipatory way out'?[5] That depends, of course, on how we conceive of new contemporary posthuman possibilities of knowing, of positioning and functioning of the subject. We could at least conceive of Forensic Architecture working like Tsing's mushrooms on the edges, the limits – on Derrida's undecidable margins indeed – involved intimately in the action as outsiders, within the state but as aliens – like those Bedouins involved in a tragic unfolding of untruths in the Israeli police raid to remove them from their ancestral lands in which they are perceived by the state as aliens. Thus, neither inside nor out, and both at the same time. Arguably Forensic Architecture performed this emancipatory manoeuvre into a total environment precisely by exploiting the notion of an architecture, of a construction of space, which is opened via its use of interdisciplinary knowledges and technologies, by accepting multi-partisan testimony and generally adopting a polyperspectival approach, but which is not tied to the objective production of enclosure.

Notes

1 Eyal Weizman, 'Open Verification', *e-flux* (18 June 2019), www.e-flux.com/archi tecture/becoming-digital/248062/open-verification.
2 See Boaventura de Sousa Santos, 'Public Sphere and Epistemologies of the South', *Africa Development*, XXXVII(1) (2012), pp. 43–67.
3 See Eyal Weizman, *Hollow Land*, Verso, 2012, p. 6.; plus talk at Glasgow School of Art on 29 November 2019 by Nicholas Zembashi of Forensic Architecture, www. gsa.ac.uk/life/gsa-events/events/f/forensic-architects/?source=filter (accessed 14 March 2021); listen especially from 1h 27 min. in.
4 Suzanne Langer, *Feeling And Form: A Theory Of Art*, Scribner, 1953, p. 98.
5 See de Sousa Santos.

Necropolitics

On 'Necropolitics' by Achille Mbembe (2003)

The question of sovereignty lies at the heart of what Achille Mbembe has called 'Necropolitics'.[1] Yet as the Brexit debate and the Trumpist slogan 'Take back Control' recently demonstrated, there is much popular confusion over the concept of sovereignty. It is at least arguable how much that confusion is the result of manipulation of mass opinions and emotions by sinister and powerful political interests. Without going into that for the moment, it is nonetheless instructive to note the comments by one interested party on the Brexit negotiations just as they reached crisis stage in late 2020. The UK–EU talks were stalling, with allegations that EU aims and proposals regarding rights to fishing in UK waters would infringe upon UK sovereignty. The Spanish foreign minister at the time, Arancha González Laya pointed out in a somewhat exasperated interview she gave on Sky TV that 'trade agreements are not made to assert one's independence, they are made to manage interdependence … it's pretty clear when you make a trade deal that you are already a sovereign nation'.[2] In fact, rather than clarity on the issue, there appeared to be a deliberate attempt at obfuscation on the issue of sovereignty by some parties in those negotiations – but we take González Laya's critical point. Yet if sovereignty is not about bickering over the share of goods and resources across such and such a territory – or if, rather, such negotiations can only be performed in the wake – as González Laya implies – of a completed and understood settlement of sovereignty then what is it that has already been decided? If we were to intervene at this stage and level of the debate with an answer to that question from Achille Mbembe, things would undoubtedly take a shockingly much darker turn. The decision which the power of sovereignty enables according to Mbembe is over who can live and who must die. At first glance that would seem like an outrageous – almost murderous – thing to assert as having any relevance to a diplomatic process of negotiation between European powers. There are, though, at least a couple of angles from which we could examine the relevance or otherwise of Mbembe's definition to the everyday political life of nations.

In the first place, if a nation's sovereignty seems somehow tied up with its territorial integrity, then as the ultimate recourse and last stand in the defence

DOI: 10.4324/9781003186922-12

of that integrity the nation claims the right to declare war against any threat of invasion. Even if that declaration lies hidden beyond the horizon of most international political intercourse, nonetheless the right to decide who must be killed remains that last resort underpinning all question of sovereignty. None of that relation to sovereignty as within the boundaries of the nation state, within the institutions empowered by the state, or within supranational institutions and networks is however what interests Achille Mbembe in the formulation of his specific definition.

Mbembe reminds us that many concepts of sovereignty are possible and that the type conceived and worked with in these modern nation states as above, follows a set of normative Western theories of democracy whereby citizens are assumed as self-understanding, self-conscious and self-representing subjects acting rationally in a given political community. The problem for the belief that this model is workable or even plausible at the most basic level is that for at least a hundred years since the publication of the works of Marx, Nietzsche and Freud, among others, the view of the individual subject as homologous with the conscious subject has no longer been sustainable, and that subject is indeed overwhelmed by forces of economics, history, desire and will and others which are often not only beyond their control, but also beyond their ken and their own power to render them meaningful. Mbembe doesn't relate this understanding specifically to Braidotti's post-humanism, but he does refer to the 'Romance of Sovereignty'[3] and to 'living beyond humanism'. The question of sovereignty is thus approached originally by Mbembe in the acknowledgement of the control, organisation and orientation of subjects by biopolitics – which is Foucault's concept of the technologies of discipline and regulation which manage human life in the pursuit of certain social goals as described in the Panopticon model in the Rem Koolhaas 'Junkspace' chapter of this volume. He sets out by attempting to understand and delineate something of an alternative Western tradition of the relation of subjectivity, not to rationality, but to death, which he examines in a passage on the works of Hegel and Bataille (and briefly touching on Heidegger).[4]

This question of the truth of the subject as found in its relationship to death rather than to rationality can be understood in a coming to terms with the reality of what Mbembe has called 'planetary scale renewal of the relation of enmity' and the contemporary proliferation of war, occupation, terror and counterinsurgency across the face of the earth. The Nazi regime had often been discussed with respect to Western history as a state of exception in its total racist and homicidal mobilisation towards the death of the 'other'.[5] In this age of war and terror across the globe, however, Mbembe reminds us that liberal Western democracies increasingly invoke and exploit the state of exception (and as Weizman points out 'manipulate and distort facts about their crimes' with 'dark epistemology') such that it has become the norm. In this new normal, Mbembe then poses the question:

Is the notion of biopower sufficient to account for the contemporary ways in which the political under the guise of war, of resistance, or of the fight against terror, makes the murder of the enemy its primary and absolute objective.[6]

It is a rhetorical question of course, for Mbembe shows how in addition to disciplinary and biopower, necropower, or the dealing of death or the sovereign right to kill, is a ubiquitous mode of contemporary subjugation of peoples around the planet. In the introduction to his book of the same title, he turns von Clausewitz's dictum on its head, and makes us face up to the reality that for our day, politics is considered a form of war.

Nearly everywhere the political order is reconstituting itself as a form of organisation for death.[7]

Mbembe traces the development of the racist technologies of necropower from the European exclusion of the rest of the world from *Jus Publicum* – in other words, the realm of the law's jurisdiction and rights, such that the Euro-colonialists recognised no legal subjects there, no government, no civil society, not even war, but just imposed slavery, terror and their own European sovereign right to kill. This raw necropower at work in the colonies and plantations was kept hidden, obscured, at arm's length from 'civilised' European society for centuries (although obviously it was connected to class relations and history there) until World War II and the Nazi's brought its methods and technologies – apartheid, exclusion, extermination, concentration camps – openly and shockingly to bear on European peoples. The grim reality, continuity and proliferation of the figure of death as constitutional in the European concept and operation of the 'subject' is brought into the open and made fully public (from those relatively obscure philosophical discussions of Hegel and Bataille) such that the technology and aims of the terror imposed by this version of sovereignty are plain to see, as Mbembe puts it, 'Terror is a defining feature of both slave and late-modern colonial regimes.'[8]

Mbembe takes Fanon's 'vivid' exposition of how classical colonial occupation is premised on the spatial 'principle of reciprocal exclusivity'[9] of the colonised and the coloniser, and shows how the terror of necropower continues and expands its work across the globe in what he refers to as late-modern colonialism, and in the proliferation of wars.[10] He finds the most exemplary case of that late-modern colonialism ('its most accomplished form'[11]) in the contemporary colonial occupation of Palestine. Mbembe identifies three major characteristics in the application of terror, as seen in the Palestinian territories. They are *territorial fragmentation*, where the population is disorientated by dispersion and by separation between settlements – this was also seen, for example, in the homelands and townships of South Africa: *reciprocal exclusivity* whereby the infrastructure in terms of roads, transport water and electricity provision are completely separate (Mbembe calls this 'splintering' after Graham and Marvin[12]), so the mean, crumbling, undermaintained

Palestinian roads and tracks have to travel around and under the modern highways joining the settlements of Israeli occupiers; and, *infrastructural warfare* which entails not simply the isolation and destruction of settlements, but the destruction of crops and agriculture (e.g. olive groves), the wasting of water systems and the destruction of local political and civil administrative infrastructure. With these three characteristics Mbembe follows Weizman's demonstration that there is a vertical organisation of two separate geographies here: coloniser and colonised, and that the discipline that can vertically organise inhabitable spaces (especially through its traditional graphical methods of sectional exposition – see Weizman chapter of this volume) and conjoin and separate circulation around, between and apart from these spaces is architecture. We might also point out the irony here of Schopenhauer's definition of architecture as the 'lowest grade' of art because it deals with the meanest or crudest of natural phenomena, namely gravity or weight, and light.[13] For in the technological construction of the vertical hierarchy of terror there, death is dealt immediately and with lighting swiftness from the air by helicopter gunships patrolling the skies ('killing becomes precisely targeted'[14]), while at ground level bulldozers mow down the shelters, property, infrastructure, dwellings and workplaces of the Palestinians with relentless brute force, delivering a more 'invisible', because effective over the long term, but still inevitable, death. Thus, we see that from the air above them to deep down in the earth below them the world of the occupied Palestinian territories is saturated with the threat of death, with a necropolitical order.

The proliferation of wars around the planet in the period of late-modern capitalism and colonialism also exposes the particular operations of necropower, and Mbembe offers us the examples of the Gulf War of 2003 and the Kosovo War as paradigms. In both cases the wars were characterised by a high-tech hit (more like, completely and accurately destroy) and run, carried out at lightning speed into the heart of the territory, then disappearing just as suddenly. The attack of 'overwhelming and decisive force' brings terror to the inhabitants much like the blitzkrieg raids of the Nazi's but now with the technological capability of executing with pinpoint accuracy the killing of individuals and the disabling of targeted components of infrastructure through the use of smart bombs, electronic sensors, laser-guided missiles, cluster bombs, drones and cyber intelligence.

Mbembe compares these attacks to the sudden, unexpected raids on settlements by bands of nomadic warriors. Yet more often, in these contemporary wars of late modernity, the engagement is more complicated than simply invasion however brief or swift by a colonial military. In fact, Mbembe uses and develops Deleuze and Guattari's concept of the war machine to bring to light this configuration of necropower. In Deleuze and Guattari a war machine would be a rhizomatic assemblage of various collected and differentiated possibilities for engagements and effects operating from different tactical points of view on the ground.[15] In Mbembe's development of the trope, war machines

appear in an age of terror when states no longer have a monopoly of violence, these machines are polymorphous, made at least partly of armed men in groups which are diffuse and have a capacity for shape-shifting to fit the operation at hand. He writes,

> Their relation to space is mobile. Sometimes they enjoy complex links with state forms (from autonomy to incorporation). The state may, of its own doing, transform itself into a war machine … War machines function by borrowing from regular armies while incorporating new elements well adapted to the principle of segmentation and deterritorialization.[16]

Through this multiform, always metamorphosing, networked engagement, terror and the constant threat of death are diffused throughout the body politic. Prominent examples of war machines in terms of their variety of forms of organisation and fields of operation might include the IRA and UDA as paramilitary bodies set up on a cellular basis and engaged in welfare works, cultural teachings, drug dealing and community policing; the organisation of Luddites who fought underground battles against factory owners in nineteenth-century England, defending threatened craft and skill bases and ultimately ways of life of certain classes. In the current day Boko Harem and Isis could be called war machines whose actions include military invasions and strikes, suicide attacks, and also operations in political and civil fields in administering regions they control, organising religious and moral teachings and distribution and administration of justice. Mbembe points to a further plurality of functions, and, in as much as 'A war machine … has the features or a political organisation and a mercantile company',[17] the US company Haliburton in its various formats and engagements – political, commercial, extraction of resources, military/security, occupation – also responds to the profile of the model. Haliburton is ostensibly an oil field service company which operates across the globe, employs tens of thousands of people in its commercial practice and has headquarters in Houston and Dubai. It has carried out extensive work for the US government including a study of the effectiveness of the use of private military forces in US contact zones and building internment/detention camps for the government. Its political networks have extended to having its erstwhile CEO Dick Cheney become Vice President of the US. Heavily involved in the neo-colonial occupation of Iraq after the 2003 War it operated there (and in its oilfields) with armed security staff, in effect mercenaries who formed its own private army. The extraction of resources by Western companies and hence the imperative for security against the indigenous population in order to control labour, value and land brings a rapid mutation of these neo-colonies into 'spaces of war and death'.[18]

The resulting spatial fragmentation, according to Mbembe, causes monetary instability and a ramping up of the state of precarity, which can lead to a descent into theatres of horrific death and torture like the Rwandan genocide of

1994. Mbembe describes in detail how the network of death dealing closes in from all sides in these modern colonies. In a protracted discussion on the seemingly irreconcilable logics of martyrdom and survival which nonetheless have played out their dialectic in the figure of the suicide bomber, Mbembe shows how for the colonised, sovereignty or freedom and death are 'irrevocably interwoven'.[19] The confrontation with death is heightened by the tension in these networks to the ecstatic experience, as described so vividly by Bataille, but ultimately revealing only the emptiness of being. In his book-length treatment of the theme, Mbembe draws heavily on the dense and complex psychoanalytical studies of colonial mentalities by Frantz Fanon to access the symbols, languages and meanings which can stage a reimagining of that fragmentation in its universality. Ultimately, the significance of necropolitics is that in the modern colony life is lived in such precarity with a questioning and denial of its worth that death becomes the absolute wager into which every life is inexorably drawn and lost. And the irony of it is that it is the West – which always accuses the 'other', and in particular Islam, of nihilism – that imposes on the whole world this catastrophe, this apocalyptic death, this end of all humanity as 'a category at once political and theological'.[20]

Notes

1 Achille Mbembe, 'Necropolitics', trans. Libby Meintjes, *Public Culture*, 15(1) (2003), pp. 11–40.
2 See www.youtube.com/watch?v=pdAL8zeQMDs last seen 15/03/21
3 Mbembe, p. 13.
4 Ibid., pp. 14–16.
5 Ibid., p. 18.
6 Ibid., p. 12.
7 Achille Mbembe, *Necropolitics*, trans. Steven Corcoran, Duke University Press, 2019, p. 7.
8 Mbembe, 'Necropolitics', p. 38.
9 Ibid., pp. 26, 28, citing Frantz Fanon, *The Wretched of the Earth*, trans. C. Farrington, Grove Weidenfeld, 1991, p. 39.
10 Fanon, p. 39.
11 Mbembe, 'Necropolitics', p. 27.
12 Ibid., p. 28; Stephen Graham and Simon Marvin, *Splintering Urbanism: Networked Infrastructures, Technological Mobility and the Urban Condition*, Routledge, 2001.
13 Arthur Schopenhauer, *The World as Will and Representation*, trans. E. F. J. Payne, Dover, 1969, vol. 1, p. 214.
14 Mbembe, 'Necropolitics', p. 29.
15 Gilles Deleuze and Felix Guattari, *Capitalisme et Schizophrenie*, Éditions de Minuit, 1980, pp. 430–527.
16 Mbembe, 'Necropolitics', p. 32.
17 Ibid., p. 32.
18 Ibid., p. 33.
19 Ibid., p. 38.
20 Mbembe, *Necropolitics*, p. 28.

Chapter 12

The undercommons

On 'The University and the Undercommons' by Fred Moten and Stefano Harney (2004)

To begin with a 'call to order', to assume there can be a beginning, and that by defining (which is what these writers never do) at the 'beginning' what this phenomenon is, its provenance, that it can be metaphorically *tied down*, is not just to run counter to the runaway ethos of refusal that blows endlessly through these pages, but to kill it stone dead. Fred Moten lives in these pages by not consenting to be so merely singular that we could say he is simply a poet and a black studies theorist, and his writing and composing partner Stefano Harney by not leaving his interests at rest in a stretch from post-colonial and race studies to business and management.[1] That background, or track record, their 'fugitivity' or their 'line of flight' in the Deleuze and Guattari sense,[2] however reductive here, can nonetheless give us a hand-up and let us into an engagement with their work as an ongoing process. That opportunity for a get-in has particular tactical effect here because Moten and Harney are always already in the middle of their work, their conversation, their 'study'; and always eschewing a definition for starters. Their concern with chosen themes, their continual return to, improvisation on, probing and trialling consequences, connections, histories and futurities in certain concepts, may on the face of it have some resemblance to the 'Keywords' project of Raymond Williams. Not to put too singular a point on it, but Williams too was a politically committed, creative and intellectual polymath. The keywords that crop up again and again in Moten and Harney's work – among the most prominent are *fugitivity, undercommons, study, policy, planning, critical, improvisation, governance, negligence* – could certainly be said to bear (as do Williams's keywords) a weight of contemporary social and cultural significance. Yet, unlike Williams's work, Moten and Harney's aim – inasmuch as they can be said to have any aims apart from carrying on with their studies – is not at all to isolate and expose a 'shared body of words or meanings',[3] but to set out from these concepts on a journey of discovery, articulating a world they find before them. There are no definitions, the drift rather, of their discourse – their study – is animated by at least two principles which can be gleaned (as a get-in) from that minimal opening biog of interests. In the first place the poetry of the word, whereby there is no attempt to fix a utilitarian definition and thenceforth to

DOI: 10.4324/9781003186922-13

use it as a tool to manoeuvre some meanings into being, but instead a free run of association, of improvisation and experimentation. The poetic can thus establish and demonstrate not just truths but emotions and ambience, moods and tones. So, for example, the deployment of the concept of 'fugitivity', which is borrowed from and calls upon slave history, and is used to invoke a political spirit of escape and transgression, a refusal to be tied down again to an alienating and punishing order, and an impulse to flee and reach an outside or a beyond. For Moten, this is a strong heritage in the experience of blackness in the USA and elsewhere, and it is a powerfully effective concept in the critique of the University to which we will return below. It also has a strong affinity with Emily Apter's concept of the 'impolitic' which embodies gestures of refusal, non-cooperation and civil disobedience, and which she defines thus:

> It mobilises a tactics of tactlessness and encompasses the right to offend and the rude-boy manoeuvres of rogues and voyous. It assaults conventions of bienséance, good taste and liberal tolerance with obscene gestures and nasty retorts. It points to instances of violent disaffiliation or dis-identification with a community, a *habitus* of citizenship, a select political estate, a given set of identitarian affiliations.[4]

In the second place Moten and Harney bring to bear an intellectual and political spirit whose operation might most usually be termed 'critical' but in the very specific case of their writing they refer to as 'study'. This mode of engagement has interventionist elements which are in apparently distinct and discrete relationship to any preformed notion of study:

> I think that writing in general, you know, is a constant disruption of the means of semantic production all the time, and I don't see any reason to avoid that, I'd rather see a reason to accentuate that not in the interests of obfuscation but in the interests of precision.[5]

This notion of 'study' is a broad one which they oppose to what they see as the restricted and restricting range of the 'critical' where the 'critical' is an individualistic and judgmental spirit operating from certain social tiers and hierarchies with given sets of standards and prejudices. 'Study' on the other hand, would not only not include certain approaches, behaviours, methods and techniques both unwelcome and suppressed by learned and academic society, organisations and institutions, or what they call here 'upstairs', 'polite company', 'rational men'[6] – but in its active seeking out of these aspects can present a 'subversive' undermining of the restrictions of the 'critical'. Thus Moten's language is often that of the street, peppered in their talks and their writings with the 'fuck' and 'shit' swear words perceived as 'obscene' or 'nasty' or otherwise unacceptable to critical academic discourse; their references range limitlessly from the forms of Jazz and Rap music to mathematical set-theory,

and they speak of the provenance and sites of the informal experimentation and planning of their study as far from the ivory tower, indeed as launched from 'any kitchen, any back porch, any basement, any hall, any park bench, any improvised party, every night'.[7] Study is thus not a sequestered activity, taking place away from everyday society. It is a non-idealised meditation, consideration, experimentation and working through of cultural and socio-political forms which refuses a given and fixed position and permanent housing, such that, again, on fugitivity in a more 'studious' take in his Introduction to their book, Jack Halberstam writes, 'Fugitivity is not only escape – it is being separate from settling. It is being in motion that has learned that "organizations are obstacles to organizing ourselves"'.[8]

In their essay 'The Undercommons and the University', these two embedded and inseparably intertwined formal approaches of Moten and Harney, the poetic and the study are distilled into their most concentrated form in the section headings that run through the work, such as 'Critical Academics are the Professionals Par Excellence' and 'The Undercommons of the University is a Non-Place of Abolition'. The undercommons refers to the existence and proliferation of non-professional and uncategorised knowledges and existences that exist and proliferate outside of institutions and official and policed society. Thus, it is related to, but not unique to, spatially confined in, or defined necessarily by those places hymned in the 'kitchen and park bench' excerpt cited above. Somewhat like Freud's unconscious, the undercommons is a relational concept, that is to say not just, and not even, in fact, a setting out of the *where* something takes place, but the *how* it exists or works in relation to other kinds of being and knowledge. The 'hold' is thus one of their figures of the undercommons, in all its poetic manifestations as a verb, a noun, a place, a store to keep a sense of darkness within an orientation of underneath, and, of course a historical grim slave reality on the ships where the kidnapped people were bundled, forced, beaten, raped and tied down, thus where a system got hold on the logistics and the effective control and policy for its global shift, while the people lay unspeaking with their bodies touching and resonating still with the despised life.

While for Moten and Harney the university, in one of their most radical accusations, is not just a 'hold' but a prison – because poetry refuses to accept there is a difference between the figurative and the literal, and, because it is a prison – still they 'refuse to refuse it'. They teach in, they work for, they 'belong' to, they research in, they are faculty of the University. Yet their favoured modality of engagement, as 'study', an ecstatic activity as outlined above, and therefore a reaching always for the beyond, unreconcilable to the bounds of a coherent moral and ethical system, can never fully, frankly and openly be absorbed by the university. Instead 'study' becomes the repressed material of the University, it needs this work but it cannot bear it. In his paraphrastic representation of Moten and Harney's questioning of the purpose of the University, and the impossibility of study there, David Wallace asks 'Why is it so difficult to have new discussions in a place that is ostensibly

designed to foster them?'[9] If de Sousa Santos, Mbembe and Ferreira da Silva and others here question and expose the white West's cultural claims as 'universal', then Moten and Harney throw into doubt the very name of the 'University'. In the furtherance of professionalism the role of the academic is officially limited to a 'critical' function, meaning that through operation of an apparently individualistic and private judgmental critique on texts and academic and scholarly material and activity, and through administration of grading and other regulatory functions they police the bourgeois constitutional boundaries of the institution. This professionalism (i.e. a dedication to institutionalism) in the university makes it easier for policy as the arm's-length tool of governance to ensure privatisation via self-policing of and in the institution. Thus, in the midst of this rap on blackness driven on through these repeated keywords and concepts as symbols studded like rhinestones on a soul singer's costume, we encounter, however, some more mundane, not to say slightly tarnished stones, from that world of public administration. Moten and Harney toss out at least a couple of references to the Clinton/Obama years, and mention is even made of the UK New Labour project. Hope, they write, was 'deployed against us in ever more perverted and reduced form'[10] throughout those twenty years or so. This targeted politico-historical point homes in on a specific administrative instrumentality, or its perceived failure. In the (neo-) liberal managerialist agenda of those administrations, it was ultimately assumed that the university system could be renewed by, among other things, reduction of blackness to a question of technique, and treatment of equivalence as an issue among others, so that it could be dealt with by governance. In a country where the prison is the black mirror of the university, where the university system was built on slave money and has been maintained and powered by the racist operations of capital with no reparation to communities robbed, raped, kidnapped, slaved, imprisoned and excluded, governance, Moten and Harney assert, is simply another 'form of expropriation'. Such a social system cannot be fixed, they say, and the 'only thing we can do is tear this shit down and build something new'.[11] In other words, as Ferreira da Silva expressed it, 'reparation or restitution of monetary sum' is not enough for decolonisation, a 'reconstruction of the world' would be necessary, which 'requires the setting up of juridico-economic architectures of redress through which global capital returns the total value it continues to derive from the expropriation of the total value yielded by the productive capacity of the slave body and native lands'.[12] As per the chapter heading above, the word 'Abolition' clearly carries a tombstone weight of symbolism in this context – for Moten and Harney that should be the foundation stone of all the possible new beginnings.

Nonetheless Moten and Harney refuse, as they put it, to refuse the university. Refusal, indeed they see not just in their job as a 'subversive intellectuals' – that is, as 'unprofessional, uncollegial, passionate and disloyal'[13] – but as a fundamental mode of all the undercommons. – 'The path to the wild beyond is paved with refusal.'[14] The wild is how that refusing works, so that the

undercommons, comprising all those who refuse and are refused rights and privileges and alliance with established power and its agents is not a residual place that is left to them, but a way of operating, of surviving, of thriving despite all; a topographical set of relations to one's environment and those who inhabit it, or as Moten and Harney describe it, as notation for music. For like a score, one note does not settle and belong in that position on the page, it is not important or significant in where it is but how it is in relation to all the others together, how it articulates with the rest of the notes in the music.

These types of outcasts as subversives rather than critical intellectuals in the university are also dubbed as 'maroons' by Moten and Harney after the name for runaway slaves, for they are 'always at war and always in hiding within the institution'.[15] Accordingly, the community of maroons in turn is referred to as the marronage. This term, the marronage, notably refers not just to a place to where the slaves would escape or hideout -for there was no permanent place of safety from the universal institution of slavery and thus from the all-powerful forces who would hunt them down. Rather, it refers to a whole range of tactics which the maroons -or runaway slaves- would adopt after break-out in order to resist the full return to slavery, and to the dynamics of interaction in which they had to persist with slave communities and potential slavers just in order to survive.

Thus while the work of Moten and Harney resembles that of Ferreira da Silva inasmuch as they both initiate an engagement, coming from blackness and bearing a refusal or refusals, there appear to be some fundamental differences at play. Ferreira da Silva refuses to obey the regulated purism and exclusivity of the grammars and syntaxes of the Western intellectual tradition. Hacking to the inside of that tradition, she exposes the absurdity of the ultimately self-referential and narcissistic range of non-sequiturs populating those grammars, and thus exposes their inert, dumb and stubborn materiality. Moten and Harney are able to expose that it is possible to be inside but not of the university, which is to say that from their own marronage, planning and manoeuvring with their subversions, their resulting topographical exposures reveal the interior as not necessarily constituted by an enclosure but by the ringing round of a horizon of discourse formed of possible approaches, relations, understandings and dealings. Even if any potential outside, via disidentification with the community, is, for the moment, totally surrounded and enveloped in that horizon of given discursive formations, the sun of abolition may still rise above, shine through and signal possible beyonds. At any rate it does not seem, with regard to Ferreira da Silva, that these different modes of refusal are in any way exclusive.

Notes

1 Fred Moten and Stefano Harney, 'The University and the Undercommons', *Social Text*, 22(2) (June 2004), pp. 101–15.

2 Gilles Deleuze and Felix Guattari, *Anti-Oedipus: Capitalism and Schizophrenia*, Univeristy of Minnesota Press, 1983.
3 Raymond Williams, *Keywords: A Vocabulary of Culture and Society*, Fontana, 1976 – from the blurb on the back of the book.
4 Emily Apter, *Unexceptional Politics*, Verso, 2018
5 Fred Moten cited in David Wallace, 'Fred Moten's Radical Critique of the Present', *New Yorker* (30 April 2018), www.newyorker.com/culture/persons-of-interest/fred-motens-radical-critique-of-the-present (accessed 15 March 2021).
6 Moten and Harney, p. 101.
7 Stefano Harney and Fred Moten, *The Undercommons: Fugitive Planning & Black Study*, Minor Compositions, 2013, p. 41.
8 Jack Halberstam, citing the Invisible Committee in *The Coming Insurrection* in his introduction to Moten and Harney, *The Undercommons*, p. 7.
9 Wallace.
10 Harney and Moten, *The Undercommons*, p. 42.
11 Ibid., p. 3.
12 Denise Ferreira da Silva, 'Towards a Black Feminist Poethics', *The Black Scholar*, 44 (2) (Summer 2014), pp. 81–97 at p. 85.
13 Harney and Moten, *The Undercommons*, p. 6.
14 Ibid., p. 5.
15 Ibid., p. 16.

Cosmopolitics

On 'Cosmopolitics' by Emily Apter (2018)

In her introduction to the *Dictionary of Untranslatables: A Philosophical Lexicon*, whose English version Emily Apter co-edited, she draws an initial comparison between that project and Williams's *Keywords* as a 'compendium of political and aesthetic terms … informed by British Marxism of the 1960s and 70s'.[1] Apter's field is comparative literature and her particular focus – demonstrated at large in several sole authored books as well as in the enormous work of the *Dictionary* edited in the original French by Barbara Cassin and Etienne Balibar – is on the question of translation. As such the comparison with Williams's *Keywords* can serve as a clarification of the aims and methodologies of the field in which Apter works, in particular of the notion of the awkward (in English) substantivisation of the term 'untranslatable'. There is, of course, an immediately apparent set of formal differences between the *Dictionary* and the *Keyword* projects: unlike Williams's work, the *Dictionary* is specifically engaged with philosophy rather than the merely political and aesthetic (though the question of the extent to which it comprehends these two latter is insistently present) and it is by definition a multilingual undertaking. Beyond that, and at a deeper level, the *Dictionary* is not an attempt to delineate concept histories, and where Williams's work seeks to substantiate universals ('bourgeois' being an interesting example for this comparison), the *Dictionary*, and Apter's work on translation in general, seeks to problematise the very notion of 'universals'. Thus the *Dictionary* is an attempt to rewrite the history of philosophy through the lens of untranslatables, terms which are either brought/taken over as loan words (e.g. polis, Dasein, sublime, lieu commun, virtù) or which undergo mistranslation or retranslation. Thus, with these terms we see that the job of translation is never finished and this is also tied not only to localised cultural and historical effects, but, as Apter puts it, to 'instability of meaning and sense making, the performative dimension of sophic effects, the condition of temporality in translation'.[2]

In the essay 'Cosmopolitics',[3] Apter applies this approach of 'untranslatables' to that eponymous field in however comparatively brief meditations on the phenomena of 'strait', 'frontier' and 'settlement'. These samples are used here to demonstrate the Balibarian problematic of universals in its cosmopolitical

DOI: 10.4324/9781003186922-14

application. With Braidotti (above) we see how historically the 'universals' applied and imposed on the world were not just exclusionary, but part of the west's inhumane 'drive to mastery', and with de Sousa Santos the failure of the 'universal' aspects of western theory are laid bare in their confrontation with activism and the political, social and cultural realities of the Global South. In Apter's work – drawing on Balibar – the notion of 'Western theory' or the Euro- in Eurocentric is further problematised by probing the questions of who, what, where and *how* is such a thing as the 'European' anyway? This is achieved – as exemplified in the samples 'strait', 'frontier' and 'settlement' by shaking the foundations of a Europe in crisis and also by demonstrating the inseparability of language, politics, philology and philosophy as culture. Apter shows us elsewhere – using the example of how translation of the French words *loi, justice* and *droit* can all be covered in their different contexts and uses by the single concept 'law' in English – how there are no direct equivalencies across languages and how the rethinking of how translation works, what are its effects and its significance, has an effect on ideas of knowledge production. This is perhaps seen most sharply in the sudden abyss that opens menacingly in Habermas's discourse when he is questioned as to the applicability to the 'Third World' of his 'public sphere' theory which he claims is for 'all humanity'. (see above in de Sousa Santos) Notwithstanding Habermas's admission that he is aware it is a 'limited ...vision', the cultural mechanics are arguably of the order of 'untranslatable'. That is to say that the words could be set into another non-European language as one protean version or another, but they might be challenging in terms of accessibility, recognition, discern-ibility and meaningfulness to what Apter calls 'ways of speaking and being' in specific cultures and/or polities.

If the phenomenon of untranslatability across languages and of shifts, ill-fits, translations, approximations makes apparent an unnecessary, incoherent and inconstant mode, internally riven with difference to the way Europe thinks and speaks, then this in turn makes us wonder if there is indeed any 'interior' to Europe, and if so, how those discursive striations play out as continuities and limits. Where, that is to say, is Europe? Following Balibar, Apter notes that there is no fixed territorial definition of Europe. That designation would shift depending on whether you judge according to membership of the Council of Europe, the EU, or the Schengen free movement zone – for all those jurisdictions are of differing territorial extent. The question is also further complicated by the continuously metamorphosing nature of the borders to any of these jurisdictions; fences, gates and barriers appear ad-hoc, in Hungary, Croatia; sudden changes are made to policing patrol regimes in the Medi-terranean and Channel. This proliferation of micro-borders, Apter says, which do not wholly impede the entrance of refugees but more often deflect that possibility to elsewhere (and thus ultimately, as pointed out above (Preciado), cost more lives.) That shapeshifting territorial element has, furthermore, taken on a more major constitutional dimension with the collapse and crisis in terms

of the European unification programme, as a relation between the nation state and the European umbrella as described by Balibar,[4] with fallout which thus far includes the secession of the UK from the EU and perhaps more consequences to follow. A further layer of potential complexity to any territorial definition is added on meditation upon de Sousa Santos's assertion that the Global South is not just a geographical concept. Clearly there is not economic and political parity even across Europe, and neither does each place have the same influence on decision making. It appears that the Global South is also marbled through European territory too in undocumented immigrants, ethnic and religious minorities, women and groups of individuals facing racism and homo- and genderphobia.

In his ruminations on the figure of the border as a heterotopia where normality between two radically different territories is suspended, Balibar gives us insight into the temporary entanglement of the issues – the lexical, the political, the spatial – when he notes, 'The reduction of the figure of the stranger to the enemy is perhaps one of the clearest signs of the crisis of the nation state.'

Ironically this intersection of the linguistic, spatial, social and historical discourses in political reality finds its most poignant expression in the citation from Middle Eastern broadcast company *Al Jazeera*, whose declaration is pinned at the top of Apter's essay as

> we will no longer use the word migrant ... We will instead, where appropriate, say refugee. Migrant is a word that strips suffering people of a voice. Substituting refugee for it is – in the smallest way – an attempt to give some back.

The linguistic racism highlighted in *Al Jazeera's* declaration points directly to the obsolescence of the European model of cosmopolitanism. As variously exposed by Braidotti, de Sousa Santos, Mbembe and others here, that cosmopolitanism, as Europe's presentation of itself as a 'universal' model for humanity via its Enlightenment notions of freedom, reason, autonomy, individual interest and natural self-sovereignty is no longer sustainable. Furthermore, the language of right, the claim to universal reach of declarations of human rights, of universal treaties, universalist models of international society and global agreements on free markets and movements often obfuscate political, social, economic and infrastructural realities on the ground in the Global South. As such, 'cosmopolitics' is proposed as an endless rethinking, retranslating, repoliticising of universals, which amongst other achievements, would allow Europe to do more beyond its misrecognition of itself as speaking to the rest (majority) of the world in univocity, to move beyond outdated and harmful fixations or fetishes like the border, and make a practical and fully conscious accommodation to global reality that finally casts off the tatters of the Westphalian settlement with its Enlightenment age obsessions with inviolable

frontiers and territorial integrity. Apter's sample work in 'philosophising in languages' here (Strait, Frontier, Settlement) to revitalise and repoliticise these concepts demonstrates how cosmopolitics can be a rethinking which repurposes and restores 'political rights whose claims are unheard in current language'. The study of these three particular terms here by Apter is also an illustration for an age where interior and limit are already merged by the ubiquity population control and covid regulation of the 'deeper and more complete analysis of enclosure' such that Balibar calls for in a cosmopolitics to renew the theory and practice of cosmopolitan citizenship. The claim is then that cosmopolitics can disentangle the notion of diversity from the obsession with borders and population control and could invent a new figure of the stranger which would not be dependent on an inside/outside exclusion.[5] In one interview, indeed, Balibar seems to call on some of the special heretical powers claimed for the essay in his aims to cosmopolitanise, 'We have to invent a generalised heresy, making both *religions* and *worldly* discourse capable of transgressing their own prohibitions.'[6]

If one aims explicitly for the heretical then clearly one expects to encounter opposition, blockage and resistance in general. In her book *Unexceptional Politics* Apter confronts critique and seems to welcome the opportunity for clarification by reproducing a review of the *Dictionary of Untranslatables* by Christopher Prendergast in the *London Review of Books*. Prendergast takes issue with what he seems to perceive as an unavoidable essentialism in the notion of the 'untranslatable' – does it smack of isolationism and the building of walls at the borders?

This is a term conservative fundamentalists like; it puts up barriers and ringfences cultures.[7]

Apter's defence, or counterargument for the liberal heresy for which we see three examples in this essay, is that 'untranslatability' is not a concept but 'a praxis of cognising philologically, deconstructively and politically.' She draws attention to the suffix -ability as an acknowledgement and an engagement with the reality that 'concepts assimilate ways of speaking and being and how ways of speaking and being interfere with concepts'.[8] Thus it is not only in its unending reality of *undecidability*, but in her numerous explicit citations, and her stress here on the word 'deconstructively' that Apter reveals the genealogy of untranslatability in the Derridean notion of *différence* as an articulation of linguistic and spatial practice. For the Derridean *différence* refers, like 'untranslatability' not only to the interminable deferral of meaning as words appeal incessantly and uniquely to other words, but also to the 'spacing' effect which allows *différence* to open up between elements in the discourse. In other words, 'place', as a static 'where', exists only as an institutional effect repressing ongoing 'spacing', and this is seen in Derrida's obsession in his work with undecidable terms like the threshold, the margin, the supplement – and instructively here, of course, translation, and the border – which all resist repression completely to the interior or exterior only, into 'place', or

otherwise into subordination by authority, hence deconstructing those institutional effects. Equally the praxis of untranslatability – as demonstrated with the sample workings on strait, frontier and settlement here – opens the question of 'spacing' endlessly, you keep on translating, it is never completed. It articulates and exposes the ruptures and discontinuities which the institutions constituting European space have sought to smooth over, to hide, to remove doubt from in order to cover the guilt and to expel the violence of European civility to the border, the limit or edge, and beyond.

Notes

1 Barbara Cassin, Emily Apter et al. (eds), *Dictionary of Untranslatables: A Philosophical Lexicon*, Princeton University Press, 2014, p. vii.
2 Ibid.
3 Emily Apter, 'Cosmopolitics', Political Concepts, 4 ('Balibar edition') (2018), www.politicalconcepts.org/cosmopolitcs-apters.
4 Étienne Balibar, 'Europe in Crisis: Which "New Foundation?"', Open Democracy, 2017, www.opendemocracy.net/en/can-europe-make-it/europe-in-crisis-which-new-foundation, accessed 6 February 2021.
5 Étienne Balibar, 'Reinventing the Stranger: Walls all over the World, and How to Tear Them Down', *symplokē*, 25(1/2) (2017), pp. 25–41.
6 Étienne Balibar, 'Democracy, Oppression and Universality', Verso, December 2017, www.versobooks.com/blogs/3518-democracy-oppression-and-universality-an-interview-with-etienne-balibar (accessed 9 February 2021).
7 Prendergast cited in Emily Apter, *Unexceptional Politics: On Obstruction, Impasse and the Impolitic*, Verso, 2018, p. 104.
8 Ibid., p. 105.

Chapter 14

Comrades of time

On 'Comrades of Time' by Boris Groys (2009)

In her book *The Human Condition* Hannah Arendt exposed the apparently unresolvable paradox of Marx's glorification of labour as what binds us to material and to nature, the 'Creator of Man' at the heart of his understanding of human history, while his vision of the future communist idyll was labour free.[1] Arendt sneers at the notion of Marx's future society as filled with private passions or 'hobbies',[2] but is that paradox to find some element of its resolution in the temporalities of contemporary art? It's certainly true that the non-productive aspect of contemporary art has always appeared as an indirect confounding of Marx's theory of value – which requires a final product as a result of labour.

Boris Groys's 'Comrades of Time'[3] is a (pluralised) literal translation of the German term for 'contemporary' – *zeitgenoessisch* – and as such the Soviet-bloc raised art critic's essay can almost be read in its assessment of discernibility, accessibility and functionality of cross-cultural linguistic notions like a long entry in Apter's *Dictionary of Untranslatables*. Groys eschews a head-on definitional and descriptive approach via literal nomination of the contemporary in the manner so admirably effected by theorists of the calibre of Lionel Ruffel, Jacob Lund and Geoff Cox – and even the somewhat mystical Giorgio Agamben. In so doing Groys avoids spatialisation of the question and shows us how art reveals our own times to us, in a Bergsonian sense of their durational intensities, as an endless, interpenetrating set of processes. Perhaps this is best illustrated by examining a work of art itself. In Beckett's novel *Molloy* there is a five-page long passage where the protagonist describes their collection of pebbles, or stones, that they keep in their pockets, and shift around, in and out of their mouth. It may, here, be the first time ever that Fukuyama has been invoked alongside or in reference to Beckett, but in this passage it appears that not only does all this work by the protagonist produce no actual product, but we experience an endlessly extended time, with no history. The five-page long section runs on in variations of this type:

> Taking a stone from the right pocket of my greatcoat, and putting it in my mouth, I replaced it in the right pocket of my greatcoat by a stone

DOI: 10.4324/9781003186922-15

from the right pocket of my trousers, which I replaced by a stone from the left pocket of my trousers, which I replaced by a stone from the left pocket of my greatcoat, which I replaced by the stone which was in my mouth, as soon as I had finished sucking it. Thus there were still four stones in each of my four pockets, but not quite the same stones.[4]

In getting at the notion of the contemporary there is a tension in Groys's narrative presentation between the reliance on a commonsensical understanding and the guidance of some canonical theoretical works in the Western tradition. In many ways this approach reproduces that of all artists to their work as understood in the German Idealist tradition as a harmony of imaginative freedom and conceptual necessity analogous to the ethical operation recommended in Kant's Categorical Imperative. At any rate, we seem to see, in Groys's presentation of it, a grounding of Derrida's critique of the present as a series of absences in the everyday experience of time as difficult to pin down, and the clichéd version of Virgil's *Tempus Fugit*; and his vernacular version of Lyotard's 'incredulity towards metanarratives'[5] as a 'disbelief in the promises' of modernity could certainly bring home a slice of the postmodern apple pie. Groys seems at first to be taking the most travelled path to the understanding of how time is experienced in the contemporary era by contrasting it with the modern conception of time as an arrow progressing steadily into the future. With a nod towards Cartesian doubt, the Wittgensteinian unnatural and Heideggerian boredom with respect to the present, the 'now' is presented with all the negative weight it bore for modernity as a hindrance and obstruction on the swift flight into progress. That's why, he explains, modernity had to dump so much tradition, in the name of hygiene and efficiency, as an economic imperative, and it may also be why he in turn loads this essay up with those weighty canonical references, which like Molloy's stones in his pocket, slow everything down.

Groys only touches very briefly the history of the modernist belief in progress and the reasons for its apparent abandonment – and rightly so, for that has been dealt with elsewhere, and at length by Lyotard, Jameson, Fisher and many other writers. Before going to specifically examine art's engagement with this age, he looks at wider evidence in society of a new prevailing critical attitude to time such that, 'The present has ceased to be a point of transition from the past to the future, becoming instead the site of the permanent rewriting of both'.[6]

This criticality is evident in a number of ways, and Groys notes that museums, for example, have become the sites of temporary exhibitions rather than permanent collections, meaning there is no longer one history and one future, but that our sense of those times is in permanent shift. This is not unrelated to Ruffel's characterisation of the 'Centre for Contemporary Arts' as the contemporary version of the museum, with its horizontality in terms of access thereinto, invitation to participate in activities (workshops and open sourcing)

and shift in form of activities – as in, from publication to co-operative pro-duction.[7] Groys also gives us insight into the reason for a contemporary obsession with the notion of 'utopia' in terms of its constant occurrence as a trope in culture – books, films, art works and so on. In Plato's *Republic* – the utopia *avant la lettre* – time itself was conceived as at a stop; Plato's explicit goal was to reinstate that Greek mythical era, the Golden Age, and with the right people placed in charge, his intention (not unlike that of Marx, as Popper was keen to claim)[8] was that nothing would change from then on, the reign of the perfect moment would last forever. As a modern, the writer who *did* invent the term 'utopia', Thomas More, was well aware that this arrested perfection had a problematic relationship with any ongoing human activity (of 'labour'). In a giveaway note of caution he writes of his own utopia that 'Everyone has his eye on you, so you're practically forced to get on with your job and make some proper use of your spare time …'[9]

And so, we all might ask, what does Molloy do with his 'spare time', or what does he make us do with ours, or does he indeed gift us some 'spare time'? But of course, in naming his paradise (Paradise coming from the Persian meaning 'delimited place') 'utopia' as a word play on both 'good place' and 'no place' in Greek, More was explicitly disavowing any fetishistic impulse and declaring that a utopia is a critical model which can be used to incessantly discuss the future and not a real place itself. Accordingly, Groys describes utopias – and Foucault's heterotopia – as sites (not *places*, we note, as per Foucault's definition[10]) where time accumulates instead of being lost. He writes:

> Politically we can speak about modern utopias as historical spaces of accumulated time, in which the finiteness of the present was seen as being potentially compensated for by the infinite time of the realized project: that of an artwork, of a political utopia.[11]

This loss of the modern conception of both a definite past and the project of an infinite future towards which all our efforts, and all our labour are directed, leaves us, as Groys says, with 'the phenomenon of unproductive, wasted or excessive time'. It is, indeed, most interesting and enlightening on this head that from the original Latin of More's circumspect phrase above – *'sed omnium praesentes oculi necessitate aut consueti laboris, aut otii non inhonesti faciunt'* – not only is 'job' given as the translation of *'labor'* (here in the dative case *'labori'*), but 'spare time' represents the Latin *'otium'* (here in the genitive case *'otii'*). This latter is a very interesting concept – again it could almost appear itself as an entry in *The Dictionary of Untranslatables* – which in its variegated cultural form of its untranslatability gives us an insight into a very specific range of ancient Roman understandings of the relationship between time and human activity. 'Otium' can mean leisure, or free – 'spare' – time, time in retirement, time devoted to artistic pursuits, to writing, to gardening, to contemplation

and relaxation. The word for business or work – *negotium* – (in English 'negotiation') is formed in framing it verbally as the opposite, the negation of *otium* – *neg-otium*. In the light of the Roman ruling classes' disdain for labour, and even for the notion of a professional calling, the definition of business as being that time when one is not at leisure makes a certain sense as contrary to the modern 'democratic' notion – promoted by More with an undertone of menace at the period of the Reformation and at the onset of modernity – that leisure ('spare time') is defined for 'everyone' ('*omnium*') by the lack or the end of labour.

With the abandonment of modernity's project of the future however, and the running down of the labour necessary to create the new material towards that infinite future, are we left with only wasted time, spare time, excess time and immaterial work as theorised by Negri and others? The age is characterised by the non-productive excesses of social media – Facebook, Twitter, Instagram – where global masses of users all operate in what Groys refers to as 'non-teleological time' in an incessant present. Groys writes of 'wasted, non-teleological time that does not lead to any result, any endpoint, any climax', and he conceives of Bataille and Nietzsche as having been the prophets of such an age. Bataille with his notion of repetitiveness, an unproductive waste of time, as the only possibility of escape from the modern ideology of progress, and Nietzsche, with his concept of the eternal return of the same (think social media ...) as the only possibility for imagining the infinite after the Death of God.

As a critical exemplar of the type of artist and artwork working with or in this type of endlessness, it is interesting, given our own choice of Beckett's *Molloy* above, that Groys, as a critic of the visual arts, also chooses a literary work – in Camus's retelling of the myth of Sisyphus, where the protagonist has to spend eternity in the underworld with the aimless, senseless task of pushing a boulder with great effort back up a hill after it rolls down to the bottom again. Groys's summation of that myth would also pass for a judgment on the passing of Molloy's stones: 'a pure and repetitive ritual of wasting time – a secular ritual beyond any claim of magical power, beyond any religious tradition or cultural convention'.[12]

The classification as ritual is key here. While this notion of non-teleological, or the non-productive aspect of art might seem familiar to the sense of Kant's seminal definition of the attitude and approach of art as 'purposiveness without purpose', the difference is that here the emphasis is on time, on producing an excess of time by repetition and other methods, rather than on creating some purposeless object (e.g. a painting, a piece of music, a sculpture). Yet it is not clear what Groys might mean, by his assertion that this ritual can be beyond both 'religious tradition' *and* 'cultural convention'. Studies of antique religions (i.e. pre-positive faiths) show that they had for the most part no creed; they consisted entirely of institutions and practices.[13] That is to say that there was no authoritative interpretation of ritual, it was imperative that certain things

should be done, but everybody was free to put their own meaning on what was done.

When Groys finally brings the essay round – and home we feel – to the discussion of the contemporary as time-based art, it is with a particular focus on the change in our mode of experience from the passive viewing of a film in a movie theatre to the type of engagement invited by a showing of an artist's film in a gallery. The passive (*vita contemplativa*) aspects are disrupted by the fact that the film there is on a repetitive loop of whatever length; that we are neither invited nor expected (-standing in a disorderly fashion among other viewers) to experience it as one whole in one complete viewing (it is near impossible to time our entrance exactly at the beginning); it is viewed as an exhibit rather than as a focused entertainment; it is displayed in a gallery among other exhibits with which we may of may not make connections; we can return to see it again, still there, at a different point in its duration perhaps, but still going on its loop. Groys notes that – as I have just pointed out about pre-modern religion – there is 'no goal of producing aesthetic judgement of choice', instead what happens is simply the ritual, 'the permanent repetition of the gesture of looking'. Thus, we at once move to a state beyond the modern, and simultaneously return to a state before the modern conception of time. A state where, as Groys puts it, time-based art turns a scarcity of time into an excess of time: there is no aim, no endpoint, no redemption. Lionel Ruffel has written – with great insight – that the appropriate and indeed vital question to ask of this era is 'How are we contemporary?'. Arguably, with a reading of Groys, we can adapt and refine that question into 'How do we do the contemporary'?

Notes

1 Hannah Arendt, *The Human Condition*, University of Chicago Press, 1958.
2 Ibid., p. 118.
3 Boris Groys, 'Comrades of Time', e-flux, 11 (December 2009), www.e-flux.com/journal/11/61345/comrades-of-time.
4 Samuel Beckett, *Molloy*, in *the Beckett Trilogy*, Picador, 1979 [1959], p. 64.
5 Jean-François Lyotard, *The Postmodern Condition*, University of Minnesota Press, 1984.
6 Groys, 'Comrades of Time'.
7 Lionel Ruffel, *Brouhaha*, Verdier, 2016.
8 Karl Popper, *The Open Society and its Enemies*, Routledge, 2002 [1945].
9 Thomas More, *Utopia*, Penguin, 2000, p. 84.
10 Michel Foucault, 'Of Other Spaces: Utopias and Heterotopias', trans. Jay Miskowiec, in *Diacritics*, 16(1) (Spring 1986), pp. 22–7 (originally published as 'Des Espaces Autres', *Architecture, Mouvement, Continuité*, 5, October 1984, pp. 46–9).
11 Groys, 'Comrades of Time'.
12 Ibid.
13 W. Robertson Smith, *Lectures on the Religion of the Semites*, Adam & Charles Black, 1889, pp. 16–17.

Chapter 15

The mentality of
the Anthropocene

On 'The Brain of History, or, The Mentality of the Anthropocene' by Cathérine Malabou (2017)

The philosopher Cathérine Malabou is most well known for her development of the concept of *plasticity*. She herself ascribes its invention to Goethe, and as a self-declared continental philosopher she sees its initial development in Hegel, which through her own work she transforms into a comprehensive concept which has, as it were, come of age.[1] Malabou has given form to this concept and elaborated it across countless fields and disciplines, such that it undoubtedly has the status of a 'universal' – that category problematised above in the work of Apter, Braidotti, de Sousa Santos and others. A definition of plasticity, or the plastic, that would give universal applicability would the 'the capacity to give or to receive form' in the sense that something can change its form definitively or cause another to do so. Malabou stresses repeatedly, however, that plasticity is not the same as flexibility, which latter only adapts given form, and does not mutate form and thus is a conservative principle which is 'mimetic and reproductive'.[2] Malabou has developed the concept of plasticity and brought it to light in her writings, and develops it through applications as various as the psychoanalyses of Freud and Lacan, the philosophy (and specifically 'grammatology') of Derrida, to the question of the transcendental in continental philosophy, the literature on Kafka and to our relationship to Artificial Intelligence and to the Anthropocene, among many others. Malabou has called it the 'motor scheme of our time', its 'coming of age', and 'the style of an era'.[3]

The specifically contemporary relevance and power of the concept is derived from the field of biology, and more particularly epigenetics. Epigenetics is a term developed by Conrad H. Waddington in 1942 to describe causal interactions between genes and their products, and is used now to refer to the mechanisms through which the environment and culture modulate the unfolding of the genome. Advances in epigenetics have overturned previous notions of genetic determinism, whereby an organism's fate is held to be fixed by its DNA. For in fact, forms of life formerly considered rigidly fixed by that order have the power to develop and change, and are open to constant metamorphosis. The argument from epigenetics is basically that our biological being is not totally determined by the given DNA coding: it is not that the

DOI: 10.4324/9781003186922-16

organism can change that code but that it can translate the code in different ways depending on context of the reading and other factors. Malabou compares the situation to that of a composer's musical score which is given different interpretations at each performance by different conductors, orchestras, musicians etc.[4] In fact the arts are not only invoked as possible analogies here, but are involved as an active part of the culture in effecting change through engaging with the neural plasticity of the brain.

What is interesting about this concept of plasticity is not just the interdisciplinarity of its application, but also of its source. Malabou has noted that up until now biology has been 'repressed' by philosophy.[5] The reconciliation of these two disciplines (-or the recognition of biology by philosophy) has special resonance and should have significant analytical effect in the age of Anthropocene (as seen below). For as Malabou asserts, there is no such thing as the existence of a split such as suggested by Deleuze, between an entirely determined biological body and a symbolic body without organs. Indeed, in her discussion of psychic matters it is significant that Malabou writes of the actual biological body; refers to neuroscientific work and discusses the brain, although in this context is also included the extra-cranial brain, meaning the externalised field of intelligence across a techno-socio-cultural habitus. Thus Freud, for example, in his mature work never defers to neuroscience (despite the fact that he originally qualified as a neuroanatomist), explicitly denies that his spatial expositions and diagrams represent the brain, claiming that they show only the topographical nature of the workings and processes of consciousness. The concept of plasticity, in its use by Malabou, can be understood then as a radical opening up of philosophy and Western thought to what might have been considered its other as constituted by the biological and mentality as embodied and situated in specific places. It is also as a recognition that one has power to develop out of oneself, and that all values are of a mutable character, such that the gamut of expediences, on the hoof policies and techniques as 'clamp, stick, fold, dump, glue, shoot, double, fuse' that Koolhaas describes in the attempt to build walls and maintain and adapt borders to prevent change and keep the outside and the other out, are exposed for the desperate and oppressive impulses they are. Indeed if Koolhaas's stylised aphoristic prose makes a dystopian mythology out of our banal and frigid political and spatial realities, then in a bizarre mirror image the wall Donald Trump said he would build at the Mexican border became more fantastical and less real the more he obsessed and fetishised on the physical features of its closure in his incoherent staccato ravings. At various different times Trump described how it would be painted black, how it would be made of transparent material (evidently so 'we' could see the Mexicans throwing their bags of drugs over …), how it would be covered in solar panels, and how it would be fronted by a ditch filled with alligators and snakes. That border wall was in fact, never built.

The fact that Trump was a cynic about climate change is not unrelated to his desire to see a wall of whatever sort bolstering the USA's borders. That

reluctance, misunderstanding, indifference and inability to empathise is one of the central themes of Malabou's 'The Brain of History, or, The Mentality of the Anthropocene'.[6] At the outset she describes the work as an essay which explores 'the link between the current constitution of the brain as the new subject of history and the type of awareness demanded by the Anthropocene'[7] In that essay Malabou never mentions the concept of plasticity by name (she does cite one principal theorist in the field using the term 'plastic') yet nonetheless, the understanding and knowledge of it is implicit and informs the direction of the narrative, driving it towards the conclusion. It is not only the definition of the Anthropocene but how it is defined and by whom that is important for Malabou's thesis. It is generally understood as the geological era in which human activity started to have a significant global impact on the earth's climate and ecosystems. The concept Anthropocene was popularised and put into wider discussion from 2000 onwards by atmospheric chemist Paul Crutzen, and although a disciplinary working group, Anthropocene Working Group of geoscientists, voted to recognise it in 2016 officially as a subdivision of geological time, neither the International Commission on Stratigraphy nor the International Union of Geological Sciences have yet done so, though the formal proposal will be submitted in 2021. The Anthropocene is thus widely understood in the popular mind as abolishing the split between nature and culture. Yet, as Malabou points out the issue is far from resolved so easily: that the Anthropocene as defined is at once both a historical moment and a natural geological era leaves us with 'two concepts that have always been if not incompatible then at least epistemologically heterogenous.' This unresolved hybrid status and the hesitation of the professional bodies is perhaps partly caused by the uncertainty concerning the chronology of its emergence. Some scientists believe that the Anthropocene really began in the late eighteenth century with the Industrial Revolution, some that it was brought on 12,000 years ago by the current geological designation the 'Holocene' and can be timed as far back as 10,000 years ago. It is this dilemma that, for Malabou, opens the question up as a philosophical one, for the relationship between history and nature has always been a prominent one in the domain of philosophy – going back as it does to Aristotle's definitions in *The Physics* of the conception of nature and animality and Plato's nature in *The Timaeus* and beyond.

Malabou performs her exploration of the Anthropocene as a dialectical critique, reading principally the works of Dipesh Chakrabarty and Daniel Lord Smail through one another respectively as thesis and antithesis. Both these authors refer – one taking a geological viewpoint and the other biological – to Deep History as a history that looks beyond notions of recorded and pre-history, defined by Edward Wilson as where 'Human behavior is seen as the product not just of recorded history, the combined genetic and cultural changes that created humanity over hundreds of [thousands of] years.'[8]

For Chakrabarty, Malabou explains, the Anthropocene as a concept opens a split between the human as a self-reflexive free agent and a natural organic

power. These are incompatible operations. The human as conscious can acknowledge the Anthropocene, but cannot experience their operation as a force of nature in the geological sense. The paradox is, according to Chakrabarty, that to appear to themselves as a geological force, they would have to have a structural sameness to the geological world, to 'become geological' – and to achieve that they have to lose consciousness. So, to be fully aware of the Anthropocene we have to be both human and non-human. This is not the same as the type of interspecies concern as we see in, for example, Braidotti and Tsing, and is even at a much deeper level than Haraway's calls for genetic exploration. For Chakrabarty, as Malabou puts it, this notion of a geological agent remains beyond consciousness and as such out of human experience. Here Malabou poses the antithesis towards a synthesis of that human/non-human question via introduction of 'the brain' rather than 'consciousness'. 'Is not the brain' she asks, 'on which Chakrabarty remains silent, an essential intermediary between the historical and the biological and the geological?'[9] To do this Malabou introduces the work of Smail, whose understanding of the Anthropocene also works through Deep History, and privileges the brain and biology (to Chakrabarty's chagrin). Smail's approach is epigenetic (as described above) and Malabou draws on the work of Malafouris[10] to demonstrate such a materialist, non-transcendental understanding of cognitive development proceeds by stressing the interaction between the biological and the cultural, and through things, matter and the organic. Smail, for example, also notes that all the great historical disciplines – geology, evolutionary biology, archaeology, historical linguistics and so on – depend on evidence extracted from things. Malabou puts it thus:

> It is a 'nonrepresentative' vision of interaction which requires no subject-object relationship, no mind seeing in advance what has to be made or fabricated. Mind, brain, behaviour and the created object happen together; all are part of the same process.[11]

One of the most notable features of this understanding is the historical dimension it lends to Barad's scientific outline of ontoepistemology and what she calls intra-action, as outlined above. While Malabou comes to this understanding from ontology via the life sciences, Barad appears to arrive at a very similar position from the physical sciences via phenomenology.

Malabou however, then points out that Smail takes things further by insisting that the constant interaction between the brain and the environment is based on brain/body state alterations. Smail explains that the brain maintains itself in relationship to its environment via addiction. Chemicals introduced from outside (e.g. coffee, alcohol etc.) or produced within (endorphins etc.) by emotions and feelings (e.g. oppression, success etc.) facilitate or block signals along neural pathways ultimately manipulating the plasticity of the brain and, in effect, allowing adaptation and commitment to new environments. This

understanding complements Anna Tsing's history of the commitment to the grain (above), by letting us see, as Smail explains, the Neolithic revolution and the rise of agriculture as an *addiction* to an expansion in calorific intake (as well as other effects).[12] It is thus as Malabou puts it, that all passages from one age to another produce new addictions and chemical body state modulations. And equally, to overcome the indifference which Chakrabarty sees in our attitude to climate change which is stuck at the level of awareness and responsibility – Smail says we have to get addicted to it, and as Malabou writes, in new modes of living, understanding, thinking, ways of eating, travelling, dressing and so on:

> How can we feel genuinely responsible for what we have done to the earth if such a deed is the result of an addicted and addictive slumber of responsibility itself. It seems impossible to produce a genuine awareness of addiction (awareness of addiction is always an addicted from of awareness). Only the setting of new addictions can help in breaking old ones. Ecology has to become a new libidinal economy.[13]

Ultimately the dilemma for Malabou is that, if humanity is not responsible for finding itself in this world, how is it then to take responsibility for its non-responsibility?[14]

The paradoxical complexities of new addictions could be a way forward to this new type of responsibility. Such addiction, by definition cannot be fully conscious, and both belongs to a wider set of processes that take place and that Malabou refers to as mentality. The significant aspect here of Smail's theory of addiction – chemicals affecting behaviour – is that these processes constitute a communication and passage, an intermediary, between biology and culture, between the material and the neural, between the geological and the biological, between the absence of consciousness and consciousness. Thus they address Chakrabarty's problem of the paradoxical necessity, in facing the question of humanity's role as a geological force, to be both human and non-human. As Malabou puts it, 'We find again the idea that the brain is the mediator between the two dimensions of (deep) history: the natural and the historical.'[15]

Malabou closes in the final pages of the essay with a discussion of the concept of 'mentality' as developed out of the work of Braudel and the École des Annales, who show how the historical force of natural time puts a drag on, or has a narcoleptic effect on social, economic and political temporalities. This led to a history of mentality as a hybrid concept comprising the materiality of the world as well as human behaviour. This concept is not as well worked out as the previously outlined dialectic between Chakrabarty and Smail, and it may well be significant in that context, that in the talk given under the same title in Sweden in 2017 to Moderna Museet, she left that section out of her presentation altogether.[16] She calls for a 'renewal and re-elaboration of the concept of mentality'. She is nonetheless clear on the definition of the locus of its

operation 'as an intermediary between the geological and the biological … between the brain, the absence of consciousness and consciousness' and on its efficacy as a notion, which unlike 'neural' evokes the emerging and mingling of materialities, even if she does not satisfactorily unpack its provenance and constitution here. Perhaps the envoi to that talk in Sweden is the best place to close here though, for she leaves it with a description of Guattari's concept of Ecosophy, and his observation that the Anthropocene means not only change to the world, but also a change in human subjectivity.

Notes

1 Catherine Malabou, *The Future of Hegel*, Routledge, 2005, p. 56.
2 Benjamin Dalton, 'What Should We Do with Plasticity? An Interview with Catherine Malabou', Paragraph, 42(2) (2019), pp. 238–54, at p. 247.
3 Catherine Malabou, *Plasticity at the Dusk of History: Dialectic, Destruction, Deconstruction*, trans. Carolyn Shread, Columbia University Press, 2010, pp. 1, 15.
4 Dalton, p. 242.
5 Ibid., p. 241.
6 Cathérine Malabou, 'The Brain of History, or, the Mentality of the Anthropocene', *The South Atlantic Quarterly*, 116(1) (January 2017), pp. 39–53.
7 Ibid., p. 39.
8 Cited ibid., p. 41.
9 Ibid., p. 45.
10 Lambros Malafouris, 'Metaplasticity and the Human Becoming: Principles of Neuroarcheology', *Journal of Anthropological Sciences*, 88 (2010), pp. 49–72; Lambros Malafouris, *How Things Shape the Mind: A Theory of Material Engagement*, MIT Press, 2013.
11 Malabou, 'The Brain of History', pp. 42–3.
12 Ibid., p. 46.
13 Ibid., p. 49.
14 In a talk given to Moderna Museet in Stockholm in 2017 as a version of this paper, Malabou appears to make an easily done slip of the tongue and say 'we are irresponsible for our presence in the world' where it appears likely that she actually means 'not responsible'. That slip does, however (as I will argue below in the Afterword) introduce an interesting further complexity to the notion of human responsibility. See Catherine Malabou, 'The Brain of History or the Mentality of the Anthropocene', talk given to Moderna Museet, Stockholm, 2017, www.arta ndeducation.net/classroom/video/276251/catherine-malabou-the-brain-of-history -or-the-mentality-of-the-anthropocene (accessed 1 March 2021).
15 Malabou, 'The Brain of History', p. 47.
16 Moderna Museet talk (note 14 above).

Afterword

When asked in interview about how others should explore the concept of plasticity in their own field, Catherine Malabou's opening response was as follows:

> You cannot really write a discourse on method about this because energy is unpredictable.[1]

This can be read as a version of Malabou's weighing up of the question of responsibility and non-responsibility of the human in relation to their existence on the earth. Accidents will happen, the unexpected, unpredictable and uncontrollable will take place, chance and the contingent will present themselves, so what should be the quality, she seems to ask, of our responsibility for our non-responsibility? It is significant that Malabou explicitly sides against Descartes in coming back to that question. Descartes's *Discourse on Method* has long been received as a response, if not an outright disciplinary rejection of the conversational, anarchic – and indeed, self-confessedly 'frivolous' – nature of the essay, and of Montaigne's essays in particular. Montaigne may have originally have set out on his essayistic journey in 1571 with the stoical aim of self-sufficiency, yet it is through the writing of the essays that we see he came instead to the sceptical standpoint embodied in that motto '*Que scays je?*'

The stoic ideal of attaining rational autonomy from the buffetings of fortune and suffering of the world by retreating to an inner realm and retaining control over the representation of the external can be gleaned from this passage from Epictetus:

> Some things are under our control, while others are not under our control. Under our control are conception, choice, desire, aversion, and in a word, everything that is our doing; not under our control are our body, our property, reputation, office, and in a word, everything that is not our own doing.[2]

With his own methodological update in 1637 of such control through radical isolation, Descartes seemed to have perceived Montaigne's frivolous essays as

DOI: 10.4324/9781003186922-17

irresponsible. Descartes thus secured certitude for the self – the ego – and distinct formal separation of the interior and exterior worlds where Montaigne's nomadic ramblings through that exterior world produce only doubt and uncertainty about who he is and what he knows. While Montaigne claims from the very start that he himself is the 'matter' – that is the subject and the object – of his essays, the irony is that does not give his assemblage of writings, of objects and authors a unity or a focus like Descartes's project for a 'method'. Indeed, as a subject assembled from many diverse parts speaking through the words of innumerable other cited authors, Montaigne refuses a position of singularity. These cited passages in turn lead us off in and to many other interpretative and discursive directions and possibilities such that it is impossible to know what limits might mark the range and capability of this one subject's intentions, desires, knowledge and understanding. This demonstration of lack of epistemological mastery breaks the limits and borders that would be set to the autonomous certain self of the interior in the Stoic model. Through writing essays on many objects, dependence on otherness and the 'exterior' world is progressively assumed. Thus, there is no refuge in self-sufficiency, but a subject always in construction, an uncertain, changing, discontinuous, contingent and incomplete subject in continuous revelation via engagement with accidental processes and 'unpredictable' energies and 'frivolous' exchanges. As we see in the work here by Ngai with her application of Master–slave dialectic to the cuteness of *Hello Kitty* graphics and *Manga* kids, and Moten and Horney's swearing at the racist machine, the essay refuses the notion of a relevant distinction between the mature and the puerile, the seriously valid and the trivial. In Malabou's terms we might say then that this probing and breaching of limits in the essay is a continual testing (*essai*) of the subject in terms of its responsibility for those things for which it is not ostensibly responsible. That type of testing may indeed grant us a Montaignesque liberty with Malabou's evident slip of the tongue in her spoken presentation version of 'The Brain of History of the Mentality of the Anthropocene' presented at Moderna Museet in Stockholm in 2017.[3] We might expand, that is to say, upon her closing conception that as regards the Anthropocene, we must take the responsibility for the things for which we are not responsible. Her 'irresponsible' slip ('we are irresponsible for our presence in the world') opens up by chance – or perhaps, who knows, by design? – a vista of a more complex triadic interplay of intention, due consideration and consequence than the simple responsible/not responsible dualism. For when someone acts 'irresponsibly' then their action operates as a disavowal of Kant's unity of time and space in the sense that their intention is properly detached from those dimensions, no due consideration is, by definition, given to rational consequences, hence they are not acting as a moral agent, according to Kant's categorical imperative. Yet in Deep History there is a different sort of time from the unity of time proposed in Kant's *Critique of Pure Reason*, and it is one for which humanity can have no responsibility. Thus, to adapt and expand Malabou's conclusion, it is only if we

understand our non-responsibility (Malabou's 'irresponsibility') as a geological force or an addictive brain that we can conceive of it as irresponsibility not to take responsibility for the Anthropocene.

It is significant too that Malabou finishes her verbal commentary on the work of that essay by referring to Guattari's observation that the Anthropocene means not only change to the world but also a change in human subjectivity. This conception of the subject as something shifting and uncertain and the refusal of the essay (or indeed its inability as a form) to hold a discourse within the definitional bounds of the rational, moral subject constructed by the methodical Descartes and the categorical Kant gives direct insight into what might be meant by the essay's heretical status. For to call something a heresy is to invoke a complex topography. The heretic is neither one of the faithful as such, nor an outright infidel: the designation is concerned with position and vectors of relative movement rather than with place. In order to be so the heretic must begin from within the orthodoxy – in the Christian church this has meant, for example, being baptised – and their beliefs, opinions, views or practices take them beyond, outside the official or permissible doctrine. As such the concept of the heresy can only belong originally to the positivist faiths (as outline above in the Groys chapter) where certain beliefs are presented as orthodox. In the sense that the hacker, in Denise Ferreira da Silva's presentation of it, reverses the order of positions and vectors – as a breaking in, that is from the outside to the inside – it cannot be considered properly as a heresy. There is also the sense that the hacker breaks from outside to the inside in order to set the orthodoxy awry, whereas the heretic breaks out in order to set the orthodoxy aright (in their own opinion at least).

Ultimately however, that designation heretic or hacker, awry or aright, depends on the position and the power of the subject who observes, decides on or describes the operation. Who gets to decide which is inside and which is out? A standard establishment view (i.e. by the 'rational men' who are 'upstairs' in 'polite company') might follow US President Gerald Ford's useful 1969 judgement on impeachment (a form of legal process prosecuted against those we might understand as political heretics in that country) that 'an impeachable offence is whatever a majority in the House of Representatives considers it to be at a given moment in history'.[4] So judges the inside on a fellow who breaks out, and equally, of course do the cardinals at the Vatican decide on the status of heresy. The essay, however, performs a continual probing of these issues. What are the limits, consistencies and differences between the two – inside and outside? Which is the grain in Tsing's fenced off, well ploughed, pesticide-sprayed fields, and which the fungi in the weed-infested marginal interstices? In the case of the liminal 'marronage' exploited as a notion by Moten and Harney for example, there is the impossibility of a *place* outside the given deeply oppressive and pernicious order, which entails that the fugitive, the subversive subject, the disaffiliated subject, can only exist as a series of positions and movements in relation to that ubiquitous order.

It is being in motion that has learned that 'organizations are obstacles to organizing ourselves'.[5]

As proposed above, Moten and Harney's attitude in the frivolous nomadic aspect of the essay form, can, to a certain extent, be encapsulated in Apter's notion of the *impolitic*, which in her definition as 'disidentification with a community, with a habitus of citizenship' (and see both Montaigne and Hume's placement on the Index) covers both the, apparently different, directional vectors of the heresy and the hack.

One after the other we find that these contemporary essayists problematise the inside/outside dichotomy, to probe its qualities, to set its new and break its old limits, to question its very existence, to bemoan and critique its persistence as a device structuring our relationships. From Koolhaas's satire on the inability to see beyond the sticking plaster on the end of our nose and the obsession with build, build, building to keep the outside out, to Preciado's perception of the inside as having retreated to a position within our very bodies – where the disciplinary mechanisms of Foucault's biopolitics are no longer understood merely as physical apparatuses inhabited by our bodies like the Panopticon but have been absorbed and ingested (e.g. the pill, Viagra etc.) so that they themselves inhabit our bodies. The question is always raised, that is to say, to outline or detail how sinister is the operation of that exclusionary structure, the inside/outside. Barad, however, takes an unusually technical route to the undoing of that dualism. It is related to quantum physics and denies not just that any transcendental being is locatable but that neither is any transcendental knowledge possible, such that being and knowing are always expressed within phenomena as intra-active. That there is no technical possibility of an outside there anyway arguably obviates the need for a political or moral critique of the structure, and may well stand as some sort of indication of the likelihood of its endurance as a thesis. Enduring is also a key feature of Sara Ahmed's conception of a familial environment. The moral economy of that environment, as Ahmed describes it – although she never actually uses the terms 'inside' or 'interior' – is entirely topographical with sets of gender, generational, patriarchal and other power relations playing across a strong central feature – the table, at once metaphorical, symbolic, everyday and practical – around which all the relata are positioned, and over and through which these positions are negotiated. Staying with that particular trouble, or persisting in the interior, 'at the table' of the family means not turning one's back on those relations however uncomfortable, and moving into exile. As she puts it, 'Feminists might be strangers at the table of happiness.'[6]

Ahmed accordingly conjures up the figure of the 'wretch' as, by definition, a stranger or an exile, a person who is vile or hapless or in deep distress. The 'wretch' for her is that unwelcome figure who refuses nonetheless to remove herself from the table – like Moten and Harney refusing to refuse the University, and like them also, she persists as a stranger, bearing to the table the strange possibilities of the other.

Right from the epigraph at the top of her essay, citing Al Jazeera on their policy on nominating refugees, Apter is on the case of strangers in the interior, and to what extent the stranger is a figure constituted by the very notion of inviolable interior/exterior division. Cosmopolitics as such is a continual analysing (taking the components apart and recomposing them) of difference and the diverse, not in order to deactivate or assimilate them, but to reveal those possibilities which would allow difference, and also limits, edges and frontiers to exist between differences in types and forms, without the fetish of a necessarily opaque and inviolable border – the Trump wall! – to hold them apart. If, as Balibar assesses, that needs a deeper and more complete analysis of enclosure,[7] then Moten and Harney's 'marronage' of operations around and in relation to the slave plantation, Ahmed's open exposure of territory with her topographical table, Preciado with his dermatological border control, and Mbembe's necro-political understanding of Weizman's exposé of the vertical (-or sectional) segmentation as a 'splintering occupation' of two 'separate geographies'[8] are all already in haptic and material complement to the etymological and lexical engagement by Cosmopolitics with the consistency of the 'insides'.

We might well wonder if this persistent concern with enclosure and the structure of an inside and an out, and their interrelation (if any), is an unavoidable part of the programme. The essay is a short form, after all, which is itself subject to limits of extent and content, whose meanings and intentions may point in many further directions, but which must always be nonetheless self-standing, a valid contribution on its own. At any rate, such formal considerations must in turn raise the question of the universal and the sovereign, for despite its subjective mode, the essay, again by definition, always essays to flourish with influence, engagement and validity beyond its own set limits as a form. The universal, as such, clearly admits of no exteriority to its validity, the essay might then be a congenial vehicle for exploration of the evident paradox of the heretofore unstoppable European juggernaut of universalism – the universal rights of man, the universal free flows of globalisation (goods, capital and labour etc. ...) – as coexistent with the current European obsession with borders and exclusionary practices. We might pronounce that 'heretofore' at this point of course, because as Braidotti shows us this 'hegemonic cultural model' of 'self-aggrandising'[9] came from a Europe which was not only of indeterminate extent as per Apter's critique, not even 'a geo-political location',[10] but rather a 'universal attribute of the mind'[11]-which is no longer sustainable (if ever it was ...). To be worthy of our times, writes Braidotti (the times that according to Groys are of interminable duration) new constructions of the human in the Humanities bring us face to face with the colonial legacy of racism and exploitation, the exclusionary regime of the patriarchy, the ongoing crude and cruel biases of globalisation, and the excluding – to death – at Europe's borders of desperate refugees, all of which make a mockery of the centuries-long European profession of universal humanity. That denial of the geo-political location of 'Europe' finds its mirror image in de Sousa Santos's

assertion that the Global South 'is not a geographical concept'. So these various institutionally demarcated Europes that we find listed in Apter, are all marbled through with manifestations of Global South, which latter, as de Sousa Santos has it, consists in ' a metaphor of the human suffering caused by capitalism and colonialism … and of the resistance to overcome or minimize such suffering'.[12] It is in such a context, of such suffering and minimal action, that we might read Ahmed's feminist critique of a published and purportedly general history of happiness (it presents itself implicitly as general …), wherein she finds only one reference to women – and following that up discovers it is actually a reference to J. S. Mill's 'The Subjection of Women'. The 'general viewing point is itself rather particular'[13] is Ahmed's somewhat bathetic remark in response to that discovery. The 'general' is naturally not quite the same as the 'universal', apparently has a more pragmatic pitch as opposed to the ideal 'attribute of the mind' in the universal, yet Balibar, for example, sees something a lot more complex in it and proposes the 'universal' as not really a concept or an idea but 'the correlative of an enunciation that, in given conditions either asserts the differences or denies them (or even prohibits them)'.[14] Nonetheless, deconstructing the role of the general as a strategic component in building the ideological orientation of universals is clearly understood by Ahmed as a task that can be taken on by the subjective mode of the essay, – that the 'very form of coherence' of the general can be 'troubled' there. At the pragmatic conference of the dining table, she writes of 'shared orientations'[15] in which she is asked to assent and participate whereby the reality of who takes precedence and priority in these sharings reveals the power dynamic and the underlying ideologies.

Equally de Sousa Santos in his essay here shows how that European hegemony as a 'universal attribute of the mind' breaks down on a pragmatic front in the confrontation, mutual unintelligibility and hostility between western leftist theory – whose privileged and prioritised position informing action is long established in European strategic political struggles of the nineteenth and twentieth centuries – and the activism of grassroots progressive movements of the Global South advocating and agitating for social justice – often through spontaneous and heterogenous types of action. This prompts a playing to the strengths of the essay, that is to say, not with a call for the abandonment of theory, but for epistemological diversity, and the recognition that the relationship between the discrete case and the summative continuities of the general can neither be monodirectional nor simply and necessarily prescriptive. We also see in the work of Weizman how the question of practice is put into an antagonistic encounter with authority. In this case the authority is usually that of state power rather than of canonical western theory. Architecture, it is true, does not seem, on first impression, a promising medium for carrying forth this struggle. The discipline does not appear to be adequately equipped in versatility or pragmatic spirit to emulate the essay and adopt a heretic disposition in its practices. Indeed, the claim to steady, un-troubled or – troubling objectivity, and to the status of the ideal is nowhere more in

evidence than in the art of architecture. As noted above, the three types of drawing formalised in the procedure of architecture by Raphael, plan, section and elevation, all frame a totally objective space, which in reality could not be viewed from any individual or subjective viewpoint at any one time. The type of spatial practice curated by Weizman uses open source, finding subjective witnessing, partial views, contributory and corroborating testimonies where it can, in order to create a space constructed entirely from an assortment of positions and a type of vector of movement in terms of its view to the action taking off – and perhaps also its engagement with it. It is indeed a subjective model assembled from a plurality of localised, situated perspectives with none of the pure, abstracted and objectivised calculation of traditional western architectural method. As Weizman states, the more details and testimonies are gathered – as a commons – the more complete the picture of the event. In this understanding that picture of the event can never be fully objective like traditional plans and drawings of an architectural space, but has a *tendency* towards objectivity. There is no final endpoint as total truth. This 'truth as a practice' in the evolving everyday acts, as he describes it, to 'socialise production of evidence'[16] in the individual, particular projects they take on, so that, as with the case of the essay, they do not seek totalising but particular practical truths of one situation at a time (although as Weizman puts it, in doing so they find not just 'the evidence of what happened, but the evidence of social relations that made it possible'). Again, like the work of the essay then, there is a mutual production going on here, the subject constructs its truths, its text, its testimony, and subjecthood itself is constituted in its possibilities by those truths, that text, that testimony.

What we witness here is how the contemporary era manifests everywhere in a coexistence – in a superposition as Ruffel has it[17] – of a multiplicity of worlds and temporalities, in a problematising of enclosure and limitation and the related question of universals, and a decentring of knowledge production that continually reconstructs the subject through endless articulation of positions and vectors of movement. It is thus no mere coincidence that Weizman's politically tendentious models – at once dense and spare – of interwoven multiple systems and formats, piecing together vectors from, among many other things, car number plates and institutional insignia on vehicles, cloud movements, take-off and landing times at airports; should in their quotidian empiricism bear such a striking resemblance to the understanding of the operation of overlapping systems of subordination that Kimberlé Crenshaw portrays in her metaphor of intersectionality as a road traffic junction:

> consider an analogy to traffic in an intersection, coming and going in all four directions. Discrimination, like traffic through an intersection, may flow in one direction, and it may flow in another. If an accident happens in an intersection it can be caused by cars travelling from any number of directions and sometimes from all of them. Similarly, if a black woman is harmed because she is in an intersection, her injury could result from sex

discrimination or race discrimination ... But it is not always easy to reconstruct an accident: sometimes the skid marks and the injuries simply indicate that they occurred simultaneously, frustrating efforts to determine which driver caused the harm.[18]

Both counter-forensics and intersectionality, that is to say, are analytical systems which have developed in acceptance of and to assess, expose, engage and negotiate with the effects of this complex of interacting multiplicities and simultaneities of the contemporary age as discussed in all their variety throughout this book. Intersectionality was first proposed in the late 80s by feminist scholar Crenshaw as an exploration of the way black women face oppression, discrimination, inequality not simply on the basis of the equally parcelled out effects of gender and race, but of both intersecting at the same time and producing especially oppressive effects in their simultaneous and irreducibly entangled operation. Without – and before the possibility of – an understanding of oppressive forces, a black woman fighting such oppression was asked to choose between (in a case of workplace discrimination) a racist analysis of the situation – which was based on the experience of black men, and so reproduced the patriarchal bias – or a feminist analysis, which was based on the experience of white women, and didn't deal with racism. Clearly neither of those analyses are adequate in themselves or even as seen working in series. The work that is thus taken on by intersectional analyses is to analyse simultaneous categories without reducing them to separate, wholly distinct, or exclusive operations or simply seeing them together as additive rather than interactive and inseparable. The significance of its provenance in feminist and in black studies of the period cannot be overestimated. Nonetheless, intersectionality has subsequently been applied to an expanded field to analyse discrimination, and privilege in relation to socio-political identities, including class, gender, sexuality, religion, disability, height and language and so on. As such, we see that for both intersectionality and counter-forensics there is a rejection of monocategorical thinking, and an embracing of a vision and analysis of reality as operating on multiple simultaneous converging and interacting axes, which are not simply variables added in the composition of a stable, given beyond, but which are structural components in creating a dynamic reality revealing lines of force and relations of power in ongoing operation. We see then, that both methods are grounded in experience, where subjects are constructed through the positions in which they find themselves and through the vectors of both their own movements, and those of the forces and powers which act on and around them. These analyses continually draw on the position of, and orientation to the world's positions, with respect to testimonies in the field, such that, as Weizman puts it, they are a 'practice of truth'. How, they ask (and as we have already ascribed to Groys's approach), do we do the contemporary?

It is in this performative context where practices of knowledge are not demarcated into strictly separated creative and critical operations that we can see why there should be a rediscovery of the essay as a form – the uncovering and revival of its dead body, in the metaphor of the introduction – from under Plato's idealised bed of the thesis. For in this era, methods and forms are required for research where subjects and identities in their truths are not just accepted as given and preformed before the work begins in a delimited disciplinary arena, but recreated continually as 'becoming' in the Nietzschean sense, in real life metamorphoses as complex interrelations and lines of force and power are discovered and revealed. Thus there is a 'working from conditions' as Rogoff has it, which has shifted from a disciplinary 'working from inherited knowledge', just as the complex construction of truth in Forensic Architecture's work is a rejection of the traditionally architectural construction of space via the omniscient view as set out by Raphael, for the open source engagement with an endlessly accumulative polyperspectivity of witnessing in the field, and a rejection by intersectional understanding of the validity of the simple ground of the cartesian individual as a blank slate affected only in turn by one thing or another for the experience of constitution via multiple and simultaneous overlapping systems of subordination, oppression and discrimination. That is not to say that the essay has some special relationship with Intersectionality, for example, that it is a formal tool that is a vital part of the approach or the explorative apparatus or repertoire of that system. The 'Intersectionality' edition of the refereed journal *Signs: Journal of Women in Culture and Society* (vol. 38, no. 4) published some particularly fine essays on the topic in 2013, but their scope is as descriptive and summative assessments, and a critique of intersectional theory and practice rather than a demonstration of the effectiveness of actual intersectionality in practice, or as Patricia Hill Collins puts it in her book, 'an analytical sensibility whose meaning emerges through use'.[19] Nonetheless, in its coming to prominence, the contemporary essay – as exemplified amply in discussion in the chapters above, has arisen at the same historical moment, with to a certain extent, a shared sensibility and world view, and an existential and political approach to that world, a world we see confronted, explored and exposed in the work of intersectionality and counter-forensics. Furthermore, in its disavowal, by nature of its form, of any claim in its presentation to a totality, ('Its totality … is that of something not total' as Adorno puts it), the essay acknowledges and is congenial to the reality of a multiple axes approach to analysis, and thus is always compatible as a contribution to research into simultaneous impressions and effects without reducing it to mono-categorical thought or additive models.

The essay then, in its tendency to objectivity which is never finalised, which cannot be finalised as theory given its definitionally relative scope as a balancing act, is always a praxis. Its practice cannot be understood as an exploration of the nature of the subject, for that would assume that the constitution of the subject is already given but merely occulted. It is a going out to reveal the

subject's condition as an ongoing dynamic always in formation and reforma-
tion with the forces and powers of the world in which it is encountered. As
Chun, Lipsitz and Shin have it in their essay in the *Signs* Intersectionality issue,
'it is important for progressive politics that people derive their identities from
their politics',[20] rather than vice versa, meaning that, in the essay as in inter-
sectional analysis no preformed identity by neo-liberalism, colonialism, racism,
sexism or imperialism is accepted as given. When Weizman in his models
builds towards the truth of some catastrophic local event, there is, perforce,
constructed a political and social truth of those subjects involved in it.
Mbembe's necropolitics as a neo-colonial political reality reveals truths about
his own subjecthood as a black African in engagement with that reality.
Equally that definitionally relative scope of the essay is an acknowledgement
and acceptance of the reality of a multiplicity of worlds and temporalities and
an assertion of the validity of decentred knowledge production and multiple-
axes thinking which rejects the 'simple falsity'[21] of the opposition between the
particular and the universal and its many manifestations including the prac-
tice – theory dichotomy and the daily horror produced by the imposition of
limits and borders on the world by the incessant conceptual and ultimately
physical construction of inside and out. Montaigne may show us a set of scales
as the emblem to his method of weighing up, while Starobinski sees in the
essay the Latin etymology of the weighing process, but the essay never pre-
tends to a totality or to be an end in itself, and in order to weigh the material
the essay must in effect be weightless. As in an Escher print, inside is out and
vice versa, we go round and round and follow successive sets of steps, but we
never reach to the ground, for the essay is drawn by none of the finalising
teleological gravity of the thesis.

Notes

1 Benjamin Dalton, 'What Should We Do with Plasticity? An Interview with
 Catherine Malabou', *Paragraph*, 42(2) (2019), pp. 238–54, at p. 245.
2 Epictetus, 'The Manual', in *The Discourses as Reported by Arrian, The Manual and
 Fragments*, trans. W. A. Oldfather, Harvard University Press, 1925, II, p. 483.
3 Catherine Malabou, 'The Brain of History or the Mentality of the Anthropocene',
 talk given to Moderna Museet, Stockholm, 2017, www.artandeducation.net/cla
 ssroom/video/276251/catherine-malabou-the-brain-of-history-or-the-mentality-of
 -the-anthropocene (accessed 1 March 2021).
4 Will Fassuliotis, 'Impeachment Stories', *The Virginia Law Weekly* (11 April 2019),
 www.lawweekly.org/col/2019/4/11/impeachment-stories-congressman-gerald-for
 ds-attempt-to-remove-justice-william-o-douglas last seen 030321
5 Jack Halberstam, citing the Invisible Committee in *The Coming Insurrection* in his
 introduction to Stefano Harney and Fred Moten, The Undercommons: Fugitive
 Planning and Black Study, Minor Compositions, 2013, p. 7.
6 Sara Ahmed, 'Killing Joy: Feminism and the History of Happiness', *Signs: Journal of
 Women in Culture and Society*, 35(3) (2010), p. 582.

7 Etienne Balibar, 'Democracy, Oppression and Universality', *Verso* (December 2017), www.versobooks.com/blogs/3518-democracy-oppression-and-universality-an-intervie w-with-etienne-balibar (accessed 9 February 2021).

8 Achille Mbembe, 'Necropolitics', trans. Libby Meintjes, *Public Culture*, 15(1) (2003), pp. 11–40, p. 28.

9 Rosi Braidotti, 'Posthuman Humanities', *European Educational Research Journal*, 12(1) (2013), p. 2.

10 Ibid., p. 2.

11 Ibid.

12 Boaventura de Sousa Santos, 'Public Sphere and Epistemologies of the South', Africa Development, XXXVII(1) (2012), pp. 43–67, at p. 51.

13 Ahmed, p. 571.

14 Emily Apter, 'Cosmopolitics', *Political Concepts*, 4 ('Balibar edition') (2018), www. politicalconcepts.org/cosmopolitcs-apters, note 13, citing from Balibar's talk 'A New Querelle of Universals'.

15 Ahmed, p. 577.

16 Eyal Weizman, 'Open Verification', e-flux (18 June 2019), www.e-flux.com/a rchitecture/becoming-digital/248062/open-verification.

17 See the discussion on 'superposition' in the Ngai chapter.

18 Kimberlé Williams Crenshaw, 'Demarginalizing the Intersection of race and Sex: A Black Feminists Critique of Antidiscrimination Doctrine, Feminist Theory and Antiracist Politics' *University of Chicago Legal Forum* (1989), pp. 139–67, at p. 149.

19 Patricia Hill Collins, *Intersectionality as Critical Social Theory*, Duke University Press, 2019, p. 23.

20 J. J. Chun, G. Lipsitz and S. Young, 'Intersectionality as a Social Movement Strat- egy: Asian Immigrant Women Advocates', *Signs: Journal of Women in Culture and Society*, 38(4) (2013), pp. 917–40, at p. 937.

21 Catherine A. McKinnon, 'Intersectionality as Method: A Note', *Signs: Journal of Women in Culture and Society*, 38(4) (2013), pp.1019–30, at p.1026.

Bibliography

Key essays

Sara Ahmed, 'Killing Joy: Feminism and the History of Happiness', *Signs: Journal of Women in Culture and Society*, 35(3) (2010), pp. 571–594.

Emily Apter, 'Cosmopolitics', *Political Concepts, 4* ('Balibar edition') (2018), www.politicalconcepts.org/cosmopolitcs-apters.

Karen Barad, 'Posthumanist Performativity: Toward an Understanding of How Matter Comes to Matter', *Signs: Journal of Women in Culture and Society, 1* (Spring 2003), pp. 801–831.

Rosi Braidotti, 'Posthuman Humanities', *European Educational Research Journal, 12*(1) (2013).

Boaventura de Sousa Santos, 'Public Sphere and Epistemologies of the South', *Africa Development, XXXVII*(1) (2012), pp. 43–67.

Denise Ferreira da Silva, '1 (life) ÷ 0 (blackness) = $\infty - \infty$ or ∞ / ∞: On Matter Beyond the Equation of Value', *e-flux, 79* (2017), www.e-flux.com/journal/79/94686/1-life-0-blackness-or-on-matter-beyond-the-equation-of-value.

Boris Groys, 'Comrades of Time', *e-flux, 11* (December 2009), www.e-flux.com/journal/11/61345/comrades-of-time.

Rem Koolhaas, 'Junkspace', *October, 100* (Spring 2002), pp. 175–190.

Cathérine Malabou, 'The Brain of History, or, the Mentality of the Anthropocene', *The South Atlantic Quarterly, 116*(1) (January 2017), pp. 39–53.

Achille Mbembe, 'Necropolitics', trans. Libby Meintjes, *Public Culture, 15*(1) (2003), pp. 11–40.

Fred Moten and Stefano Harney, 'The University and the Undercommons', *Social Text, 22*(2) (June 2004), pp. 101–115.

Sianne Ngai, 'The Cuteness of the Avant Garde', *Critical Enquiry*, 31(4) (Summer 2005), pp. 811–847.

Paul Preciado, 'Learning from the Virus', *ArtForum* (May/June 2020), www.artforum.com/print/202005/paul-b-preciado-82823.

Anna Tsing, 'Unruly Edges: Mushrooms as Companion Species', *Environmental Humanities, 1* (2012), pp. 141–154.

Eyal Weizman, 'Open Verification', *e-flux* (18 June 2019), www.e-flux.com/architecture/becoming-digital/248062/open-verification.

Secondary works

Theodor W. Adorno, *Aesthetic Theory*, Bloomsbury Academic, 2013.

Theodor W. Adorno, *Notes to Literature*, Columbia University Press, 2014.

Giorgio Agamben, *What is an Apparatus? And Other Essays*, Stanford University Press, 2009.

Sara Ahmed, *The Promise of Happiness*, Duke University Press, 2010.

Benedict Anderson, *Imagined Communities: Reflections on the Origin and spread of Nationalism*, Verso, 1983.

Emily Apter, *Unexceptional Politics*, Verso, 2018.

Hannah Arendt, *The Human Condition*, University of Chicago Press, 1958.

Marc Auge, *Non-Places: Introduction to an Anthropology of Supermodernity*, Verso, London, 2009.

John Langshaw Austin, *How To Do Things with Words*, Martino Fine Books, 2018.

Étienne Balibar, 'At the Borders of Citizenship: A Democracy in Translation?', *European Journal of Social Theory*, 13(3), 315–322.

Étienne Balibar, 'Democracy, Oppression and Universality', Verso, December2017, www.versobooks.com/blogs/3518-democracy-oppression-and-universality-an-inter view-with-etienne-balibar, accessed 9 February 2021.

Étienne Balibar, 'Europe in Crisis: Which "New Foundation?"', Open Democracy, 2017, www.opendemocracy.net/en/can-europe-make-it/europe-in-crisis-which-ne w-foundation, accessed 6 February 2021.

Étienne Balibar, 'Reinventing the Stranger: Walls all over the World, and How to Tear Them Down', *symplokē*, 25(1/2) (2017), pp. 25–41.

Karen Barad. *Meeting the Universe Halfway: Quantum Physics and the Entanglement of Matter and Meaning*, Duke University Press, 2007.

Jean Baudrillard, *The Gulf War Did Not Take Place*, trans. Paul Patton, Indiana University Press, 1995.

Samuel Beckett, *Molloy in the Beckett Trilogy*, Picador, 1979 (first published 1959).

Walter Benjamin, *Illuminations*, trans. Harry Zorn, Schocken Books, 2007.

Henri Bergson, *Time and Free Will*, George Allen and Unwin, 1950.

Rosi Braidotti, *The Posthuman*, Polity Press, 2013.

Peter Buerger, *Theory of the Avant-Garde*, University of Minnesota Press, 1984.

Judith Butler, *The Force of Non-Violence*, Verso, 2020.

Judith Butler, *Gender Trouble: Feminism and the Subversion of Identity*, Routledge, 1999.

Thomas Carlyle, 'Signs of the Times', in *Selected Writings*, Penguin, 1971.

Barbara Cassin, Emily Apter*et al.* (eds), *Dictionary of Untranslatables: A Philosophical Lexicon*, Princeton University Press, 2014.

J. J. Chun, G. Lipsitz and S. Young, 'Intersectionality as a Social Movement Strategy: Asian Immigrant Women Advocates', *Signs: Journal of Women in Culture and Society*, 38(4) (2013), pp. 917–940.

Patricia Hill Collins, *Intersectionality as Critical Social Theory*, Duke University Press, 2019.

Le Corbusier, *Towards a New Architecture*, Architectural Press, 1946.

F. M. Cornford, 'The Invention of Space', in M. Čapek (ed.), *The Concepts of Space and Time*, Springer, 1976, pp. 3–16.

Geoff Cox and Jacob Lund, *The Contemporary Condition: Thoughts on Contemporaneity and Contemporary Art*, Sternberg Press, 2016.

Kimberlé Williams Crenshaw, 'Demarginalizing the Intersection of Race and Sex: A Black Feminists Critique of Antidiscrimination Doctrine, Feminist Theory and Antiracist Politics', *University of Chicago Legal Forum*, 1(8) (1989), pp. 139–167.

Benjamin Dalton, 'What Should We Do with Plasticity? An Interview with Catherine Malabou', *Paragraph*, 42(2) (2019), pp. 238–254.

Gilles Deleuze and Felix Guattari, *Capitalisme et Schizophrenie, L'Anti-Oedipe*, Éditions de Minuit, 1972.

Jacques Derrida, *Acts of Literature*, ed. Derek Attridge, Routledge, 1992.

Jacques Derrida, *Of Grammatology*, tr. Gayatri Chakravorty Spivak, Johns Hopkins University Press, 1976 (French edition published 1967).

Jacques Derrida and David Wills, 'The Animal that Therefore I Am', *Critical Inquiry*, 28(2) (Winter 2002), pp. 369–418.

Brian Dillon, *Essayism*, Fitzcarraldo Editions, 2017.

Epictetus, 'The Manual', in *The Discourses as Reported by Arrian, The Manual and Fragments*, trans. W. A. Oldfather, Harvard University Press, 1925.

Roberto Esposito, *Living Thought: The Origins and Actuality of Italian Philosophy*, Stanford University Press, 2012.

Frantz Fanon, *The Wretched of the Earth*, trans. C. Farrington, Grove Weidenfeld, 1991.

Will Fassuliotis, 'Impeachment Stories', *The Virginia Law Weekly* (11 April 2019), www.lawweekly.org/col/2019/4/11/impeachment-stories-congressman-gerald-fords-attempt-to-remove-justice-william-o-douglas, accessed 3 March 2021.

Denise Ferreira da Silva, 'Hacking the Subject: Black Feminism and Refusal beyond the Limits of Critique', *philoSOPHIA*, 8(1) (Winter 2018), pp. 19–41.

Denise Ferreira da Silva, 'Hacking the Subject: Black Feminism, Refusal, and the Limits of Critique', www.youtube.com/watch?v=T3B5Gh2JSQg, accessed 21 March 2021.

Denise Ferreira da Silva, 'Towards a Black Feminist Poethics', *The Black Scholar*, 44(2) (Summer2014), pp. 81–97.

Mark Fisher, *Capitalist Realism: Is there no Alternative?*, Zero Books, 2009.

Michel Foucault, *The Archaeology of Knowledge*, Pantheon Books, 1972.

Michel Foucault, *Discipline and Punish: The Birth of the Prison*, Penguin, 1991.

Michel Foucault, *The Order of Things*, Routledge, 2002.

Michel Foucault, 'Of Other Spaces: Utopias and Heterotopias', trans. Jay Miskowiec, *Diacritics*, 16(1) (Spring 1986), pp. 22–27.

Michel Foucault, 'Space, Power, and Knowledge (Interview by Paul Rabinow)', in Simon During (ed.), *The Cultural Studies Reader*, Routledge, 1993.

Sigmund Freud, *Jokes and their Relation to the Unconscious*, Penguin, 1973.

Francis Fukuyama, 'The End of History?', *The National Interest*, 16 (1989), pp. 3–18.

Siegfried Gideion, *Space, Time and Architecture*, Harvard University Press, 2008.

Stephen Graham and Simon Marvin, *Splintering Urbanism: Networked Infrastructures, Technological Mobility and the Urban Condition*, Routledge, 2001.

Clement Greenberg, 'Avant Garde and Kitsch', *The Partisan Review* (1939), pp. 34–49.

Donna J. Haraway, 'Manifesto for Cyborgs: Science, Technology, and Socialist Feminism in the 1980s', *Socialist Review*, 80 (1985), pp. 65–108.

Donna J. Haraway, *Staying with the Trouble: Making Kin in the Chthulucene*, Duke University Press, 2016.

Donna J. Haraway, *When Species Meet*, University of Minnesota Press, 2008.

Stefano Harney and Fred Moten, *The Undercommons: Fugitive Planning and Black Study*, Minor Compositions, 2013.

Heinrich Heine, 'London', in *The Prose Writings of Heinrich Heine*, ed. Havelock Ellis, Walter Scott, 1887.

John Higgins, *Raymond Williams: Literature, Marxism and Cultural Materialism*, Routledge, 1999.

Eric Hobsbawm, 'The Machine Breakers', https://libcom.org/history/machine-breakers-eric-hobsbawm, accessed 4 January 2021.

David Hume, *Essays and Treatises on Several Subjects*, 2 vols, A. Millar, 1768.

David Hume, 'My Own Life', in Geoffrey Sure-McCord (ed.), *Moral Philosophy*, Hackett, 2006.

David Hume, *Selected Essays*, Oxford University Press, 1998.

David Hume, *A Treatise of Human Nature*, Penguin, 1985.

Fred Inglis, *Raymond Williams*, Routledge, 1998.

Frederic Jameson, *Postmodernism or the Cultural Logic of Late Capitalism*, Duke University Press, 1991.

Immanuel Kant, *Critique of Pure Reason*, Cambridge University Press, 1998.

Rem Koolhaas and Hal Foster, *Junkspace with Running Room*, Notting Hill Editions, 2013.

Suzanne Langer, *Feeling And Form: A Theory Of Art*, Scribner, 1953.

Jacob Lund, *The Contemporary Condition: Anachrony, Contemporaneity and Historical Imagination*, Sternberg Press, 2019.

Jean-François Lyotard, *The Postmodern Condition*, University of Minnesota, 1984.

Alasdair MacIntyre, 'On Having Survived Academic Moral Philosophy', talk given to University College Dublin, School of Philosophy, March2009, www.youtube.com/watch?v=Hbs4MjHWh8A, accessed 19 January 2021.

Catherine Malabou, 'The Brain of History or the Mentality of the Anthropocene', talk given to Moderna Museet, Stockholm, 2017, www.artandeducation.net/classroom/video/276251/catherine-malabou-the-brain-of-history-or-the-mentality-of-the-anthropocene, accessed 1 March 2021.

Catherine Malabou, *The Future of Hegel*, Routledge, 2005.

Catherine Malabou, *Plasticity at the Dusk of History: Dialectic, Destruction, Deconstruction*, trans. Carolyn Shread, Columbia University Press, 2010.

Lambros Malafouris, *How Things Shape the Mind: A Theory of Material Engagement*, MIT Press, 2013.

Lambros Malafouris, 'Metaplasticity and the Human Becoming: Principles of Neuroarcheology', *Journal of Anthropological Sciences*, 88 (2010), pp. 49–72.

Achille Mbembe, *Necropolitics*, trans, Steven Corcoran, Duke University Press, 2019.

Achille Mbembe, *Out of the Dark Night: Essays on Decolonisation*, Columbia University Press, 2021.

Catherine A. McKinnon, 'Intersectionality as Method: A Note', *Signs: Journal of Women in Culture and Society*, 38(4) (2013), pp. 1019–1030.

Jim McGuigan, *Raymond Williams: Cultural Analyst, Intellect*, University of Chicago Press, 2019.

Michel de Montaigne, *Shakespeare's Montaigne: The Florio Translation of the Essays, A Selection*, New York Review of Books, 2014.

Eugenio Montale, *Auto da fé: Cronache in due tempi*, Il Saggiatore, 1966.

Thomas More, *Utopia*, trans. Dominic Baker-Smith, Penguin, 2000.

Sianne Ngai, *Our Aesthetic Categories: Zany, Cute, Interesting*, Harvard University Press, 2012.

Friedrich Nietzsche, *Human All Too Human*, Cambridge University Press, 1996.

George Orwell, 'What is Fascism?', *Tribune* (24 March1944).

Erwin Panofsky, *Three Essays on Style*, MIT Press, 1995.

Pier Paolo Pasolini, 'Il Perche di Questa Rubrica', *Tempo*, 32(XXX, 'Il caos') (6 August 1968).

Bob Perelman and Francie Shaw, *Playing Bodies*, Granary Books, 2004.

Francis Ponge, *The Voice of Things*, trans. Beth Archer, McGraw-Hill, 1972.

Karl Popper, *Open Society and its Enemies*, Routledge, 2002 (first published 1945).

Paul B. Preciado, *An Apartment on Uranus*, Fitzcarraldo Editions, 2019.

Paul B. Preciado, *Testo Junkie: Sex, Drugs and Biopolitics in the Pharmacopornographic Era*, The Feminist Press, 2013.

Saverio Ricci and Caterina Fastella, 'La Censura Romana e Montaigne: con un documento relativo alla condanna del 1676', *Bruniana & Campanelliana*, 14(1) (2008), pp. 59–79.

W. Robertson Smith, *Lectures on the Religion of the Semites*, Adam & Charles Black, 1889.

Irit Rogoff, 'Keynote: Irit Rogoff', talk at Nottingham Contemporary, 2019, www.youtube.com/watch?v=QGSf5N-Bm7o, accessed 19 January 2021.

Lionel Ruffel, *Brouhaha: Les Mondes du Contemporain*, Verdier, 2016.

Joseph Rykwert, *The Idea of a Town*, MIT Press, 1988.

Edward Said, *Orientalism*, Penguin, 2003.

Arthur Schopenhauer, *The World as Will and Representation*, trans. E. F. J. Payne, Dover, 1969.

Boaventura de Sousa Santos, 'Decolonising the University and Beyond', 2020, www.youtube.com/watch?v=enqNHDYdBwE, accessed 18 December 2020.

Boaventura de Sousa Santos, *The End of the Cognitive Empire*, Duke University Press, 2018.

Gayatri Chakravorty Spivak, 'Can the Subaltern Speak?', in Cary Nelson and Lawrence Grossberg (eds), *Marxism and the Interpretation of Culture*, University of Illinois Press, 1988, pp. 271–313.

Gertrude Stein, *Tender Buttons: Objects, Food, Rooms*, Sun and Moon Press, 1990.

Ravi Sundaram, 'Aesthetics, Technological Politics and the Video Age', undated, www.thedrouth.org/aesthetics-technological-politics-and-the-video-age-by-ravi-sundaram, accessed 24 October 2020.

E. P. Thompson, *The Making of the English Working Class*, Penguin, 2002.

Anna Tsing, *The Mushroom at the end of the World*, Princeton University Press, 2017.

David Wallace, 'Fred Moten's Radical Critique of the Present', *New Yorker* (30 April 2018), www.newyorker.com/culture/persons-of-interest/fred-motens-radical-critique-of-the-present, accessed 15 March 2021.

McKenzie Wark, *General Intellects: Twenty-one Thinkers for the Twenty-first Century*, Verso, 2017.

McKenzie Wark, *A Hacker Manifesto*, Harvard University Press, 2004.

Eyal Weizman, *Hollow Land*, Verso, 2012.

Raymond Williams, *Keywords: A Vocabulary of Culture and Society*, Fontana, 1976.

Raymond Williams, *The Politics of Modernism*, Verso, 1989.

Virginia Woolf, *The Common Reader*, Harcourt Brace, 1948.

Paola Zanardi, 'Italian Responses to David Hume', in P. Jones (ed.), *The Reception of David Hume In Europe*, Continuum, 2005.

Nicholas Zembashi, 'Forensic Architecture', 2019, www.gsa.ac.uk/life/gsa-events/events/f/forensic-architects/?source=filter, accessed 14 March 2021.

Bruno Zevi, *The Modern Language of Architecture*, Australian National University Press, 1978.

Shoshana Zuboff, *The Age of Surveillance Capitalism*, Profile Books, 2019.

Index